KENNETH McCONKEY

British Impressionism

Φ

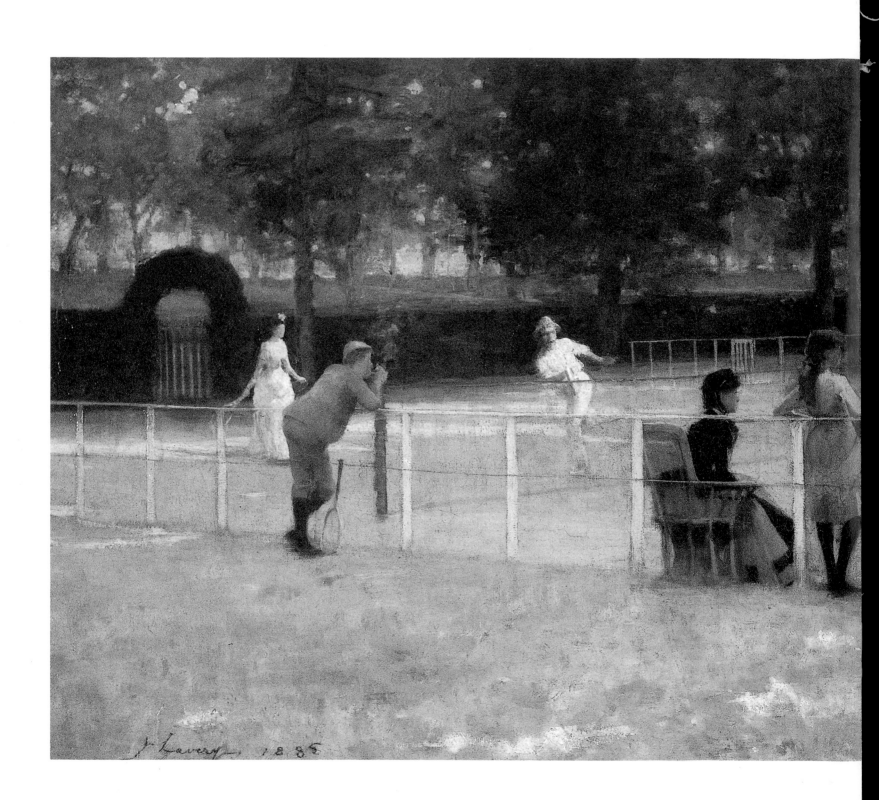

For Sarah and Thomas

Phaidon Press Limited, Regent's Wharf, All Saints Street, London N1 9PA

First published 1989
First paperback edition 1998
© Phaidon Press Limited 1989
Text © Kenneth McConkey

A CIP catalogue record for this book is available from the British Library

ISBN 0 7148 2956 0

Printed in Hong Kong

Acknowledgements

The publishers have endeavoured to credit all known persons holding reproduction rights for illustrations in this book, and wish to thank all the public, private and commercial owners, and institutions concerned.

Plate 78: Browse and Darby, London; 67, 98, 105, 102, 115, 133: Christie's; 21, 26: Cliché des Musées Nationaux, Paris; 87: Ewan Mundy Fine Art, Glasgow; 38, 61, 62, 63: Fine Art Society; 31, 116: Phillips; 16, 108: Pyms Gallery; 95: Richard Green Galleries; 21, 26: reproduced by courtesy of the Trustees of the Victoria and Albert Museum.

Additional photography: Vincent Moore.

TITLE PAGE. Alexander Harrison, detail from *In Arcadia* (Plate 52).
FRONTISPIECE. John Lavery. *The Tennis Party*, 1885. Oil on canvas, 77 × 183.5 cm (30⅓ × 72¼ in.). Aberdeen Art Gallery. When he returned to Glasgow at the end of 1884 Lavery devoted himself to recording the lives of the wealthy middle classes. Lawn tennis was a newly fashionable pursuit which occupied his attention on more than one occasion, and he claimed that he was led to this subject by Bastien-Lepage, who had advised him always to study figures in movement.

Contents

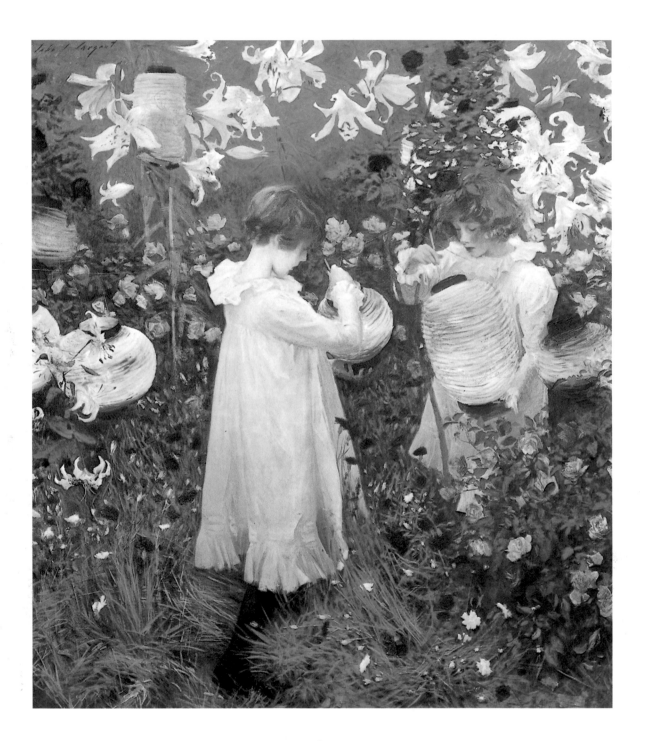

1
John Singer Sargent
(1856–1925).

Carnation, Lily, Lily, Rose, 1885–86. Oil on canvas, 174 × 153.7 cm.
(68½ × 60½ in.) London, Trustees of the Tate Gallery. *Carnation,
Lily, Lily, Rose* was essentially the first piece of public Impressionism to
be produced in Britain, and for several years after its exhibition in
1887 it remained the salient example of the new manner. It was
memorable not least because its title was drawn from the refrain of a
popular song. It was begun at Broadway in the autumn of 1885, and
recommenced the following year when the light conditions were
equivalent. Obviously the work could be compared with a number of
Monet's garden scenes of the late 1870s, but the shallow space,
evening light and the aestheticism of lilies and carnations suggests that
Sargent had motives beyond Impressionism

2
Harold Knight
(1874–1961).

In the Spring, 1908–09. Oil on canvas, 132.2 × 157.9 cm.
(52¼ × 62¼ in.) Newcastle upon Tyne, Tyne and Wear Museums.
The differences between Knight's *In the Spring* and Guthrie's
Midsummer (Plate 92) are as interesting as the similarities. Knight
brought with him to Newlyn a solidly realistic manner of painting
which depended more upon drawing and tone than upon colour. His
figures, unlike those of Guthrie, are carefully delineated. Design and
distribution of masses takes precedence over atmospherics.

Preface and Acknowledgements

Problems of definition beset the study of Impressionism. Degas, inviting Tissot to join in what was to become the first Impressionist exhibition in 1874, stated his conviction that there must be 'a salon of the realists'. One important critic, Jules-Antione Castagnary, reviewing the exhibition and talking about Monet's work, made the distinction between the rendering of landscape as such and the sensation produced by the landscape. This merely extended the definition of naturalism advocated by Emile Zola in the 1860s. Another important critic, Edmond Duranty, writing in 1876 on the 'new painting', expanded the naturalist sensibility by stressing acuity of observation of human character. In this, an opposition was set up between the painters of landscape and those who portrayed urban subject matter. Zola, in praising Bastien-Lepage at the naturalist Salon of 1880, gave the clear implication that landscape 'impressions' were by definition superficial, if they could not be realized in a larger context.

These confusions within the group remained unresolved as the character and balance of the Impressionist exhibitions changed between 1874 and 1886. They were live issues at the 'university', the café called Nouvelle-Athènes, where George Moore spent his undergraduate years. Having arrived in Paris in 1873, with his valet, he aimed to lead a sort of *vie de bohème*. A few years later, he gate-crashed on the Impressionist group and briefly became friendly with Manet and Degas. After he settled in London in 1881, Moore committed this sentimental education to paper in a variety of publications spanning a thirty-year period. Although often inaccurate in points of detail, his writings had the virtue of authenticity, and particularly in the 1890s, when he was grouped with D. S. MacColl and R. A. M. Stevenson as one of the 'new' critics, his opinions were influential amongst those British painters who were responding to Impressionism. Apart from stating his preferences, however, Moore was not able to settle the essential differences which existed within the Impressionist group. Without the benefit of critical distance, British artists did not evolve a synthesis in response to the clear divergence of approach between Manet, Degas and the urban naturalists, and Monet, Pissarro and the landscape Impressionists. Indeed, by a strange inversion of history, the younger generation of British painters, active in the 1880s, began by admiring an appealing synthesis in the work of Bastien-Lepage, before addressing its component parts.

British Impressionism was therefore as disparate as French painting in the *fin-de-siècle*. It developed quickly as knowledge, understanding and the dissemination of images became ever more sophisticated. Its history is rich and complex and comprises not only the description of what painters did and with whom they conferred, it also involves the pro-active role of critics like Moore and MacColl,

as well as the re-active stance of those who had espoused other forms of the *avant-garde*. At the same time, there is a history of ideas and tastes, a set of social and cultural constraints which frames the preoccupations of painters at any given moment. A consciousness of these led Sickert, by 1910, to evolve the notion of a developing consensus.

In formulating *British Impressionism*, I have profited greatly from the writings of Wendy Baron, Roger Billcliffe, William H. Gerdts, Anna Gruetzner Robins, Bruce Laughton and Richard Ormond – all of whom have provided detailed accounts of aspects of the subject. My grateful thanks are also due to Warren Adelson, Janet Barnes, Chloe Bennett, William Darby, Rose Eva, Edward Hickey, Alan and Mary Hobart, Jonathon Horwich, Barbara Gallati, Esme Gordon, Francina Irwin, Amanda Kavanagh, Susan Kent, Graham Langton, Andrew McIntosh Patrick, Joe Marchman, Jennifer Melville, David Messum, Edward Morris, Ewan Mundy, Peter J. Solomon, Peyton Skipwith, Donna Seldin and Sheenah Smith for helping me to obtain photographs. As ever, I am indebted to my wife, Annette, for her assistance in the preparation of the manuscript.

Kenneth McConkey
March 1988

CHAPTER ONE

Difficulties of Definition

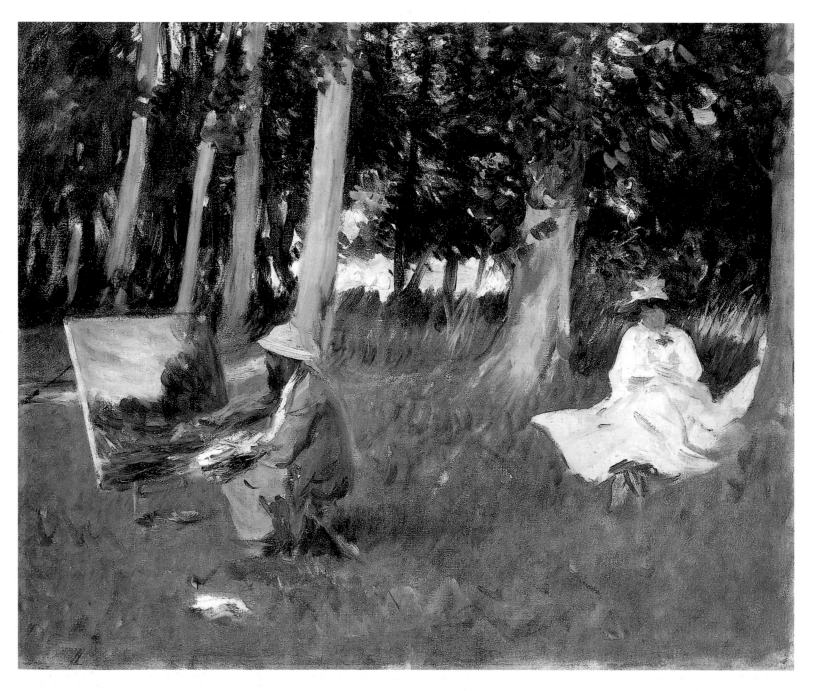

One summer's day, towards the end of the 1880s, Claude Monet sat painting at the edge of a wood near his home at Giverny. Although he was already being besieged by eager American students, Monet was apparently oblivious to the fact that, on this occasion, his activities were being observed. As he quietly painted, John Singer Sargent made him the subject of his own quick sketch. Behind Monet, heedless of either artist, its an unidentified woman, probably Suzanne Hoschedé, the daughter of Mme. Ernest Hoschedé, the French painter's future wife. Nothing in the tall grey trees disturbs the painter's concentration. There is no evidence to suggest that Sargent thought particularly deeply about his subject matter – the making of an Impressionist picture (Plate 3). Paintings of artists at work were common enough in the nineteenth century. Having installed himself at Giverny, Monet was, by the end of the 1880s, becoming an object of pilgrimage. Well-known in Paris, he was arousing considerable curiosity in London, where Sargent was now exhibiting his own important works. Presumably for this reason Sargent sent his portrait of Monet to the New Gallery exhibition in 1888 (Plate 4). The painting reinforced the growing importance of French Impressionism and Sargent's own relationship to it.[1] Yet for all the 'great breadth and freedom' observed in it by one reviewer, the portrait is dutiful and conventional compared to *Claude Monet Painting at the Edge of a Wood*. This latter canvas has been swiftly worked, in dialogue with nature, the foliage suggested with dabs of pigment which remain self-assertive and are not manipulated into some sort of eye-deceiving effect. *Claude Monet Painting . . .* has some of the urgency of real Impressionism. It is one of a series of pictures in which Sargent temporarily adopted the Impressionist ideal, whilst at the same time laying the foundations of true success in portraiture. The strength of his affiliation is almost measurable. He is preoccupied as never before with a manner of representing, as much as with the things represented, and because the canvas is couched in Monet's terminology, it begs direct comparison. Whilst Sargent's handling lacks the density of the Impressionist's impasto, Monet's characteristic 'comma' brushstrokes are present in the foliage.

Thus Sargent momentarily creeps into the history of French Impressionism because of his privileged relationship with Monet. Was this a unique relationship? Was it the model by which others in the broader context should be judged? Is the history of British Impressionism merely a history of such fragmentary contacts? What general understanding of French painting was there at the time when Sargent sat down to record Monet's aesthetic deliberations? Should these questions be construed differently if they are posed for the mid-1890s or for the early Edwardian years? So various were the usages of the word 'impression' during this period, that it had no absolute meaning. Like most appealing neologisms, it was not strictly defined. Whilst the knowledge of French Impressionism deepened, it was not understood according to any developmental principles. Between 1874 and 1886, the dates of the first and last Impressionist exhibitions in Paris, Impressionism changed considerably. Within any one of the eight exhibitions, there were many different types of Impressionist. The movement's heroes emerged gradually and even if they were latterly applauded, their distinction was less apparent in the 1880s than at the turn of the century. This presupposes that they were noticed at all within the rich panorama of French art. The task of describing a developing consensus in Britain around Impressionist

3
John Singer Sargent
(1856–1925).

Claude Monet Painting at the Edge of a Wood, 1887. Oil on canvas, 54 × 64.8 cm. (21¼ × 25½ in.) London, Trustees of the Tate Gallery. One of Sargent's most important Impressionist essays appropriately depicts the making of an Impressionist picture. It provides evidence of the painter's firsthand experience of Monet at work in a manner with which its subject would identify.

4
John Singer Sargent
(1856–1925).

Claude Monet, 1887. Oil on canvas,
40.6 × 33 cm. (16 × 13 in.) New York, National
Academy of Design. Paradoxically, Sargent's
portrait of the Impressionist painter reveals less
of the identity of his sitter than *Claude Monet
Painting at the Edge of a Wood*. It conforms to the
pattern of realist profiles such as Carolus Duran's
earlier portrait of *Zacharie Astruc* in being
concerned with the precise and the particular.

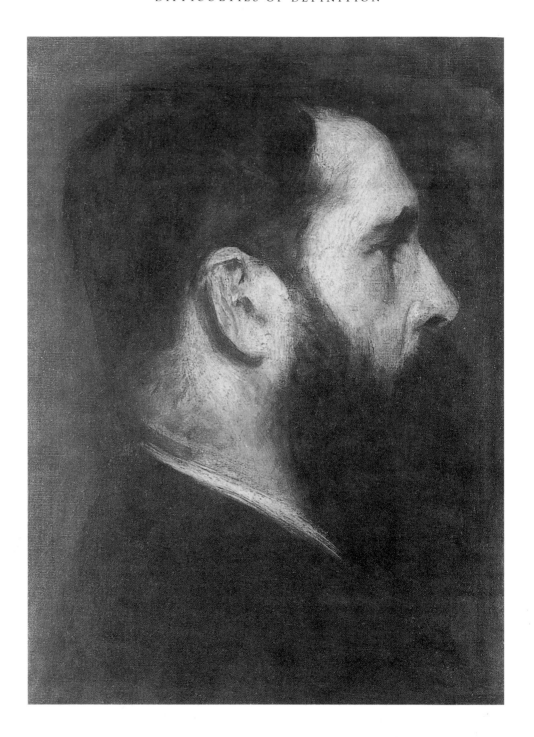

practice between 1880 and 1910 is much more problematic than simply logging
contacts between French and British painters.

The conventional viewpoint is that the work of Walter Sickert and Philip
Wilson Steer is central to this development – one a follower of Whistler and
Degas, the other extending practices derived from Monet.[2] Around the time that
Sargent was in Giverny, Sickert had embarked upon a struggle to gain control of
the avant-garde group in London. As he strove to define an Impressionism of the
urban metropolis, he engaged issues which his French counterparts had never

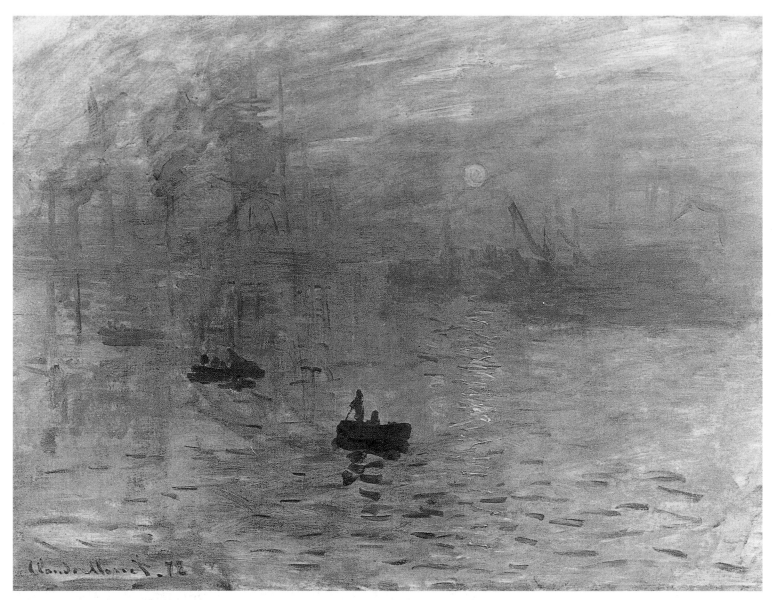

5
Claude Monet
(1840–1926).

Impression: Sunrise, 1872. Oil on canvas,
49.5 × 64.7 (19½ × 25½ in.) Paris, Musée
Marmottan. Although he worked with a close
range of tone and colour harmonies, similar to
those of Whistler, Monet was concerned more
with transient effects than with carefully
premeditated compositional balance.

fully resolved. Degas, whose ideas Sickert greatly admired, had a deep distrust of those who, like Monet and Sargent, were painting *en plein air*.

Sickert's first master, Whistler, was by another set of definitions also popularly regarded as an Impressionist. The possibility of Monet having seen Whistler's *Nocturne in Blue and Green: Chelsea* (Plate 6), might well have propelled him towards *Impression: Sunrise*, the seminal work from the first Impressionist exhibition.[3] Whistler had been invited to participate in this particular show, but having planned his first solo exhibition in London in 1874, he declined.[4] For the average spectator of the period, his nocturnes, especially those of fireworks at Cremorne Gardens, must have appeared less comprehensible than the works of the Impressionists. One of these, *Nocturne in Black and Gold: The Falling Rocket* (Plate 7), was declared by John Ruskin to be a piece of 'cockney impudence' when it was shown at the first exhibition of the Grosvenor Gallery in 1877. The celebrated libel action which followed can only have damaged the public reputation of both protagonists, but it must have had a decisive effect upon the

13

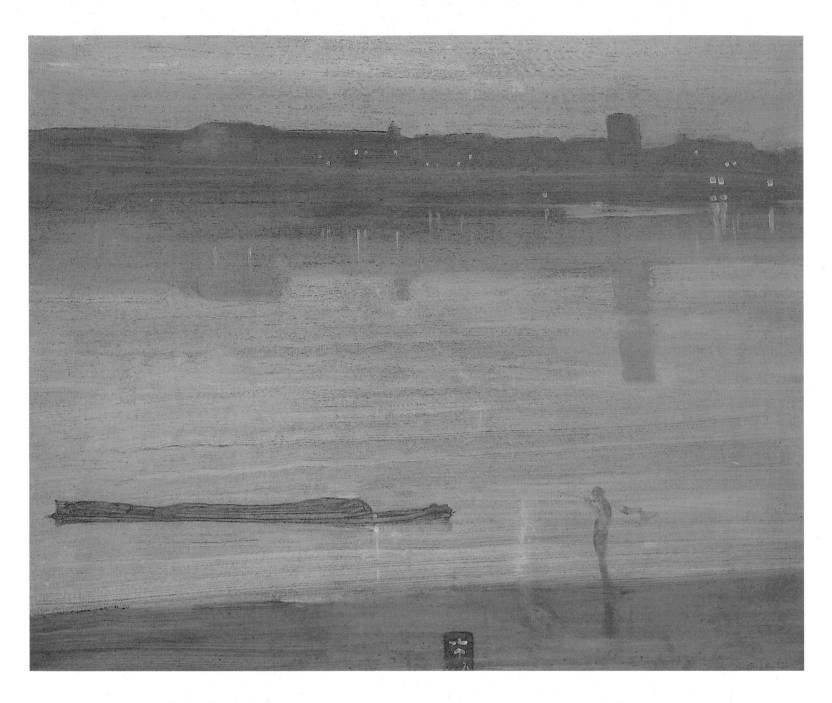

6
James McNeill Whistler
(1834–1903).

Nocturne in Blue and Green: Chelsea, 1870. Oil on panel,
50.2 × 59.1 cm. (19¾ × 23¼ in.) London, Trustees of the Tate
Gallery. The flowing fluid cross strokes, colour harmony and careful
position of the horizon, the barge and the elongated figure,
demonstrate the influence of Japanese prints upon Whistler's art. In
this his work was closely related to that of the Impressionists, even
though he did not develop their broken colour.

7
James McNeill Whistler
(1834–1903).

Nocturne in Black and Gold: The Falling Rocket, 1877. Oil on panel,
60.3 × 46.6 cm. (23¾ × 18⅜ in.) Detroit, Institute of Art, gift of Dexter
M. Ferry Jnr. In the polemics of Modern Art, this extraordinary
picture occupies a position similar to Manet's *Nana* or Gervex's *Rolla*.
The problems it posed, however, were less to do with its scandalous
subject matter than with its legibility. In the legal battle with Ruskin
which the picture provoked, Whistler felt he had won the painter's
right to exhibit works which were solely concerned with abstract
harmony and in this made no concessions to the Victorian demand for
narrative.

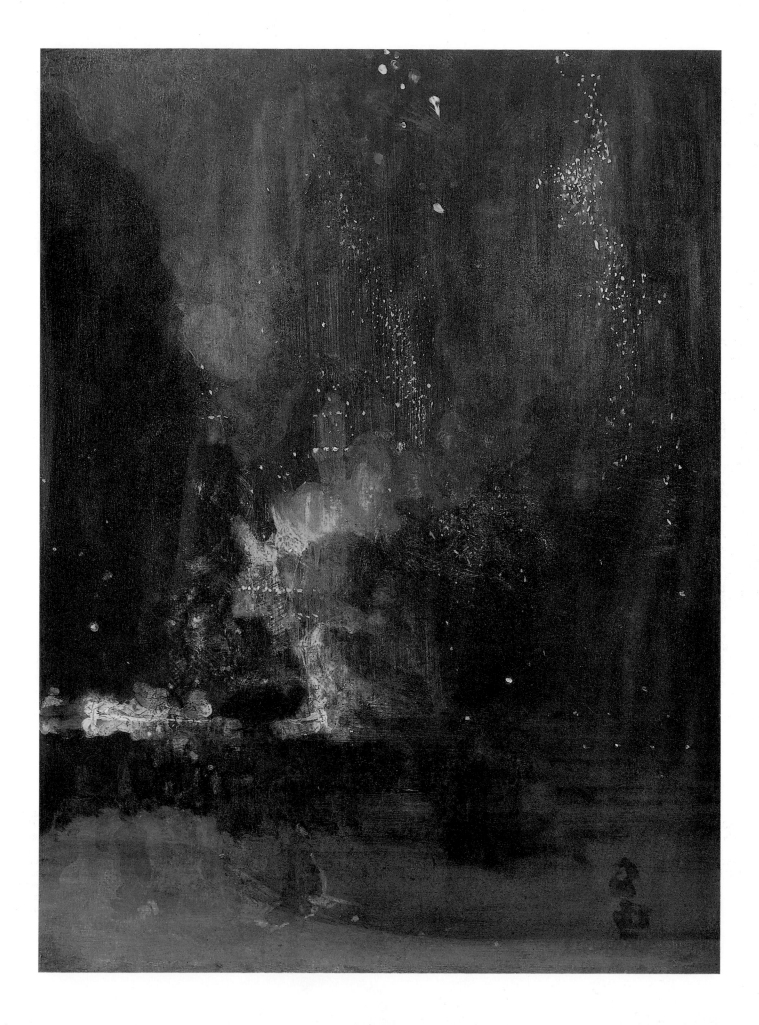

8
Philip Wilson Steer
(1860–1942).

Walter Richard Sickert, c.1893. Oil on canvas,
59.7 × 29.8 cm. (23½ × 11¾ in.) London, National
Portrait Gallery.

9
Walter Richard Sickert
(1860–1942).

Philip Wilson Steer, 1890. Oil on canvas, 90.2 × 59.7 cm
(35½ × 23½ in.) London, National Portrait Gallery.

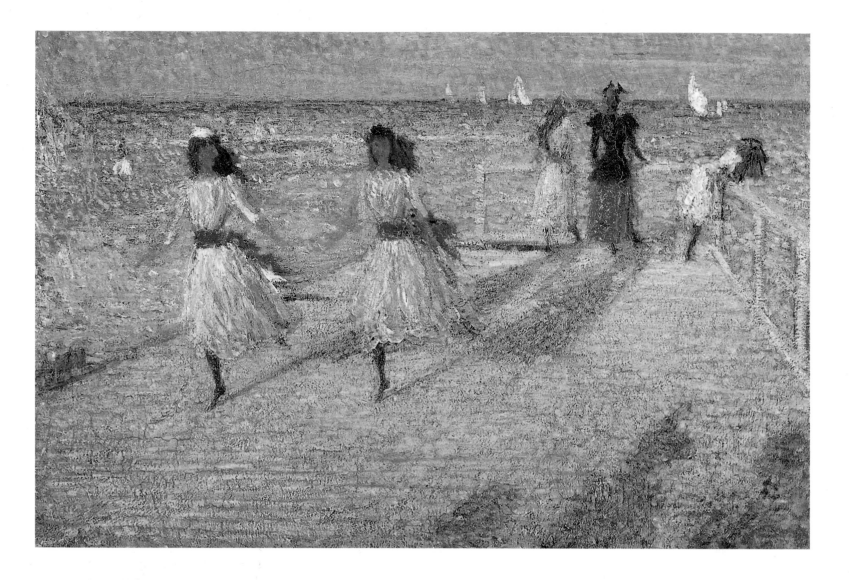

10
Philip Wilson Steer
(1860–1942).

Girls Running, Walberswick Pier, c. 1890–94. Oil on canvas,
69.2 × 92.7 cm. (27¼ × 36½ in.) London, Trustees of the Tate
Gallery. Steer's classic Impressionist picture has been applauded as
much for its extraordinary composition as for its technique. Its
weightless butterfly figures, fixed in space and heavily impasted,
provided much more than a momentary impression. Their actions
contain the passionate intensity of recreated memory.

11
Henry Herbert La Thangue
(1859–1929).

An Autumn Morning, 1897. Oil on canvas, 121 × 95 cm.
(47½ × 37½ in.) The Marchman Collection. La Thangue wished to
portray dynamic figure movement by means of selective focus. As a
naturalist painter he juxtaposed tight meticulous draughtsmanship in
head and hands against an amazing freedom of handling in the leafy
setting. In this mass of stipple, a background figure is almost
submerged.

younger generation of painters. The remote courtroom fisticuffs might have been amusing, but in the eyes of many, the combative 'coxcomb', as Ruskin labelled Whistler, had become a popular hero. 'Such a man!' wrote the nineteen-year-old Sickert, 'the only painter alive who has first immense genius, then conscientious persistent work striving after his ideal, knowing exactly what he is about and turned aside by no indifference or ridicule.'[5] This adulation was to be tempered by close acquaintance, and when he got to know Degas, Sickert was prepared to sacrifice Whistlerian atmospherics for the more scientific naturalism of modern life recreated in the studio.

When it was investigated at the turn of the century, Monet's and Pissarro's interlude in London during 1870–77 assumed greater importance than it ought. It allowed Constable, Turner and Crome to be admitted to the composite picture of Impressionism and thus provide *ex post facto* justification for tendencies then current in British painting.[6] These entanglements did not detain Sickert and Steer, whose work was openly experimental, at times risking resolution in the pursuit of effects more readily associated with the French Impressionists. Steer's swift advance towards the more extreme form of Impressionism and his subsequent retreat from it have been frequently observed, if never satisfactorily explained. Nevertheless, it has been because of the distinctive autographic quality of their painting, that both he and Sickert have been isolated from their contemporaries and admitted to direct comparison with the early masters of modernism. They are, therefore, essential to the validation of British painting as a deviant offshoot from the mainstream. Such a history inevitably stresses points of contact with France and evolves its own checklist of stylistic traits by which specific examples could be judged. At times, even these painters could be found wanting. If Renoir had painted Steer's *Girls Running, Walberswick Pier* (Plate 10), as Sir John Rothenstein observed, 'the effect might have been of greater breadth': if painted by Lautrec, the girls' strangeness 'might have been defined'.[7] For all Rothenstein's sensitivity to Steer's work, the comparisons are invidious. Rendered by either French painter, *Girls Running . . .* would lose its passionate intensity – what Rothenstein aptly described as 'visionary splendour'.

The orthodox history of British Impressionism, in so far as it has emerged, has concerned itself with Steer and Sickert and their immediate circle (Plates 8 and 9). Artists outside this circle, of the same generation, and trained in the Paris ateliers, occupy a subordinate role as prefaces or postscripts, the masters of a naturalism quickly rendered defunct, or an Academy Impressionism of conventional afterglows. Neither mode is to be taken seriously. Difficulties increase when considering Steer's later work in the Edwardian period. Sickert's interest in quirky narrative and his continual use of a restricted colour range pose problems to the point where it becomes necessary to ask whether there truly was a British Impressionism. Aside from this, claims are advanced on behalf of Irish and Scottish 'Impressionists', many of whom originated in the same art colonies as the English rustic naturalists and Newlyn School painters.[8] These artists painted *en plein air*, under white sketching umbrellas, just like the Impressionists. But what are the differences? Does this broader sweep, taking in the Scots and the Irish, necessitate a definition of Impressionism in Britain which sets up different terms of reference analogous to, but separate from French Impressionism? Does this imply that at its seedling stage, British artists were reticent about

modernism? These issues can only be settled at a critical distance, and without preconceptions as to what the answers ought to be.

Taking the description of this phenomenon as an account of what the broader knowledge of French painting enabled British artists to do in the years between 1880 and 1910, it becomes necessary to produce a general history in which both knowledge and practice develop according to their own internal momentum. In this, Steer and Sickert are only two of the participants. They and others were urged to their particular explorations of style and subject matter by a sense of community and common purpose, motivating the young French-trained painters of their generation. At the end of the period under consideration, Sickert reviewed the work of one of his contemporaries, Henry La Thangue, and stressed the individuality which had emerged. 'The very fact that La Thangue does not give us, ready-made, and over again, the gamut of Monet, or to be *fin-de-décade*, of Cézanne, is just what gives La Thangue his reason for existence,' he stated emphatically.[9] As a painter of rustic subjects, derived initially from Millet and Bastien-Lepage, La Thangue had always remained fascinated by issues to do with *métier*. He evolved his own method. What was produced set up its own parameters, against which the checklist derived from Monet or Cézanne would only operate up to a point. As La Thangue painted the serious young peasant woman, raising her knee to break a faggot in *An Autumn Morning* (Plate 11), he too was breaking away from jaded academicism and from the rustic naturalist prototypes of his youth. He stands for an extraordinarily accomplished generation of British painters, born in the 1850s and 1860s, who were anxious initially to dispose of the inherited wisdom of the Royal Academy, and to do this they placed themselves in the centre of the debate about the cultural programme of the Third Republic. Around 1880, when La Thangue and his contemporaries were in Paris, large naturalistic pictures of peasants, loosely inspired by the work of Jean-François Millet, were constantly the focus of public attention.

CHAPTER TWO

Figures and Fields

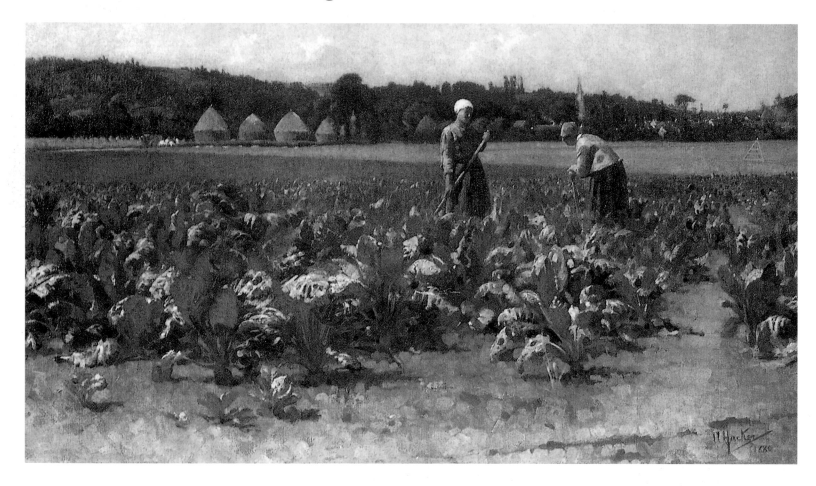

12
Arthur Hacker
(1858–1919).

The Turnip Field, 1880. Oil on canvas, 45.7 × 81.3 cm. (18 × 32 in.)
London, David Messum Fine Paintings. Arthur Hacker's early
landscape differs considerably from French scenes by Hennessy and
more mature British painters. Its broad handling and naturalistic
lighting gives a convincingly open air effect.

French and English versions of Alfred Sensier's *Jean-François Millet, Peasant and Painter* appeared in 1881. In his biography, the author set out to lionize one of the great folk-heroes of recent French painting.[1] Millet had died six years earlier and already his reputation was immense. He was genuinely of peasant stock and as an art student in Paris he earned the nickname 'man of the woods'. The moral tale of this painter whose artistic struggle led him to abandon the cosmopolitan art world of Paris for the rustic simplicity of village life was to become a paradigm. It epitomized integrity and conviction, the painter's lonely battle with social and artistic convention to obtain recognition for the peasant's life as a legitimate source of subject matter in art. To his biographer, Millet was a 'labourer who loves his field – ploughs, sows and reaps it. His field is art. His inspiration is life, is nature – which he loved with all his strength.'[2]

Sensier's encomium had widespread effects. His words were enthusiastically consumed by many young artists in western Europe – Vincent Van Gogh among them. In Britain the publication was complemented by many others. In the same year the Fine Art Society, for instance, published *Twenty Etchings and Woodcuts* of Millet in facsimile, and the process of canonization continued until the turn of the century. D. C. Thomson's study of the Barbizon School was produced in 1891, Julia Cartwright's *Jean-François Millet, His Life and Letters* in 1896, and so on. These publications were, however, a long way after the artistic interest which had first been kindled by Durand-Ruel in the 1870s. In 1872 a delegation of students, including the future leaders of the New English Art Club, George Clausen, Frederick Brown and Havard Thomas, went to the dealer's gallery at 168 New Bond Street to see *The Sower* and *The Angelus*. As time passed, these images became very familiar in etchings, lithographs and all the various types of reproduction (Plate 13). Seeing Millet at a time when critics were waxing lyrical over Millais' *Hearts are Trumps* at the Royal Academy was seminal. Millet's elevation to Old Master status and the obligatory pilgrimage to Paris can only have underscored the importance of the day at Durand-Ruel's. The French painters who were increasingly purchased by the State were those who depicted the regional customs and festivals of the French peasantry. The emphasis upon rural life was a deliberate means of deflecting attention from the growing industrial metropolis, in the wake of Baron Haussmann's redevelopment of central Paris and the terrors of the Franco-Prussian War and the Commune. Even Pissarro returned to rustic subject matter around 1880. Millet's message was carried out in the final decades of the nineteenth century by Jules Breton and the younger Salon painters.

In England, however, the painting of peasants engaged in field work was regarded as intellectually inferior. Rustics when they appeared in the novel were colourful characters who acted either as a faint foil to the sophistication of middle-class gentility, or were subservient and industrious like Eliot's Adam Bede. A robust commitment to the description of the conditions of rural life only came with Thomas Hardy, Richard Jefferies and Edward Thomas. The watercolours of Helen Allingham and Myles Birket Foster (Plate 14) presented a rural Arcadia which had none of the elemental rawness and ritual toil of Millet's *gens du filage*. It is not surprising that the work of Alphonse Legros, a second-generation realist, portraying the devotions of the *Boulonnais* peasants to a Royal Academy audience in 1864, should be regarded as 'crude' and 'repellent'. Legros, like Millet, insisted

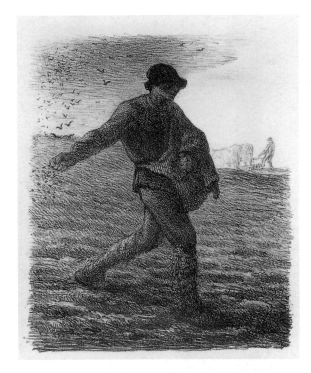

13
Jean-François Millet
(1814–75).

The Sower, 1851. Lithograph, 19.5 × 15.6 cm. (7¾ × 6¼ in.) Glasgow Art Gallery and Museum. Millet's image of rural labour received wide circulation in Britain in the late nineteenth century. Artists like Clausen had their own collections of Millet prints. It is not surprising therefore that his motifs were often repeated with variations.

upon the peasant's mythic status, but being an art teacher in London he was not in daily contact with his source of inspiration. The Old Masters increasingly provided his visual stimulus while he meditated the fables of La Fontaine and absorbed the stories from Champfleury's monumental *History of Popular Imagery* (1869). His primary reputation was as a draughtsman and printmaker, and because of these competencies he was at first employed to teach at the National Art Training School, South Kensington, and in 1876 was appointed Slade Professor of Fine Art at University College, London. In that year, Legros accepted an invitation from Degas to exhibit in the second Impressionist exhibition. Two years later he showed ten paintings at the Grosvenor Gallery and amongst these was *Le Repas des Pauvres* (Plate 15). Critics received this as a 'presentment' of 'cheerlessness in real life' in a 'not actually sordid sort of restaurant'. Leaving aside the unmistakable echoes of Titian and Rembrandt, this picture, coming two years after Degas' *L'Absinthe* but in the same year as Herkomer's *Eventide: A Scene in the Westminster Union*, sits midway between French naturalism and British social realism. Its subject matter might in literary terms be pulled directly from the *ventre* of Paris, but it could equally be derived from Doré's London or Dickens' *Oliver Twist*.

Legros was an unashamed promoter of fellow Frenchmen, particularly former pupils of the Petite Ecole du Dessin where he had been trained. Two of these *confrères* who enjoyed a considerable British reputation were Jean-Charles Cazin and Léon Lhermitte. Whereas Legros increasingly steeped himself in an archaic style, Lhermitte and Cazin moved towards naturalism. Lhermitte's *The Pardon at Ploumanach* (Plate 18), for instance, exhibited in London in 1879, confirmed the rapidly growing fascination for the peasant life of Brittany, Normandy and the Pas-de-Calais. London-based painters such as W. J. Hennessy and Phil Morris who had a background in social realism, gravitated towards French peasant scenes by the end of the 1870s. Hennessy's *Fête Day in a Cider Orchard, Normandy* (Plate 19) appeared in the same Grosvenor exhibition as Legros' *Repas . . .*, but its open-air effect was remarkable. As an Irish-American member of the National

14
Myles Birket Foster
(1825–1899).

A View in Surrey, n.d. Watercolour on paper, 24 × 36 cm. (9½ × 14¼ in.) Newcastle upon Tyne, Laing Art Gallery. Millet's powerful peasants contrast starkly with the less substantial rustics depicted in British watercolours. The work of Birket Foster carried on traditions of representation which had been initiated by the followers of Constable.

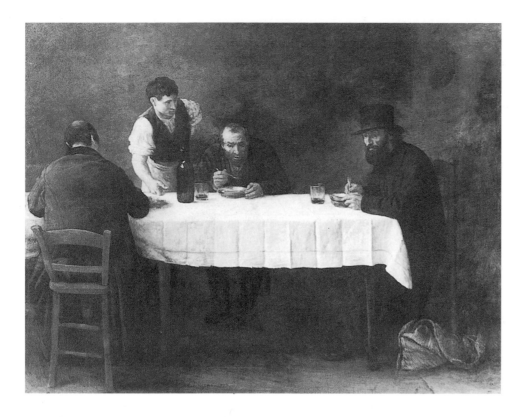

Academy of Design who worked almost exclusively in Calvados and Finistère,
Hennessy had similar 'outsider' credentials to those of Legros. Part of the reason
why such pictures were popular was to do with the increase in tourism. Brittany
was extolled in the opening pages of the new monthly *Magazine of Art* which
began its circulation in 1878. 'Nowhere in France', declared Henry Blackburn in
his book *Artistic Travel*, 'are there finer peasantry.' These ancient types were at
once more enthralling than the rosy rustics and bonnie babies of Helen
Allingham and Birket Foster. The more robust characters of MacBeth,
McGregor, J. R. Reid, Morris and Hennessy were a foretaste of the transform-
ation which was to come in the following decade.

Latent tendencies to anecdote in the work of the artists of this generation were
dispelled in 1880 by the presence in London of Jules Bastien-Lepage's *Les Foins*
(The Hay Harvest) (Plate 20). Again, the Grosvenor Gallery,[3] which had
provided the arena for Whistler and Legros, played host. Around this large Salon
picture of two exhausted field workers 'a little knot of worshippers or scoffers,
admiring or condemning in the most vehement manner . . .' gathered. This
prominent position within the Grosvenor exhibition was normally '. . . filled by
such painters as Messrs. Burne-Jones and Holman Hunt'.[4] What was so
controversial about Bastien-Lepage's painting? The immediate answer was that it
compressed all of the various strands of contemporary painting and presented
them as a single challenging and aggressive record of actual circumstances.
Important changes in the quality of perception are obvious when *Les Foins* is
compared to *The Tinker* (Plate 21) by Legros. The older French artist has
carefully delineated his figure amidst pots and pans in the studio before
surrounding it with a landscape derived from Rembrandt and Titian. The
younger painter has taken pains to represent actual peasants in actual fields in *Les*

16
George Clausen
(1852–1944).

Hoeing Turnips, 1884. Watercolour on paper, 37.5 × 57 cm.
(14¾ × 20 in.) Private collection. During 1883 Clausen produced a
series of photographs of labourers at work in the fields near his home
at Childwick Green. These, combined with individual studies and
sketch-book notes, supplied the necessary information for a series of
fresh *plein air* depictions of field gangs which accentuate atmospheric
conditions.

17
James Guthrie
(1859–1930).

The Stone-Breaker, c. 1885–1923. Oil on canvas, 178.2 × 144 cm.
(64¾ × 44 in.) Paisley, Renfrew Museum and Galleries. Whilst
A Hind's Daughter marks Guthrie's introduction to a new manner,
The Stone-Breaker reveals a shift away from it. Its evidence cannot be
considered precise because it was re-worked as a fragment of a larger
composition, later in Guthrie's career. Undoubtedly the removal of
another figure on horseback for whom the workman has interrupted
his task, serves to focus the viewer's attention. In Millet-esque terms it
renders the isolated *Stone-Breaker* almost heroic.

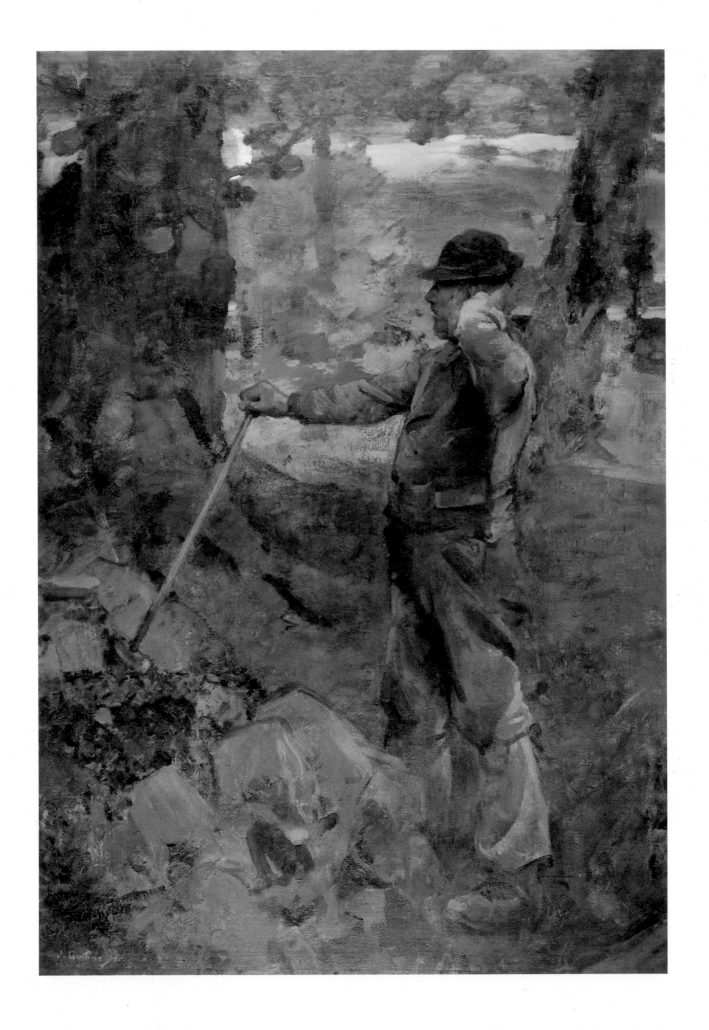

Foins. Listening to Bastien-Lepage describe it – 'a debauch in pearly tones – the clumps of trees on the banks of the stream and in the meadow will stand out strongly with a rather Japanese effect' – one might be forgiven for thinking that this was to be a radical piece of Impressionism.[5] However, the importance of the picture lay in the fact that it incorporated Impressionism into a much fuller and more sophisticated naturalism. As *Les Foins* was hanging in the Grosvenor Gallery, Emile Zola argued forcibly on Bastien-Lepage's behalf that his superiority over the Impressionists was due to his ability to realize his impressions.[6] In short, the swift sketch had its place in the process, but on its own it was by definition superficial. *Les Foins* was a complex construction, Impressionist in the background, but calling for greater naturalism in the foreground and figure. This essential truth of vision was confirmed for British observers by their familiarity with the work of the Pre-Raphaelites and by the narrow field of focus in contemporary photography. The appearance of Bastien-Lepage around 1880 coincided with the crisis which the Impressionists felt themselves.

Renoir at this time had become conscious of the inability of his method to cope with concepts rather than simply to respond to visual stimuli. The British therefore had Impressionism delivered to them in a particular set of historical circumstances, the unravelling of which, in some cases, was never satisfactorily carried out. What were the immediate results of Salon naturalism?

Bastien-Lepage was hailed as the master of the *plein air* school and from 1880 his work regularly appeared in London exhibitions. *Le Mendiant*, his Salon exhibit of 1881, followed by *Pas Mèche*, *Pauvre Fauvette* (Plate 23), *La Petite Coquette* and *Le Père Jacques* – the Salon picture of 1882 – all received a London airing in quick succession. The effect upon the younger generation of art students was enormous. It produced, on the one hand, mechanical transcriptions of

18
Léon Lhermitte
(1844–1925).

The Pardon at Ploumanach, 1879. Crayon on paper, 47.4 × 62.5 cm. (18⅝ × 25⅝ in.) The Marchman Collection. The enormous popularity of Brittany among British artists during the 1880s was in part due to the work of painters like Lhermitte. In their simple stagecraft Lhermitte and Legros challenged the tired traditions of peasant representation in Britain.

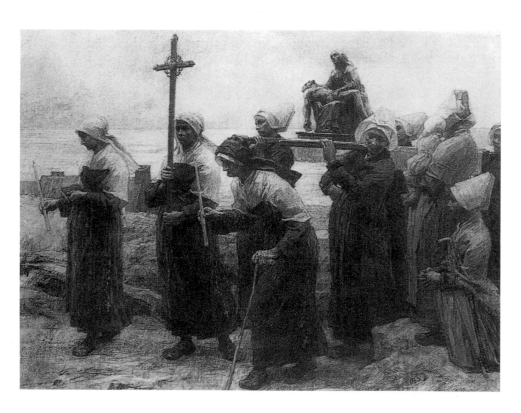

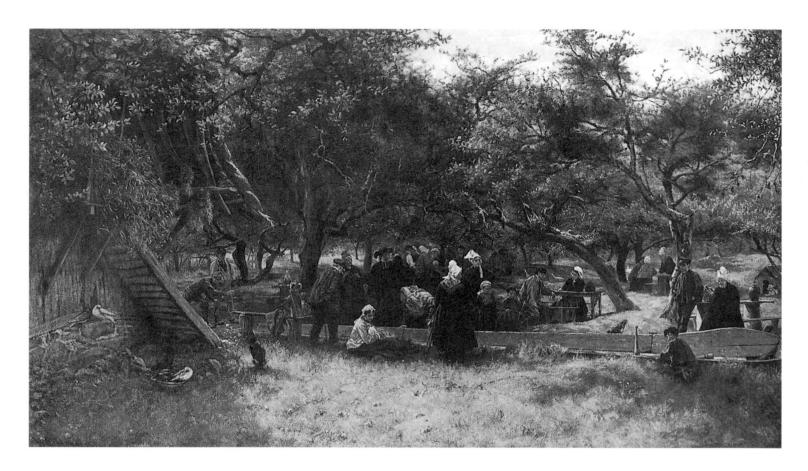

Bastien-Lepage's mannerisms, imperfectly digested, or, on the other, more personal adaptations which combined acceptable sentiment.

Fired by Bastien-Lepage's example, young painters took the Channel packet and if they could not gain access to the ateliers or to the Ecole des Beaux Arts for a winter term, a summer in Brittany was a practical alternative. They wished to learn not only to draw and to paint, but in the words of one contemporary, 'to forget as much as they can of the theory and practice' acquired in the Royal Academy Schools.[7] The immediate appeal to *plein air* naturalism is apparent in the work of two students who shared a garret in Paris. Arthur Hacker in 1880 painted *The Turnip Field* (Plate 12) in a terrain stroked by the late summer sunlight of northern France. Such a picture with its wide format and obligatory female hoers comes straight from the work of Jules Breton. So crisply do the leaves of the foreground plants stand out in the sunshine, that they are almost tangible. Stanhope Forbes, Hacker's companion, embarked upon a very different composition the following year. Working at Cancale in strong sunlight, between July and October, he painted an 'afternoon' subject which involved a girl standing by a doorway, plaiting straw (Plate 24). The background shows a steep narrow street with other figures engaged in similar pursuits, but each is painted broadly, across the form, with no surface detail, to give simply a general effect. Not surprisingly, when he looked back, the artist regarded the picture as a 'turning point'. With extraordinary enlightenment, the committee of the Walker Art Gallery, Liverpool, purchased the painting.

19
William John Hennessy
(1839–1920).

Fête Day in a Cider Orchard, Normandy, 1878. Oil on canvas, 99 × 178 cm. (39 × 70¼ in.) Belfast, Ulster Museum. Hennessy's elaborate scene of Normandy peasants *en fête* demonstrates the increasing interest taken by English-speaking artists in French rural customs.

20
Jules Bastien-Lepage
(1848–84).

Les Foins, 1878. Oil on canvas, 180 × 195 cm. (71 × 77 in.) Paris, Musée d'Orsay. With *Les Foins* Bastien-Lepage became a controversial figure. Exhibited at the Salon of 1878 the picture immediately recasts the types of Millet, Courbet, and Legros in a modern open air landscape. When the work was shown in London two years later its female subject was described as 'a primeval Eve' indicating that in her exhaustion she had almost become sub-human.

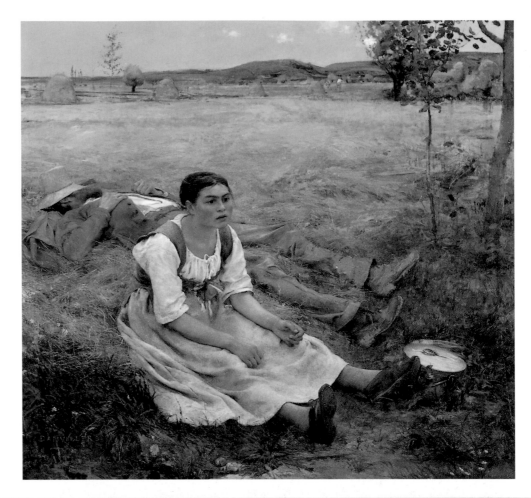

21
Alphonse Legros
(1837–1911).

The Tinker, n. d. Oil on canvas, 140 × 170 cm. (55¼ × 67 in.) London, Victoria and Albert Museum. By comparison to Bastien-Lepage's work, Legros' *The Tinker* is a realist studio piece, an assemblage comprising figure, still life, and landscape setting without the light and air which characterized naturalism.

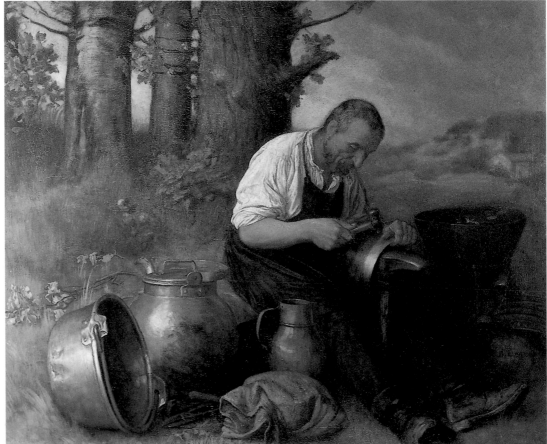

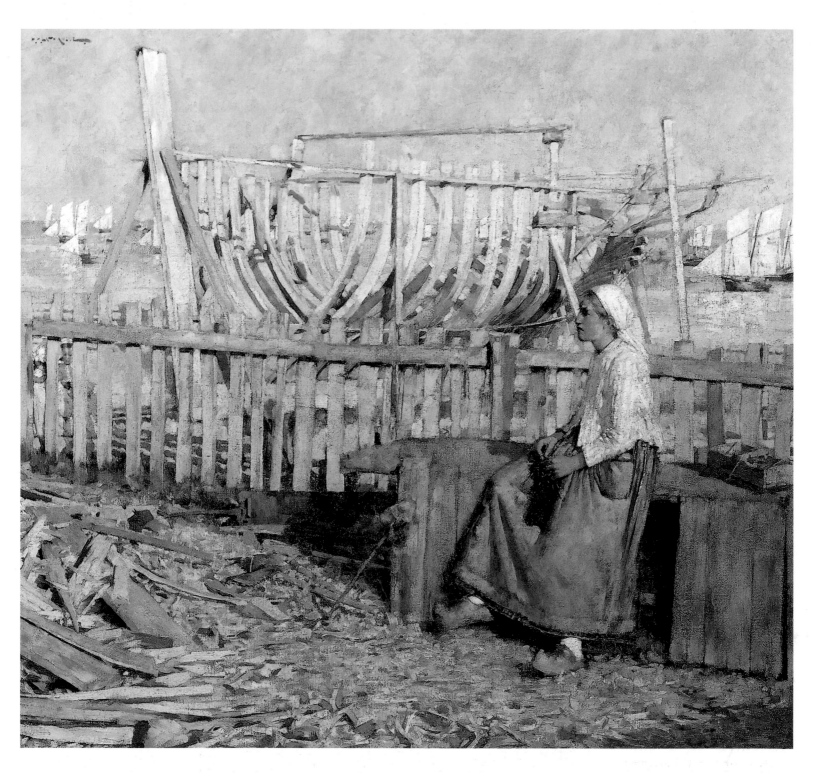

22
Henry Herbert La Thangue
(1859–1929).

A French Boat Building Yard, 1882. Oil on canvas, 76.2 × 81.3 cm. (30 × 33 in.) London, National Maritime Museum. Clausen later remembered the dramatic silhouette of La Thangue's skeleton boat under construction in this picture. The measured notation of effects suggested, for him, the work of Vermeer. Unlike Cazin's and P. R. Morris's treatment of a similar subject, La Thangue's boat building yard is calmly observed in sunlight.

During the summer of 1881, one of the other British art students working at
Cancale along with Forbes, Henry Herbert La Thangue, posed his young
Bretonne in a boat-builder's yard (Plate 22). Comparison with Forbes and Hacker
reveals the extent of mutual sympathy and the desire for absolute fidelity to the
facts of appearances. The method of working broadly across the form challenged
the painter to think in design terms and to acknowledge the flatness of the surface
upon which he worked. In La Thangue's case, he would often paint upon
unstretched canvas simply tacked to a piece of board and this would help him
regulate and systematize his brushstrokes. The degree to which handling
detached itself from the objects it aimed to describe was observed by a later writer
who noted that the practitioners of the method '. . . leave the brush marks and do
not smooth away the evidence of method, thus sometimes insisting on the way
the picture is painted . . .'[8] Here and in later works, La Thangue nudged towards
the autonomous stroke, standing for itself, like Monet's *taches*.

These examples stand for a whole group of British, American and Scandi-
navian painters who congregated around Bastien-Lepage at Concarneau in the
summer of 1882. On one occasion, Bastien turned out with large brushes and
produced results which fascinated his admirers. According to A. S. Hartrick,
'this was the origin of the "square-brush act".'[9] Walter Osborne, Blandford

32

Fletcher, George Clausen, James Guthrie, Edward Stott and many others were in on 'the act' and each produced his own thesis picture in the new manner. The most important point was that this method, coupled with peasant subject matter, was seen as fundamentally honest and democratic. There was no concealment or trickery. The effects in nature were honestly observed and the artists were almost interchangeable. One of the most competent early examples of the new method was Clausen's *Breton Girl Carrying a Jar* (Plate 26), painted at Quimperlé in October 1882. To Forbes, Clausen was one of the 'sacred band' who had forsaken scenes of London life for the rough impasto of rustic naturalism. Clausen's initial response to *Les Foins* was *Day Dreams* (Plate 25), but even the residual anecdote of this work was dispelled in pictures like *Labourers after Dinner*, *Winter Work* and the watercolour, *Hoeing Turnips* (Plate 16).[10] As he observed the field workers, Clausen was acutely conscious of the debates about migrant gang labourers, part of the traditions of agricultural practice which were dying. His pictures often showed workers of different generations moving in unison over the fields and to achieve the most truthful effects he sketched on location and, as an *aide-memoire*, took his own photographs.

These procedures evolved to support the sophisticated naturalism applauded in the Paris Salon. By the time Clausen was producing his paintings of field workers, British and American artists were beginning to enjoy success in this arena. In 1882, two paintings by William Stott of Oldham, *The Ferry* (Plate 27) and *The Bathers* were awarded a third class medal. They were lavishly praised for qualities which transcended the literal. Their cool pitch encapsulated a mood of seeing reminiscent of Corot at his most elegiac. They were manifestly the best of a group of rural idylls which incorporated Welden Hawkins' *Le Lavoir de Grez*, Frank O'Meara's *Reverie* and the American Lovell Birge Harrison's *Novembre*. Each of these painters had worked at Grez-sur-Loing, a sleepy village on the fringe of Fontainebleau which was 'discovered' by the pupils of Carolus Duran in 1875.[11]

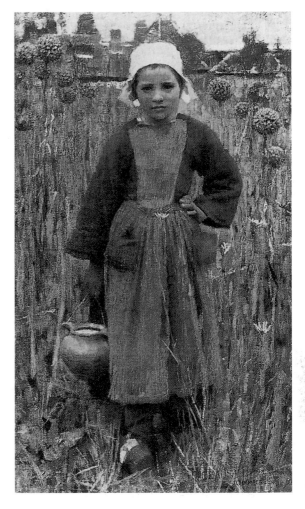

26
George Clausen
(1852–1944).

Breton Girl Carrying a Jar, 1882. Oil on canvas, 46 × 27.5 cm. (18¼ × 10¾ in.) London, Victoria and Albert Museum. *Breton Girl Carrying a Jar* is Clausen's exercise in the new naturalist manner, painted in the autumn of 1882 at Quimperlé. In keeping with the tenets of Bastien-Lepage, the subject is observed against a field with a high horizon, creating the effect in the viewer's mind of a direct encounter with the figure.

25
George Clausen
(1852–1944).

Day Dreams, 1883. Oil on canvas, 70 × 152.5 cm. (42 × 60 in.) Private collection. Having been impressed by the brutal naturalism of Bastien-Lepage's *Les Foins*, Clausen produced a number of pictures of labourers resting. Of these, *Day Dreams* makes the greatest concession to Victorian taste, in its contrast of young and old field workers in dappled shade.

27
William Stott of Oldham
(1857–1900).

The Ferry, 1882. Oil on canvas, 109.2 × 214 cm. (43 × 74½ in.) Private collection. *The Ferry* was one of two pictures exhibited by Stott at the Paris Salon of 1882. It was lavishly praised by French critics for its tonal delicacy and was awarded a third class medal, a rare accolade for a young English painter. Its success therefore must have confirmed the path of British rustic naturalists. In addition the picture came to typify the poetic charm associated with the work produced at Grez-sur-Loing.

Its pellucid river, ancient bridge and ruined castle provided a natural setting for paintings like O'Meara's *Towards the Night and Winter* (Plate 28) which seemed to express the ebbing of life and energy. The village atmosphere had the important effect of leading its young visitors away from the mechanical methods of the ateliers to discover what Robert Louis Stevenson described as 'the incommunicable thrill of things'.

Grez was to prove a vital testing ground for John Lavery.[12] He visited the village in 1883 and 1884 and produced his large picture *On the Loing: an Afternoon Chat* (Plate 29) in the new manner. Here he imitated the stereoscopic effects of photography with richly impasted foreground details, square handling in the middle distance and pale almost translucent effects in the background. The dreamy sunshine of Grez and its indolent washerwomen make the harder world of Clausen's hoers and mowers seem prosaic. Grez was to lead Lavery away from peasant subjects. He became preoccupied with the efforts of his fellow painters to work *en plein air*. A small panel sketch for a large picture shows a young woman painter in deep concentration under the shade of a white umbrella (Plate 31). Artists' activities feature a good deal in other Grez pictures, such as *A Day in Midsummer*, *The Principal Street in Grez* and *On the Bridge at Grez*. But perhaps the painting which most clearly sums up the essence of this charmed art student colony is *A Grey Summer's Day, Grez* (Plate 32) – a tiny gem-like canvas which for all its apparent casualness has been carefully premeditated. Lavery sets up a single vanishing point near the right edge of the picture and relates the man in the straw hat, the dog and the woman in the campaign chair to this simple perspective. The inferred relationship of figures is intensified by their having been placed in an arboretum of viridian foliage.

At the end of 1884, Lavery transposed his Grez palette to the grime of Glasgow. He, Kennedy, Alexander Roche and Joseph Crawhall had all spent varying lengths of time in the Paris ateliers. Edward Arthur Walton had returned from Dusseldorf Academy and only James Guthrie amongst the principal painters of what was to be the Glasgow School had not received a foreign training.[13] Yet for all this, Guthrie was in some senses the most committed to the new manner. Having produced a lugubrious set-piece in *A Funeral Service in the Highlands*, Guthrie visited London in 1882 and studied the pictures of Bastien-Lepage, four of which were on display within walking distance of the Royal Academy. His

28
Frank O'Meara
(1853–88).

Towards the Night and Winter, 1885. Oil on canvas, 150 × 127 cm. (59¼ × 50 in.) Dublin, Hugh Lane Municipal Gallery of Modern Art. Of all the 'tonalist' painters at Grez, Frank O'Meara is one of the least known and most influential. As is evident in *Towards the Night and Winter*, he was possessed of a perfect sense of pitch, more characteristic of painters of the Hague School and Corot than the Impressionists. Like Stott, his frieze of buildings adjacent to the bridge at Grez is rendered in subtle gradations of grey and green.

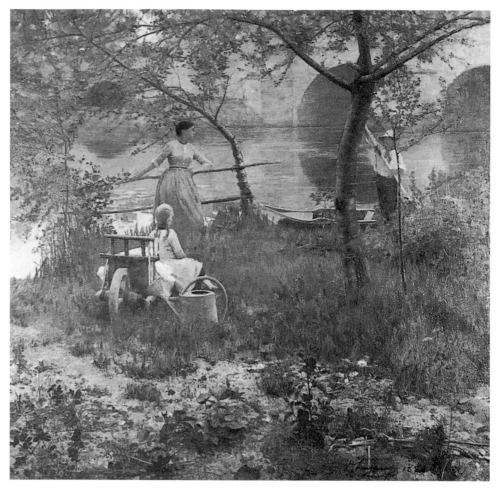

quick reflexes produced within eighteen months, *To Pastures New* and *A Hind's Daughter* (Plate 30), paintings which rely heavily upon Bastien's *Pas Mèche* and *Pauvre Fauvette*. However Guthrie maintained grander ambitions and as the members of the nascent Glasgow School gathered around him at the Berwickshire village of Cockburnspath, he embarked upon a large canvas of *Field Workers Sheltering from a Shower* which was abandoned and later destroyed. His efforts in 1886 at Kirkcudbright were equally abortive. On this occasion, he worked up another large picture of a stonebreaker stopping for a wayside conversation with a farmhand astride a white horse (Plate 17). This did not survive in its original form and only the figure of the stonebreaker was salvaged to be completed later. There is enough in the fragment to indicate the strength of Guthrie's attack. By that point, he was no longer simply a zealous adherent of Bastien-Lepage.

Strong independence characterized the work of the Glasgow painters. They were not slow to adapt the lessons of French art to a more personal expression. Edward Arthur Walton, for instance, in a work entitled *Noon-day* takes a typical subject derived from Barbizon painters like Charles Jacque and translates it into the new manner with a figure loosely dependent upon Bastien-Lepage. In 1884, he painted a portrait of Joseph Crawhall and inscribed it 'Joe Crawhall the Impressionist by E. A. Walton the Realist'. The work was carried out in solid slabs of colour applied, for the most part, with a palette knife. The intention might almost be to create a *cloissonist* effect of the type later exploited by George

Henry and Edward Atkinson Hornel. Walton then proceeded to repaint Bastien-Lepage's *Les Foins* and Clausen's *Day Dreams* in his own terms as *The Daydream* (Plate 34) in 1885. The exhausted reapers of his mentors were turned into charming Scottish children. For the deep space of the French picture, Walton substituted a decorative screen of foliage, and isolated daisies and dandelion clocks replace the dense grasses and half-dry hay. It is not difficult to see why, by the end of the decade Scottish painters were propelled towards the decorative and the mystical.

But first the implications of Lavery's studies at Grez remain to be explored. In 1885, upon his return, Lavery was taken up by the rich cotton manufacturers of Paisley whose sons and daughters were *afficionados* of the newly fashionable game of lawn tennis. Witnessing their mixed doubles, Lavery had the subject for the most celebrated Scottish picture of the decade, which George Moore later described as 'a work of real talent.'[14] (Frontispiece) Certainly it was exceptional enough to attract the other members of the group to go to Cathcart near Paisley

30
James Guthrie
(1859–1930).

A Hind's Daughter, 1883. Oil on canvas, 91.5 × 76.2 cm. (36 × 30 in.) Edinburgh, National Gallery of Scotland. Of all the followers of Bastien-Lepage with the possible exception of Henry La Thangue, Guthrie emphasized the single 'square brush' technique of painting across forms. In this the figure was given the same treatment as its surroundings. There was as a matter of principle, no hierarchy of importance in the composition other than to make foreground objects almost palpably real.

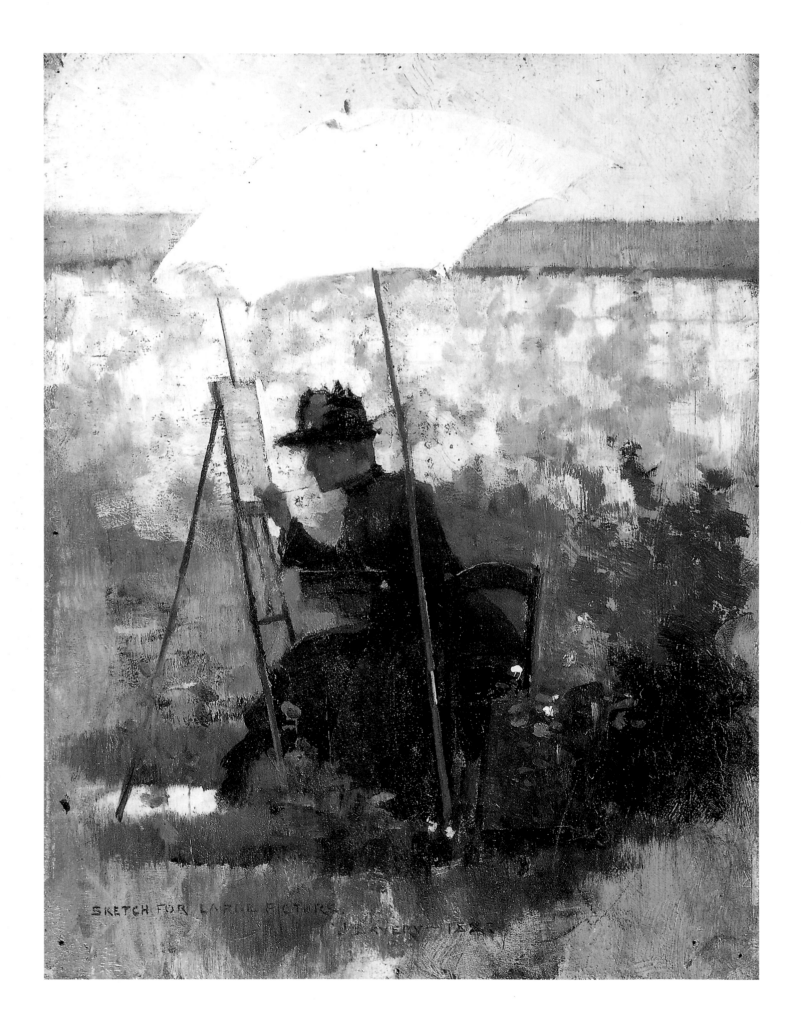

SKETCH FOR LARGE PICTURE
J L AVERY 1885

31
John Lavery
(1856–1941).

Sketch for 'A Pupil of Mine', 1883. Oil on panel, 24 × 18.5 cm.
(9⅜ × 7¼ in.) The Fine Art Society. On more than one occasion at
Grez, Lavery turned his attention to other artists at work. In this he
reveals a great deal of information about his and their working
methods. Here the *plein air* kit, of light portable easel and white
sketching umbrella, is faithfully described, as well as the rapt
concentration of the female subject.

32
John Lavery
(1856–1941).

A Grey Summer's Day, Grez, 1883. Oil on canvas, 19 × 24.3 cm.
(7½ × 9½ in.) London, Andrew McIntosh Patrick Esq. There can be
no finer evocation of the relaxed ambiance at Grez than *A Grey
Summer's Day, Grez*. In adopting techniques associated with Degas and
the urban naturalists, Lavery anticipated works such as *The Tennis
Party* (Frontispiece).

33
Edward Arthur Walton
(1860–1922).

Portrait of Joseph Crawhall, 1884. Oil on canvas,
73.6 × 37 cm. (29 × 14½ in.) Edinburgh, Scottish
National Portrait Gallery. Captions in the
background of Crawhall's portrait revealed the
debate which must have animated their
conversations – a debate between realism and
Impressionism.

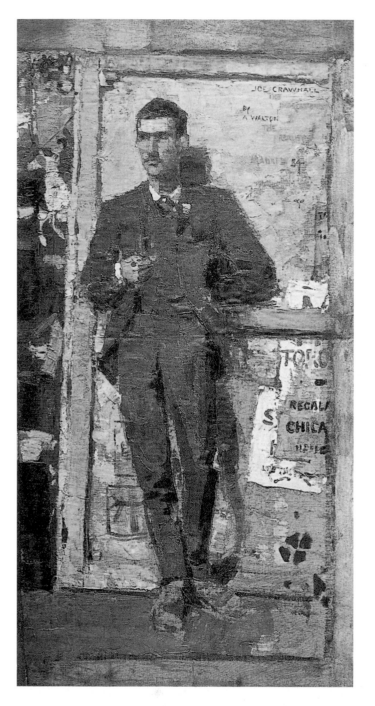

to offer criticism while it was still on the easel. But in general terms, the work
marked a decisive shift away from peasant genre to contemporary middle-class
life. In related pictures Lavery showed the *politesse* which surrounded the game
and which to a certain extent embodied his own social aspirations.

Although the group shared a sense of common purpose, they were never
isolated. The Glasgow Institute of Fine Art, where many of their pictures were
shown, contained important loan sections of foreign art which served to educate
public taste and to create a climate of acceptance for Glasgow's own radical
painting. Contacts with London were consistently maintained and the work of

Monet and Whistler digested. William Kennedy, who based himself at Stirling, painted the local railway station in 1887 in a splendid piece of summary naturalism conveying the bustle of passengers disembarking from a train (Plate 35). In this case, he is more likely to have been aware of Sidney Starr's *Paddington Station* (Plate 36) of the previous year, than the canvases of Manet or Monet. Both works, in so far as the Starr can be judged, reveal a preoccupation with scale and perspective. The movement of crowds in public places claimed Lavery's attention in 1888, when he acted as the resident artist at the Glasgow International Exhibition. In a sequence of vivid sketches of *The Gondola*, *The Indian Pavilion*, *The Blue Hungarians*, *The Musical Ride of the 15th Hussars* and, most particularly, *The Glasgow International Exhibition* (Plate 37), he blocked in the crowd masses, picking out salient bits of local colour. The animated crowds and smudgy isolated figures convince the spectator of the authenticity of the perception. Yet Lavery was not producing actual snapshots any more than Monet was when he painted the *Boulevard des Capucines*. The rubbing in of casual visitors to the International was self-consciously willed – their positions were often revised and their attitudes carefully noted.

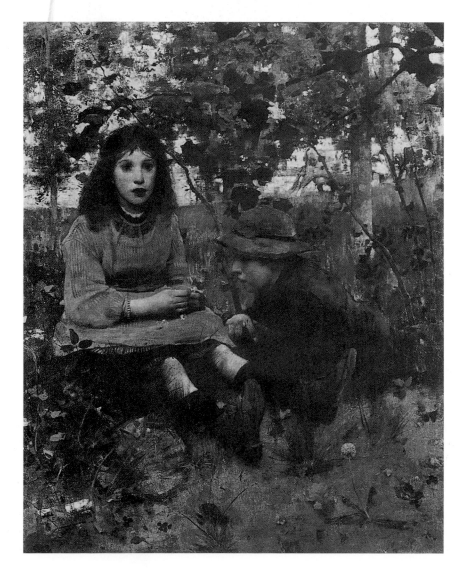

34
Edward Arthur Walton
(1860–1922).

The Daydream, 1885. Oil on canvas, 139.7 × 116.8 cm. (55 × 46 in.) London, Andrew McIntosh Patrick Esq. *The Daydream* is in essence Walton's response to Bastien-Lepage's *Les Foins*, with the important differences being that two children stand in for peasants and a decorative frieze of trees has replaced the distant landscape.

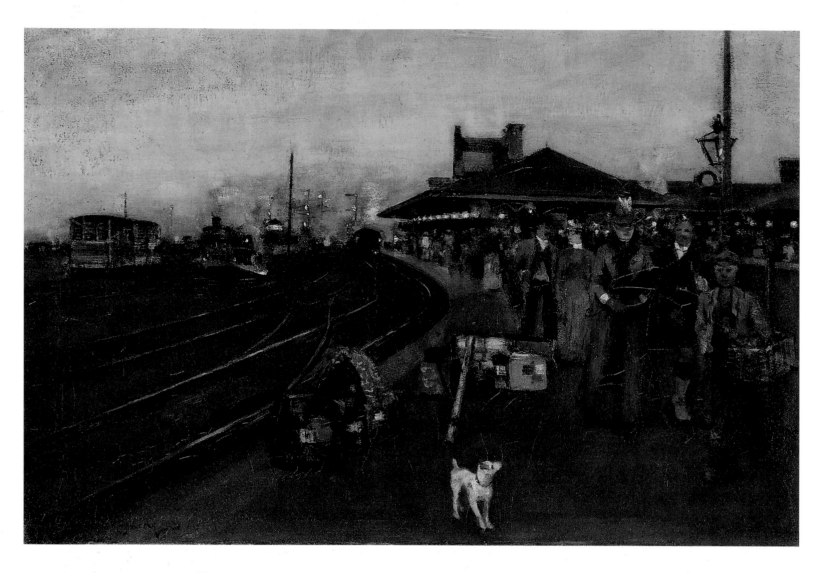

35
William Kennedy
(1859–1918).

Stirling Station, 1887. Oil on canvas, 52 × 80 cm.
(20½ × 31¼ in.) London, Andrew McIntosh Patrick Esq. By the
late 1880s Kennedy's early commitment to the representation of
peasants was supplanted by the rendering of modern subject
matter in *Stirling Station*. His observation of the bustle of such a
scene owes as much to Tissot as the subdued tonalities might be
taken as evidence of a follower of Whistler.

36
Sidney Starr
(1857–1925).

Paddington Station, 1886. Unlocated (from an illustration by
Walter Sickert). Apart from the canvases of Monet, railway
stations had a rich iconography emanating from Victorian
painters such as Frith and Holl. The flower sellers and other street
vendors who frequented these thoroughfares generated their own
genre. As a naturalist/Impressionist follower of Whistler, Starr is
likely to have accentuated the prevailing atmosphere of the
station rather than the subsidiary characters.

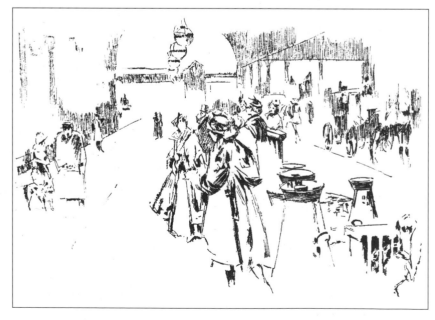

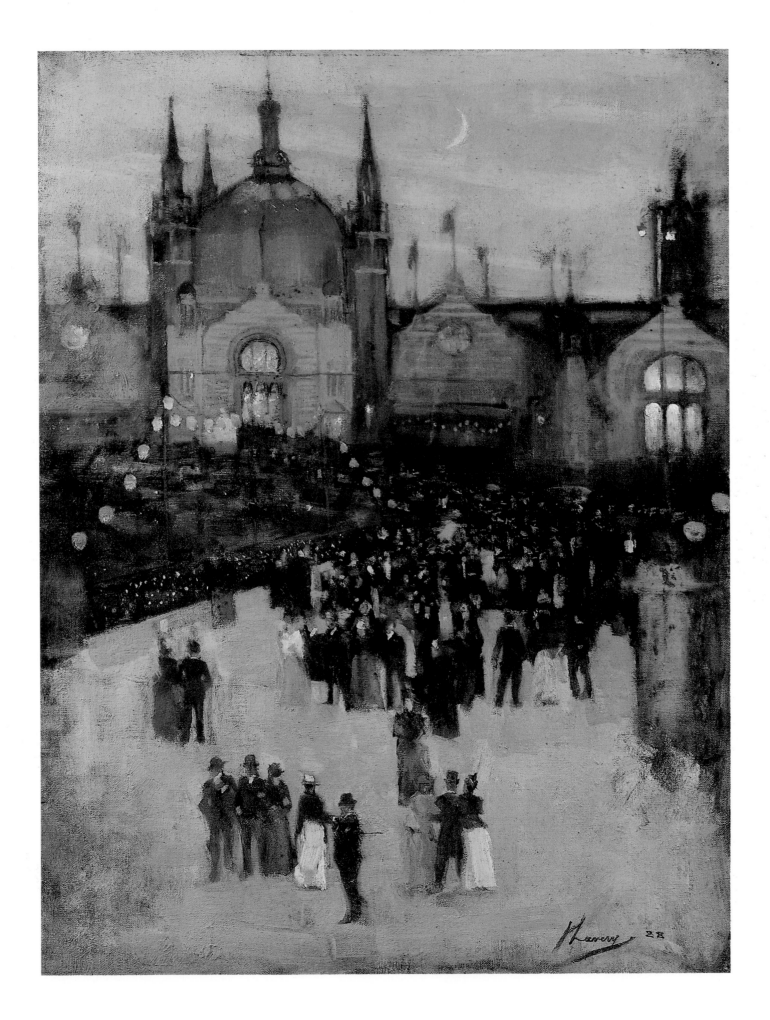

37
John Lavery
(1856–1941).

(See page 43) *The Glasgow International Exhibition*, 1888. Oil on canvas, 61 × 45.7 cm. (24 × 18 in.) Glasgow Art Gallery and Museum. In 1888 Lavery acted virtually as an artist in residence at the Glasgow International Exhibition. The role involved him in painting portraits of visitors and exhibitors, views of tea-houses and trade stands as well as general studies of the crowds which the great display at Kelvingrove attracted.

The effort to reproduce dynamic figure movement in a swifter, less orthodox application of paint preoccupied artists south of the border as well as those in Scotland. Henry La Thangue, who retired to Norfolk in the later 1880s, was no less radical in single figure studies where the figure blends with the shadows of surrounding foliage. To some extent, his *Hedger* (Plate 38) of 1888 demonstrates the suggestiveness of summary execution. La Thangue's urgent reporting has much in common with the work of the East Anglian photographer, Peter Henry Emerson, with whom he and Clausen maintained regular contact.[15] Emerson's 'naturalistic' photographs were as carefully staged as La Thangue's paintings, but they imitated the conditions of art in their balance between the general and the particular (Plate 39). Clearly, La Thangue and one or two of his Glasgow

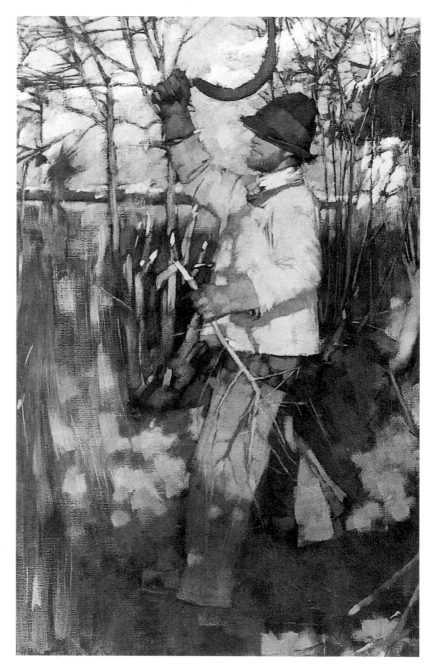

38
Henry Herbert La Thangue
(1859–1929).

The Hedger, 1888. Oil on canvas, 61 × 39.4 cm. (24 × 15½ in.) Private collection. La Thangue submerged himself in the life of the Norfolk Broads in the late 1880s. Many studies of local peasants were produced at this time, and none more dynamic than *The Hedger*. In this, La Thangue demonstrates as keen an interest in figure movement, as Lavery had done in *The Tennis Party*. (Frontispiece)

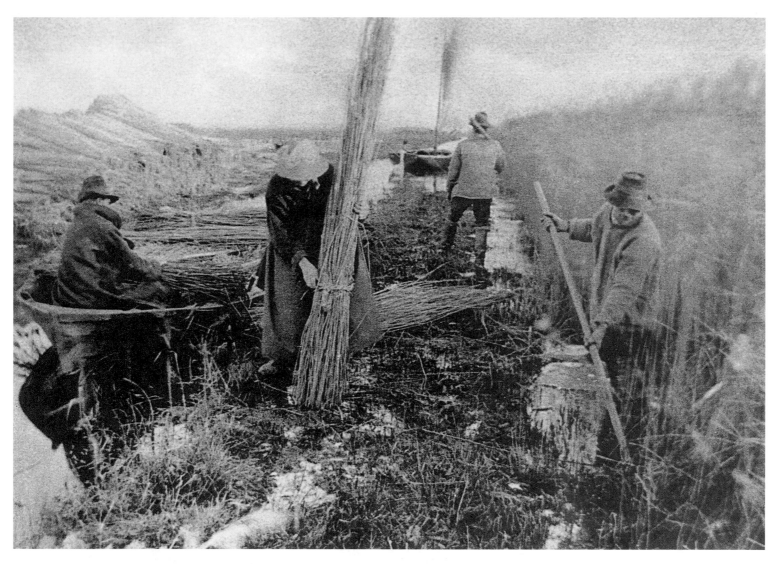

39
Peter Henry Emerson
(1856–1936).

During the Reed Harvest, 1886. Photograph,
private collection. Emerson's photographic
albums, and his attempts to define naturalistic
photography as a fine art in the later 1880s, had a
wide currency. Since he was closely involved with
the painters of the New English Art Club, his
imagery was undoubtedly shared by them.

contemporaries risked the disintegration of the objects which they wished to represent, in their search for the integrity of the 'impression'.

There was yet another kind of impression which was equally appealing in British art in the mid-1880s. This too was a by-product of summers spent off the coast of East Anglia. In 1884 and 1885, Walter Osborne worked at Walberswick producing pictures of banks of sand and shingle with occasional groups of children (Plate 40).[16] The effect was often pristine and jewel-like, the colour bright and fresh, as if the world was being seen for the first time. Osborne's wide vistas and long jetties stretching out to sea do more than establish the setting for Steer's Impressionist essays; they create a precedent for a high-key, almost visionary re-creation of reality which he shared with Edward Stott, John Lavery and a few others. The colour was so strident, the notation so precise, that the questions to be asked about such works were all to do with how far the interrogation of appearances in bright illumination could be taken.

The formation and dispersal of short-lived summer colonies was a consistent feature of the 1880s which contributed to tangling the skeins of development. Constant cross-reference has to be made between groups which were momen-

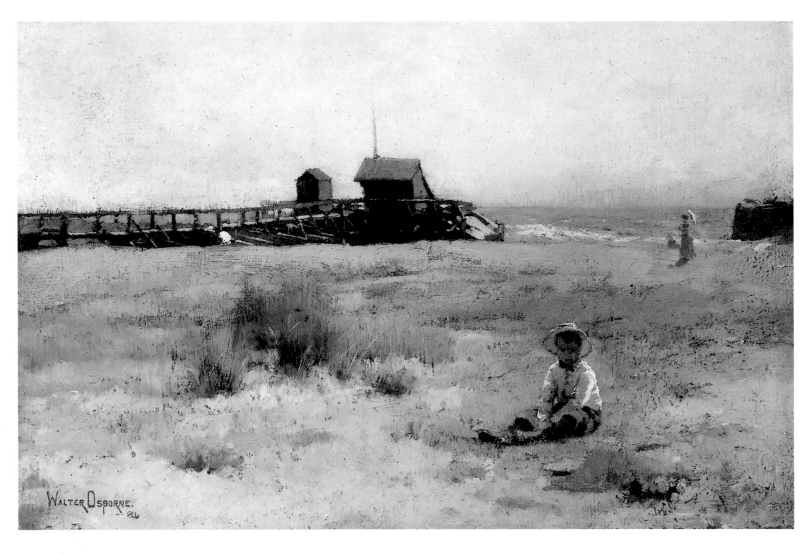

40
Walter Osborne
(1859–1903).

Boy on a Beach, 1884. Oil on canvas, 20.2 × 30.5 cm. (8 × 12 in.)
Private collection. Osborne's pictures of the estuary at Walberswick
had at times aspired to almost visionary intensity.

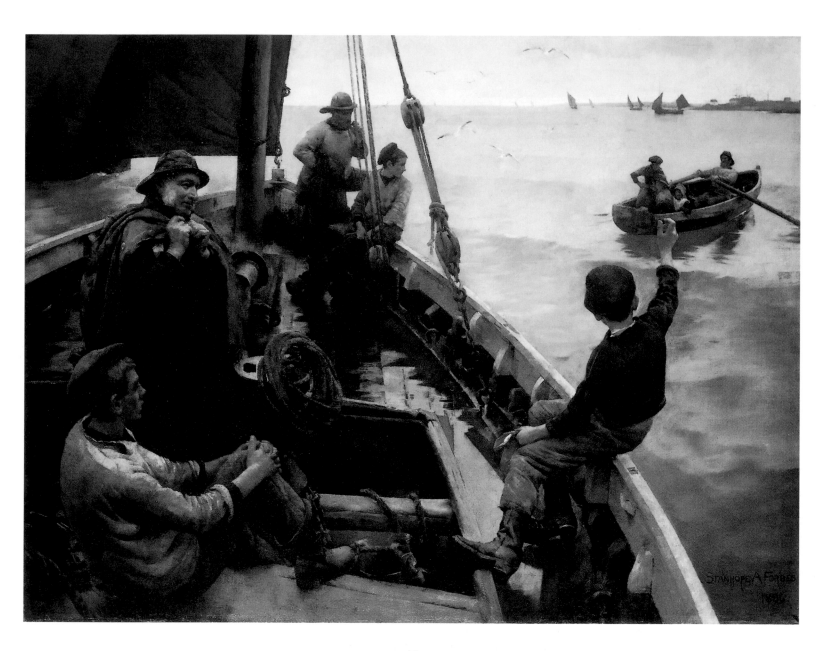

41
Stanhope Alexander Forbes
(1857–1947).

Off to the Fishing Ground, 1886. Oil on canvas, 116.8 × 152.4 cm.
(46 × 60 in.) Liverpool, National Museums on Merseyside. Painters of
the Newlyn School retained the belief that plein-air studies could
contribute towards monumental exhibition pieces. Works like *Off to
the Fishing Ground* might seem no more than enlarged genre pictures,
but they carried the implicit belief that such ordinary subjects could be
portrayed in the face of High Art.

**42
James Guthrie
(1859–1930).**

'Hard At It', 1883. Oil on canvas, 31.1 × 46 cm. (12 × 18¾ in.) Glasgow Art Gallery and Museum. All the dedication of the 1880s plein-airists is distilled in Guthrie's little picture of one of his colleagues busily painting.

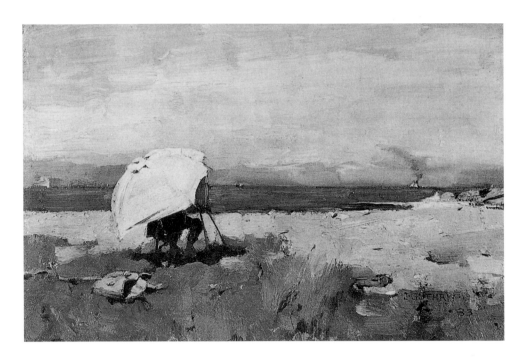

tarily formed and then forgotten. The one colony which had become an institution by 1886 was that at Newlyn in Cornwall.[17] Stanhope Forbes, who first went there at the beginning of 1884, discovered Walter Langley, E. A. Waterlow and several other painters already in residence. Within a short time, the village became an 'artistic Klondyke' playing host to Frank Bramley, Edwin Harris, Leghe Suthers, Ralph Todd, Albert Chevallier Tayler, Thomas Cooper Gotch and, for a short time, Henry Scott Tuke. At Newlyn 'every corner was a picture, and more important from the point of view of the figure painter, the people seemed to fall naturally into their places, and to harmonize with their surroundings.' Immediately Forbes embarked upon ambitious compositions such as *A Fish Sale on a Cornish Beach*, exhibited in 1885, and *Off to the Fishing Ground* (Plate 41), a work shown in the following year. Forbes admitted that what drew him to these scenes was the sheer practical difficulty of their realization. Convinced that he was not for the comfortable studios of the fashionable artists' quarters, he positively courted danger with all his impedimenta and a large canvas to hand. 'It may seem somewhat of a paradox,' he stated,

> but I have often found the success of a picture to be in inverse ratio to the degree of comfort in which it has been produced. I scarcely like to advance the theory that painting is more successful when carried on in discomfort, and with everything conspiring to wreck it, for fear of rendering tenantless those comfortable studios the luxury of which my good friends in the Melbury Road and St. John's Wood so much enjoy.[18]

How much credibility should be attached to this homespun philosophy? In one sense it is no more than a recapitulation of what Forbes saw to be the animating ethos of the progressive art of the Salon. His work would fit well into the Third Republic and would find its way to democratic patrons – the rich municipalities which were interested in acquiring collections of art which had the universal legibility of Newlyn naturalism. No doubt for similar reasons, such works as *Off to*

the Fishing Ground were acquired by the Aldermen of the Corporation of Liverpool. The foil to these exhibition pieces was provided by smaller paintings which selected the picturesque corners of old Newlyn. Forbes in *The Daily Bread* discovered the equivalent of Osborne's Walberswick, in simple relationships of figure to setting and in more basic formal arrangements. The question of signification remained however in the great compositions. *Off to the Fishing Ground* was a record of an event and attempted to persuade the viewer that what was being experienced was reality itself. At the same time, such a picture, laid out as a spectacle, could be more than a *tableau vivant*, embodying a universal theme – the coming of manhood in the lad's farewell to his mother and sister. Forbes's canvas was constructed on the premise that the Academy exhibit should be in itself an important statement, which ought not necessarily to conform to the dominant ideas of the institution. It should prioritize direct experience, even though it might be constrained by the desire to fabricate a fictional situation. To that extent, he, and more particularly Frank Bramley, bowed in the direction of popular taste. There was a thin line between the legitimate wish for universal legibility and the public thirst for pot-boiler narrative.

How do these disparate lived experiences cohere in British painting? By 1885, it was generally the case that the younger generation of painters had accepted naturalism. This was defined in practice rather than in print, though Francis Bate, a future secretary of the New English Art Club, addressed the topic in 1886. For him naturalism was simply '. . . the difference between an object (or the sign used for the object) and the *appearance* of the object under certain effects, and in certain fixed relations to other appearances.' In his essay Bate placed great emphasis upon 'the integrity of the first impression' as providing the essential criterion by which a work should be judged.[19] This gradually militated against the kind of self-consciously 'important' exhibition piece to which Forbes and the Newlyn painters devoted their energies. Thus the very mechanism to which Forbes's visual research was directed was increasingly under attack. Though it might be drawn together from studies, a picture ought to be carried out *en plein air*. Even in those circumstances the method was persistently dubbed 'French' if not 'Impressionist'. In fact, *plein air* painting was positively not Impressionist because while the result might be an 'impression', the technique was not directly comparable to that of Monet and Renoir. It was rather the case that such painting was part of a structured experience, and the liberation which gave greater autonomy to the paint mark and less to the overall illusion had yet to be achieved.

The ethos and internal force of artists' colonies were essential to the development of a naturalism of impressions. Whilst it may seem that painters sat down in sunlight, under white sketching umbrellas in a holiday mood, they nevertheless went 'hard at it' in circumstances which were conducive to keen competition (Plate 42). Often there is a sense of artists observing one another or being observed by passers-by and this stimulated confidence. By 1885, for many British painters, the studio was not a place of retreat from the world. Like Monet and Renoir, they relocated it in the *mêlée*, in the accidental circumstances of life. Such notions were difficult to implant in Britain and they provided the *raison d'être* for self-help colonies. The outlets for the production of these groups remained to be constituted.

Secessionist Societies –
the 'New English' and the 'British Artists'

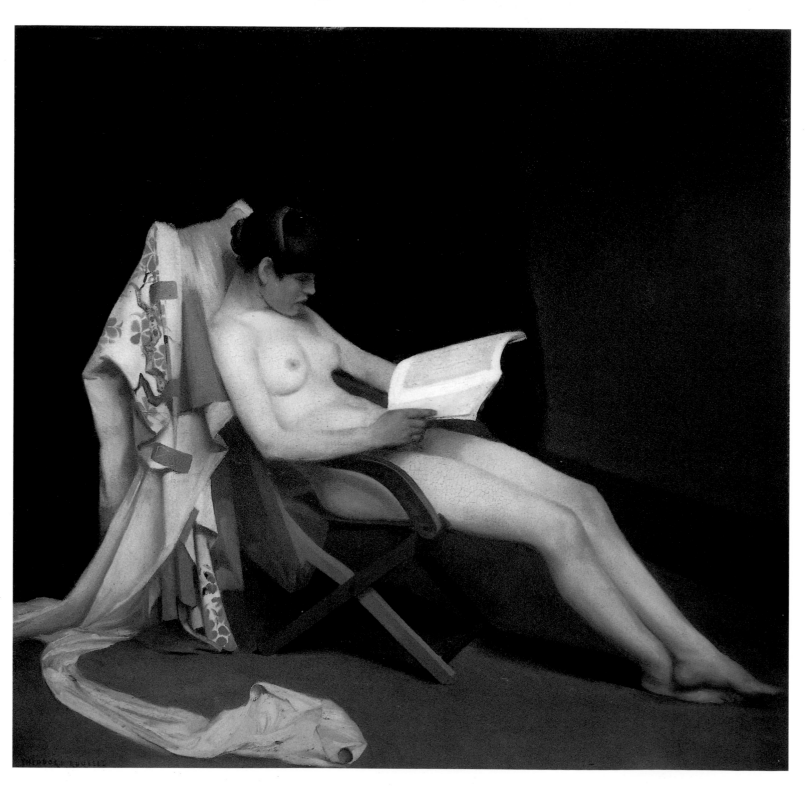

The debates about surface and symbol may have provided the sub-plot for the early meetings of the painters who formed the New English Art Club.[1] Its first half-dozen exhibitions were the battleground for new ideas. The Club had its real origins in Paris amongst the art student community. Its young adherents described themselves as 'Anglo-French'. They first convened on 4 January 1886, and began planning for an exhibition to open at the beginning of April, one month before the Royal Academy. Martin Colnaghi, a dealer in Old Master paintings, declared himself 'for the better representation of the younger English painters' and agreed to provide rent for the Marlborough Gallery in Pall Mall. All went well, until he visited some of the studios. After he had seen Henry Scott Tuke's studies of nude boys (Plate 44), he had a change of heart, and with only two weeks to go till the opening, he withdrew his support. At this juncture, the Club was obliged to fall back upon one of its own members, W. J. Laidlay, who was of sufficient means to guarantee the rent. The show opened a week late on 12 April 1886 and consisted of 58 pictures and two sculptures. One of its early visitors was Sir Frederic Leighton, President of the Royal Academy, and he predicted a life span of three years at the most for the Club.

Critics on the whole were not so unkind.[2] *The Times* was typical in greeting the new exhibiting society with cautious optimism, commenting upon the exhibitors' desire to be seen separately from the 'reminiscences' of Pre-Raphaelitism and the canvases 'inspired by Mr. Frith'. The Pre-Raphaelites, in the opinion of the *Pall Mall Gazette* 'Extra', provided the precedent for this new departure, though 'it is hardly too much to say that the Club, although starting from a less pretentious and aggressive standpoint, is fully likely to influence for good the rising practitioners of English art.' The aim was seen to be realism, 'in its proper sense', namely of the cultivation of qualities associated with good technique. These, of course, were French rather than English, and because the young painters were, as their catalogue declared, 'more or less united in their art sympathies', their show had more coherence and overall integrity than that of the Grosvenor Gallery or the Royal Academy. Such general views were initially expressed and for the most part individual works by the New English painters were described in praiseworthy terms. Even Tuke's *Bathers*, which had made Colnaghi flinch, was accepted by one critic as a 'good solid piece of work'. Most preferred the conservative offerings such as Gogin's *The Soothsayer* and Hacker's *Cradle Song* (Plate 45). This genre piece was 'entirely pleasing and justifiable in motive' to *The Art Journal*. It was purchased by Colnaghi because it so explicitly expressed the perceived aim of the Club to employ superior French techniques to express 'English feeling'.

Looking broadly at the first New English Art Club exhibition, there seems less unity than one might expect. Being fifty strong, they could never have been as tightly programmed as the Pre-Raphaelite Brothers. Although there were portraits, scenes from Shakespeare like Greiffenhagen's *Laertes and Ophelia* and the 'Mikado' Japonaiseries of Menpes, the majority of the works were rustic naturalist. Frederick Brown's *Hard Times* (Plate 48) typifies the subject matter. Here again is an interior with an itinerant workman resting after a long and fruitless search for employment. It has been pointed out that Degas' *L'Absinthe* may have contributed to the compositional idea, providing, perhaps, the angle of viewpoint and the general attitude of the male figure, but this remains conjecture.[3] Interiors of this class like Tayler's *The Latest Novelty from London*

43
Theodore Roussel
(1847–1926).

The Reading Girl, 1887. Oil on canvas, 152.4 × 161.3 cm. (60⅛ × 64⅝ in.) London, Trustees of the Tate Gallery. Because of its resistance to painting flourish and overt symbolic detail, it is tempting to regard *The Reading Girl* as little more than an academic exercise. Less challenging than *Olympia*, it nevertheless recalls Manet's canvas in aspects of the figure pose and in the even frontal light which reduces the form to a series of carefully observed transitions of local colour. The girl's hairstyle, the discarded kimono and the campaign chair upon which she sits attest to aesthetic preoccupations which are not permitted to dominate the composition.

and Bramley's *Winter* (Plate 46) were not uncommon in the years when Herkomer's social realism remained strong. What separates Brown from his Newlyn contemporaries is his personal modification of square-brush naturalism. Like Bramley and Tayler, he had, according to the critic D. S. MacColl, been a practitioner of 'one of the popular School methods of painting' associated with the Atelier Julian and described as 'a caricature of the mannerisms of Bastien-Lepage'.[4] By 1886, however, Brown was painting in a softer low-toned manner which was more suited to his moody contribution to the third New English exhibition – *When the Evening Sun is Low*. This picture drew him into the elegiac naturalism of O'Meara, as a way-stage on the road to Impressionism.

One important picture, out of step with the majority of those on display, was Steer's *Andante* (Plate 49).[5] This represented a demure middle-class music room with a lady cellist and two young accompanists on the violin and piano. Sadly, this painting, which was hung close to the ceiling, much to the annoyance of Brown, has only survived in the *Pall Mall Gazette 'Extra'* illustration. There is no reason to assume that it was anything other than a piece of modern naturalism in the manner of Sargent, Duez or Gervex. Steer's music-making was separated from the vague aestheticism of Whistler and Albert Moore. His trio bids farewell to peasants *en plein air*, and to his fellow rustic naturalists it may have been interpreted as a move away from, rather than towards radicalism.

The most controversial exhibitor at the New English Art Club in 1886 was Henry Herbert La Thangue, showing a picture recently painted in France entitled *In the Dauphiné* (Plate 50). This too has disappeared. Dubbed an 'unfinished study', it was described by one critic as 'broad and systematic in touch, high bluish and open-air-like in colour.'[6] Here the detachment of brushstroke from what was being portrayed must have appeared extreme. Having

44
Henry Scott Tuke
(1858–1929).

The Bathers, 1886. Unlocated. Tuke's picture of fisher boys bathing was one of his first renderings of a favourite but not uncontroversial subject. Removing the veil of classicism and showing present day male nudes in full sunlight implied an assault upon contemporary mores which led the dealer Colnaghi to withdraw his support from the New English Art Club.

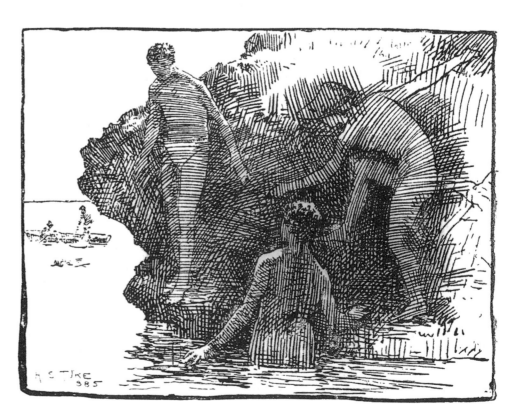

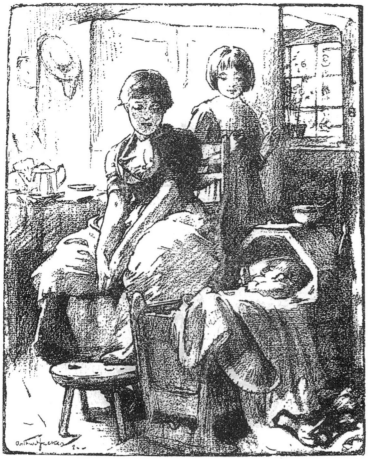

45
Arthur Hacker
(1858–1919).

Cradle Song, 1886. Unlocated. Not all of the New English Art Club exhibitors were committed to radical approaches. Hacker's *Cradle Song* exemplifies the work of a number of painters who were using the club as a way to commercial success.

46
Frank Bramley
(1857–1915).

(See page 54) *Winter*, 1885. Oil on canvas, 49.5 × 35.6 cm (19½ × 14 in.) The Marchman Collection. In general terms Bramley's *Winter* shares the theme of Brown's *Hard Times* (Plate 48); its aggressive square brush hatching, the play of space and reflected light, all the strategies deployed to give the sense of unposed convivial circumstances, emphasize Bramley's naturalist origins and ambitions.

47
William Llewellyn
(1860–1941).

(See page 55, top) *A Winter Night*, 1887. Oil on panel, 28 × 40 cm. (11 × 15¾ in.) London, The Fine Art Society. Llewellyn's lamp-lit interior from the second New English Exhibition recalls memorable images of the 1860s by Whistler, Monet and Degas. Although he may not have been aware of these particular precedents, Llewellyn's work derives from the content of more recent bourgeois naturalism, which in turn depended upon the social observation of the second half of the Second Empire.

48
Frederick Brown
(1851–1941).

(See page 55, bottom) *Hard Times*, 1886. Oil on canvas, 72 × 93 cm. (28⅜ × 36⅝ in.) Liverpool, National Museums and Galleries on Merseyside. Brown's exhibit at the first New English Art Club exhibition stemmed from the social realism of a decade earlier. More naturalistic than Legros' *Le Repas des Pauvres* (Plate 15), it portrays a male–female relationship which remains unexplained beyond the obvious reading of the figures as a pair of itinerant work people.

organized itself as a limited group of like-minded artists, the Club was just receiving its first reviews when La Thangue criticized its elitism. What was required, in his view, was a much larger movement organized along the lines of the Paris Salon, which six years earlier had begun to be run by the artists themselves. Participation in La Thangue's 'bigger movement' would be sought from every painter and sculptor who had exhibited during the previous three years and the principle of universal suffrage would be applied to the hanging and selecting committees for its exhibitions. La Thangue outlined his ideas at a meeting held at the Monico Restaurant, Chelsea, on 18 May 1886, and he succeeded in persuading many of the committee members of the New English Art Club. However, following a special meeting on 29 May, it became clear that W. J. Laidlay had grave misgivings about widening the orbit of the Club – possibly because of its financial implications. Matters came to a head during the next two weeks and La Thangue was obliged to resign. What he appeared to be talking about was reform of the Royal Academy, though in a letter to *The Times*, Clausen, Holman Hunt and Walter Crane called for a 'really national exhibition' rather than forcing 'small reforms' upon the Academy.[7] At the same time, key members of the Club such as Brown and Clausen saw no contradiction between continued allegiance to it and canvassing on behalf of La Thangue's scheme. Throughout the autumn there was intense activity. La Thangue explained his position in *The Magazine of Art* and various critics rallied in support; however the 'bigger movement' remained a pipe dream.[8]

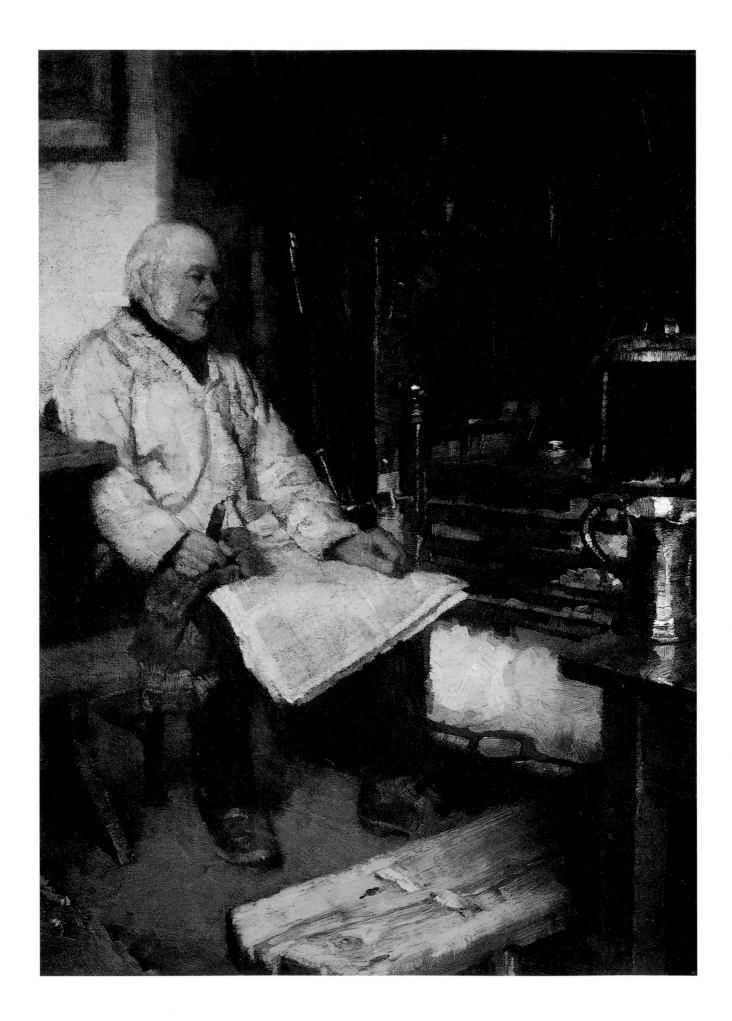

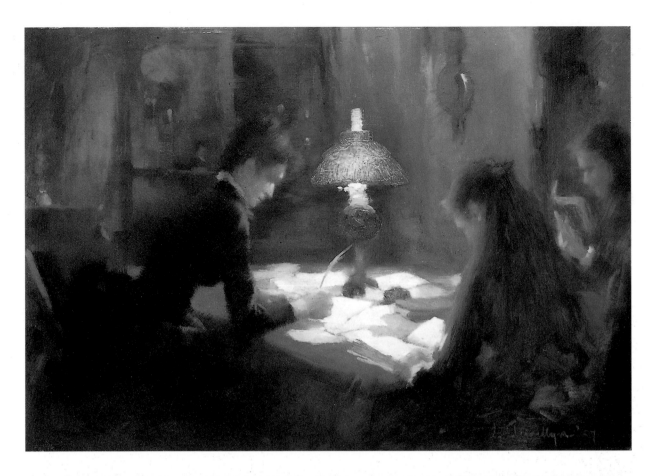

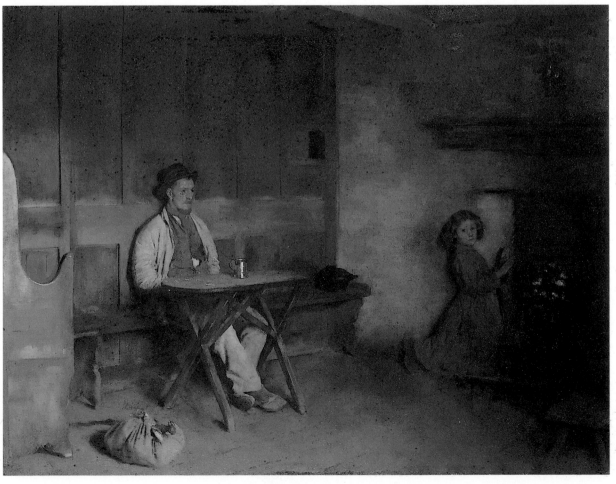

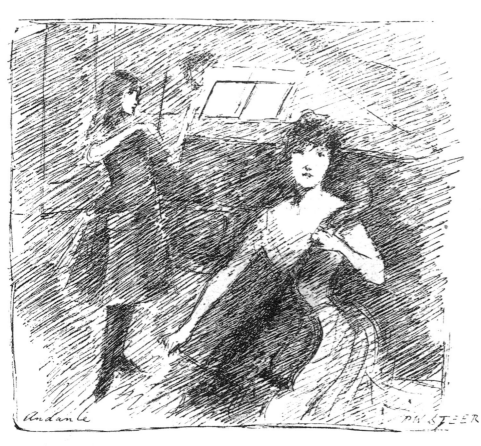

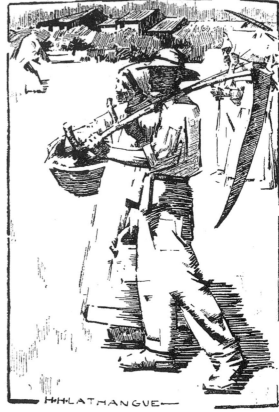

49
Philip Wilson Steer
(1860–1942).

Andante, 1886. Destroyed. Like other members of
the New English Art Club, Steer explored a
variety of genres. Although he may have been
unjustly treated by fellow club members when
Andante was 'skied' at the first exhibition, this
may be evidence that his colleagues sensed a lack
of conviction in the work.

50
Henry Herbert La Thangue
(1859–1929).

In the Dauphiné, 1886. Untraced. To some of his
colleagues La Thangue demonstrated an almost
wilful lack of concern for public taste and
standards of finish in his work. In his first New
English exhibit, the product of a trip to France, he
was prepared to flaunt the broad handling of the
Paris ateliers before English eyes that were
untrained in accepting it.

The debate succeeded in flushing out reactionary opinions. Sir James Linton,
President of the Royal Society of Painters in Watercolour, delivered an onslaught
upon those young painters who were guilty of '*rechauffés* of Millet's and Breton's
peasants'.[9] One such was George Clausen, whose *The Stone Pickers* (Plate 53)
could have been seen as a reheating of the old recipes of the French painters of
peasants. A powerful supporter of Linton's position was the French critic Ernest
Chesneau, who considered that the over-reliance upon the training methods of
his fellow countrymen had endangered the English School. Clausen responded to
this challenge by claiming that there were no special secrets to be learned in
Paris, but he asked rhetorically if the real cause of offence might not be 'the open-
air school and the development of impressionism'.[10] The discussion continued in
the art press, and culminated in a tirade from the aged painter of *Derby* Day,
William Powell Frith. He declared that those who had received the 'impressions'
which he had seen, must have minds which were 'in a state of disease'. This could
not be the end of the argument, but it did sum up some of the misapprehensions
which Impressionism had engendered. Yet it remains to be seen whether even the
defenders of radical French practice could have satisfactorily explained Sargent's
observations of Monet.

In part, these questions can only be addressed by examining the general
character of New English Art Club exhibitions. First, the small concession won
as a result of the debate on the 'bigger movement', was to extend the membership
to eighty. Thus the second exhibition contained over one hundred items.
Despite its enlargement, the show was similar in character to that of the previous
year, with rustic naturalist pictures dominating. Aside from Steer and Brown,

there were interesting deviations in the direction of contemporary middle-class themes. William Llewellyn, for instance, accompanied his rustic scene *Summertime near the Sea* with *A Winter Night* (Plate 47), an interior with figures seen in the glow of lamplight. Three other notable exceptions to the general trend were: Theodore Roussel's *Mortimer Menpes Esq.* (Plate 54) and *The Reading Girl* (Plate 43), and Alexander Harrison's *In Arcadia* (Plate 52), all of which established interesting connections with French painting. The first of this group depended heavily upon Whistler in its isolation of a bat-like shape upon a monochrome background. At the same time, such a portrait of an artist/flâneur has obvious links with the bourgeois naturalism of the Salon. Menpes was almost vying with his master in his self-projection as a man of taste. It was this which led him to the ultimate one-upmanship over Whistler of his trip to Japan in 1887. Roussel's major work in the exhibition was however *The Reading Girl*, a large picture which stemmed directly from the Manet/Whistler tradition of the 1860s, an aesthetic version of Manet's *Olympia* (Plate 55). The final painting in this group was ostensibly more modern. It carried the authority of recent Salon success. The work of a 'tonalist' Grez painter, it showed nude bathers in the dappled sunlight of an orchard. The washerwomen on the banks of the Loing were suddenly liberated from their labours and, bathed in sunlight, their natural setting became an Arcadia. All of these canvases were a foretaste of the growing commitment to aestheticism and Impressionism in the Club. Indeed, the following year, Walter Sickert began to exhibit and to feel that the New English was the place for the 'young School in England'. Sickert was encouraged to this conclusion for both positive and negative reasons. By 1888, Whistler's short reign as President of the Royal Society of British Artists had come to an end.[11] His two-year Presidency was an extraordinary episode. Back in November 1884, the members, conscious of falling attendance, and of the galleries being used by young couples as 'a quiet spot for spooning', voted to suspend their rules and to invite Whistler to join them. Partly flattered and partly bewildered, Whistler sent a number of pictures to the following winter and summer exhibitions only to find, eighteen months later, that he was being approached to take on the role of President. Immediately the character of the Society's exhibitions changed. He installed drapes and a 'velarium' or suspended muslin sheet used to diffuse the light. Thus it almost appears in Roussel's sketch of the galleries that the spectators were strolling through a permanent twilight (Plate 51). More significantly, Whistler restricted the number of exhibits and turned the shows into a didactic exercise. 'If you are uncertain for a moment, say "Out",' he instructed one member of the hanging committee, 'we want clean spaces round our pictures. We want them to be seen. The British Artists must cease to be a shop.' The severity of this advice not unnaturally antagonized the older members, but it was accepted by the younger painters in Whistler's entourage. The Society's reformation was hailed by Francis Bate:

> This Society has passed the limits of mere tolerance, and has boldly come forward to give help, much needed, to the most earnest and thoughtful effort to progress in Art that has been made for generations. It has advanced with the advanced, and the last few exhibitions held in its rooms have been conspicuous, not only as the most interesting, but as showing much the highest average of good and careful work, and certainly higher attainments than any other collection.[12]

51
Theodore Roussel
(1847–1926).

Interior and Drapery, 1887. (Society of British Artists). Unlocated, from an illustration. In the 1880s Whistler raised the question of the installation of exhibitions. A few pictures in controlled, diffused light, hung with an eye to balance and symmetry, created the ideal conditions in which aesthetic sensation could be conveyed.

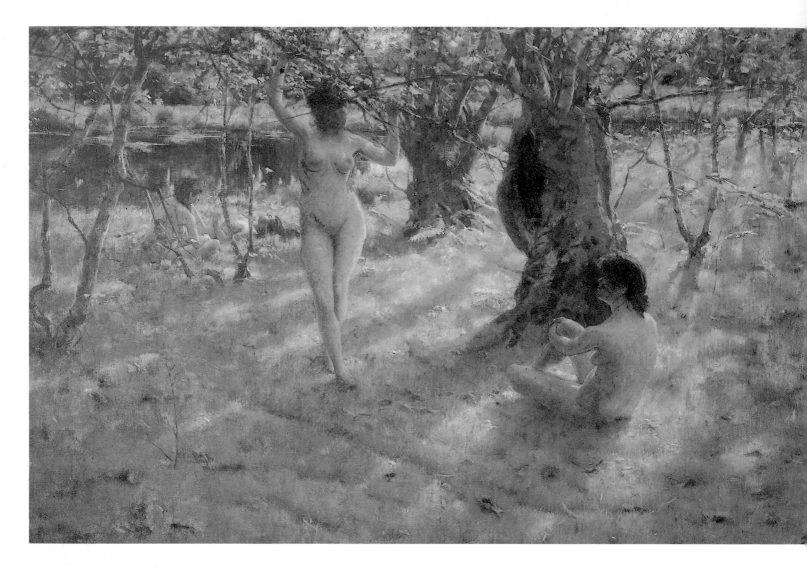

52
Alexander Harrison
(1853–1930).

In Arcadia, 1886. Oil on canvas, 195 × 202 cm. (76⅞ × 79½ in.).
Paris, Musée d'Orsay. Harrison's *In Arcadia* was much admired by the
New English Art Club painters, being displayed at their second
exhibition only twelve months after its success at the Paris Salon. In it
Harrison revealed his studies of dappled sunlight, the magic rays of
which banish Bastien-Lepage's peasants and introduce an ideal world.
Although there may be comparisons with Renoir as well as
anticipations of Matisse, this world of 'luxe, calme et volupté' remains
remarkably literal.

53
George Clausen
(1852–1944).

The Stone Pickers, 1887. Oil on canvas, 106.5 × 79 cm. (42 × 31 in.).
Newcastle upon Tyne, Tyne and Wear Museums. Clausen's profound
understanding of French naturalistic practice is evident in *The Stone
Pickers*. The placing of the figure upon a hillside and the distribution of
objects around it with varying degrees of emphasis in the handling,
recall the spatial strategies of Bastien-Lepage.

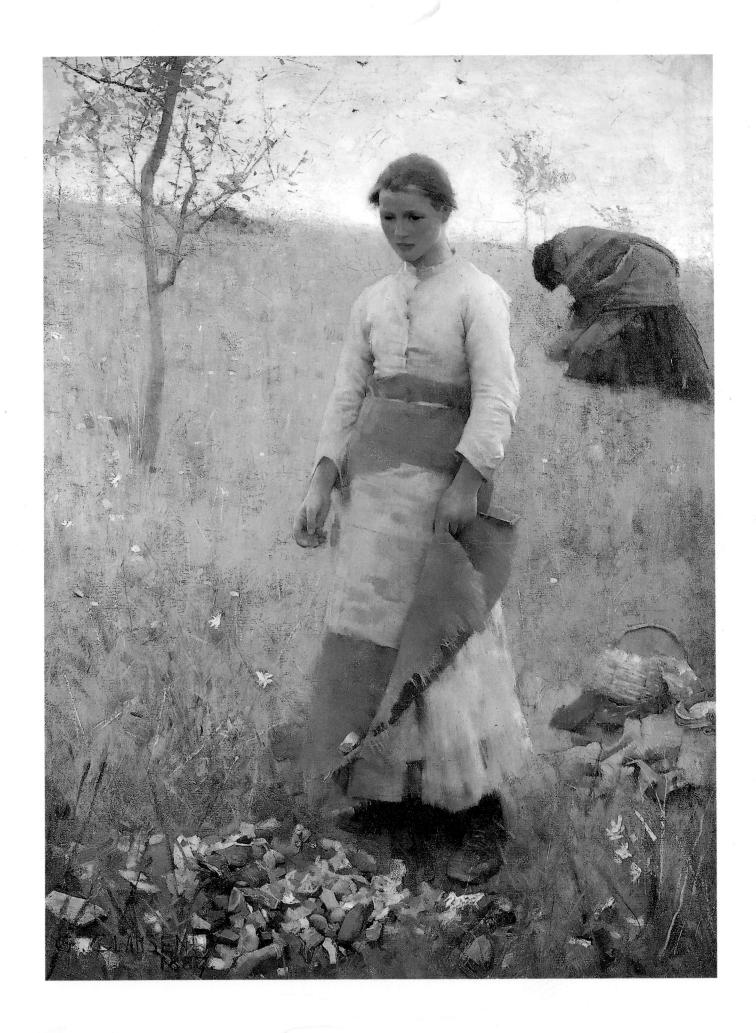

54
Theodore Roussel
(1847–1926).

Mortimer Menpes Esquire, 1887. Oil on canvas, 121 × 63 cm. (47¾ × 24⅜ in.) Private collection. Roussel's portrait of the painter *Mortimer Menpes Esquire* is an exercise in Whistlerian decorum. His essential concern was less with character than with the abstract shape which the figure makes in relation to the monochrome background.

These plaudits were not enough. When Whistler redecorated the Suffolk Street Galleries in primrose yellow, in anticipation of a visit from the Prince of Wales, the more conservative members repaired to the Hogarth Club to decide what to do. Upon the Prince's arrival, he asked about the age and history of the Society, to which Whistler replied with characteristic aplomb, 'Sir, it has none, its history begins today!' The results of his innovations were controversial, but when some of the now very limited space was filled with canvases by Monet, in the winter exhibition of 1887, even the fact that he had obtained royal patronage for the Society did not protect Whistler. By June 1888, his enemies had gathered sufficient strength to oust him and his followers.

The significance of these events was chiefly in two respects. First, Whistler had been given the opportunity to state in exhibition terms his doctrinal position. He refused to involve himself with the developments in the New English Art Club. Nothing could be further from his elitist approach than the democratic ideals

55
Edouard Manet
(1832–83).

Olympia, c. 1863–64. Oil on canvas,
130.2 × 189.8 cm. (51½ × 74⅞ in.) Paris,
Musée d'Orsay.

which motivated the 'bigger movement'. His disappearance from the Royal Society of British Artists, coupled with the collapse of this movement and the formation of the Arts and Crafts Exhibition Society, left followers like Sickert with little option other than infiltrating the Club. Initially, Sickert was wise enough to realize that,

> Our friends i.e. the impressionist nucleus in the N.E.A.C. have all advised that *my name must not this year appear* much in proposing or seconding people, as my work is said to be most unpopular with a dull but powerful section of the N.E.A.C. the people whose touch is square and who all paint alike and take their genealogy I believe from J. P. Laurens.[13]

These fascinating confidences reveal Sickert's growing commitment to Impressionism as defined by friends who were poised between France and England such as the Anglophile Jacques-Emile Blanche and the Francophile George Moore. These companions were at a discreet distance from the mechanical methods of the Atelier Julian and the aestheticism of Whistler. For Moore 'the great studio of Julien's [sic] is a sphinx and all the poor folk who go there for artistic education are devoured', while Whistler was 'of all artists . . . the least impressionist'.[14] Thus, in 1888 Sickert's position was defined; he knew what he was moving away from and what he was moving into.

CHAPTER FOUR

Impressionism in Britain

56
Theodore Roussel
(1847–1926).

Blue Thames, End of a Summer Afternoon, Chelsea, 1889. Oil on canvas,
83.5 × 119.4 cm. (33 × 47½ in.) David Messum Fine Paintings.
Throughout the 1880s the shadow of Whistler lay upon Roussel and
his pupil Paul Maitland. By the end of the decade in works such as
Blue Thames, Roussel had begun to break up his surfaces and broaden
his range beyond the limited tonalities of Whistler's nocturnes.

During the early 1870s the work of Impressionist painters had been regularly displayed at Durand-Ruel's gallery in Bond Street. Reactions in the Press ranged from outrage to cautious interest. Manet's *Argenteuil (Les Canotiers)* (Plate 57) was, for example, 'coarse and ugly' and its figures were regarded as a 'singularly offensive couple'.[1] Despite the fact that his work appears not to have been exhibited at the end of the decade in London, Manet continued to excite curiosity. In December 1877 *The Architect* sent its Paris correspondent to his studio and not only were readers given a word picture of this 'pre-eminently aristocratic' painter, they were also treated to a description of the contents of his studio.[2] *Les Canotiers* was recalled and Manet's principle was quoted – 'she wore that gown on the day I painted her; I draw things as they are; I paint nature.' This was seen as the ideal of the 'Impressionists'. The names of Pissarot [sic], Renaire [sic], Monet, Morisot, and Fanutin la Tour [sic] were quoted as Manet's followers and 'worshippers of Nature, and light, and sunlit atmosphere'. Manet, the writer concluded, was going to lie low in the year of the Exposition Universelle, 1878, and re-emerge in 1879 with a '100 pictures' in an atelier constructed for the purpose.

This piece, complemented by those of Philippe Burty in *The Academy*, suggests that there was at least a small but serious interest in French painting. At the same time several naïve articles were published illustrating the wariness of British writers in the face of radical art. Durand-Ruel continued his proselytizing in a small exhibition in the summer of 1882, followed by a larger display in 1883. The first serious article on the Impressionists was printed in *The Fortnightly Review* between these two shows.[3] Frederick Wedmore, its author, saw the work of the Impressionists as modern art reflecting modern life. The full effect of the division in the Impressionist ranks between the painters of urban naturalism and those of atmospheric landscape was not fully perceived. In 1883, Degas might be better appreciated by British audiences for his stylistic affinities with Tissot, as much as for his conscious desire to cultivate a British clientele. One of his supporters was Captain Henry Hill of Brighton. In addition to several ballet rehearsal scenes, Hill owned Degas' *L'Absinthe* – at that time simply known as *A Sketch at a French Café*. These works were those of a 'typical realist and impressionist of his time', and their relationship to 'naturalistic literature' in a 'complete denial of the ideal' was recognized. In the same collection an orchard scene 'full of blossom and spring feeling' by Monet provided welcome relief.[4] Hill was, however, more eclectic than he seems from these examples. Although some leading Academicians were not represented in his collection, he possessed works by the newer social realist painters of the 1870s such as Holl, Morris and MacBeth, as well as a particularly fine example of the bourgeois naturalism of Ernest-Ange Duez. Although the general character of the collection was similar to those formed by the Bradford mill owners of the 1880s, it was exceptional in its Impressionist examples. Replacing the works of Degas and Monet into the contemporary mêlée gives true significance to the emergence of the New English Art Club painters.

In later years Sickert always stressed his impeccable European connections. His father had been one of the pupils of Thomas Couture, the teacher of Manet. As a young man he pursued an acting career before joining the Slade School of Fine Art in 1881 under Legros. This experience lasted less than a year because after a chance second meeting with Whistler, he was persuaded to abandon the Slade to

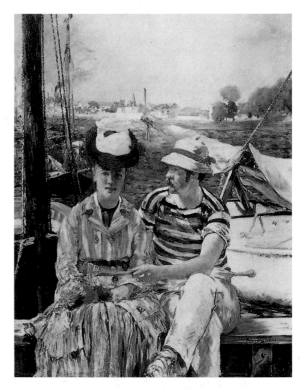

57
Edouard Manet
(1832–83).

Argenteuil (Les Canotiers), 1874. Oil on canvas, 149 × 115 cm. (58¼ × 45⅜ in.) Tournai, Musée des Beaux Arts.

59
Edgar Degas
(1834–1917).

A Group of Friends. 1885. Pastel on paper, 115 × 71 cm. (45⅜ × 28 in.) Providence, Rhode Island School of Design. Degas' incisive pastel, documenting a summer sojourn at Dieppe, expresses his regard for the young Sickert. It is he who is isolated from the group of friends, and shown in full length, momentarily oblivious of their conversation.

58
Jaques-Emile Blanche
(1861–1942).

Jeune Fille à la Fenêtre, 1884. Oil on canvas, 167 × 84.5 cm. (65⅞ × 33¼ in.) Private collection. In his early career as a pupil of Henri Gervex, Blanche developed a methodical naturalism. Although this was later transformed into stylish slickness, in the 1880s he shared Sickert's enthusiasm for Manet and Degas.

become a studio assistant for the American painter. The relationship flourished, and in 1883 Sickert was entrusted to deliver Whistler's celebrated portrait *Arrangement in Grey and Black No. 1, The Artist's Mother* to the Paris Salon. He was supplied with introductory letters to Manet and Degas, and was shown around Manet's studio, though unlike *The Architect* reviewer, he was not given an interview. Manet at that stage had not long to live. For the immediate future, however, Sickert remained a pupil of Whistler. In June 1885, following his marriage to Ellen Cobden, Sickert visited Dieppe. There, he joined the company of Degas, Whistler, Monet, Jacques-Emile Blanche and others. Degas was evidently impressed by Sickert's appearance, since he presented him in full-length as an isolated figure, looking away from the others in an extraordinary *Rendez-vous des amis* (Plate 59).[5] One of the six friends in Degas' pastel, perhaps the most important in the long term for Sickert, was Blanche. As a pupil of Henri Gervex, Blanche received his training from a young artist in the circle of Manet and Degas who had successfully overlaid their 'modern life' themes with obvious narrative. It is not surprising that Blanche's early works, such as *Jeune Fille à la Fenêtre* (Plate 58), reveal an intelligent student, fully conversant with the language of naturalistic representation. Like Sickert, he was as yet uncommitted.

Throughout this summer, Sickert behaved predictably. He produced pastels and oil panels of the *plage* as well as a number of paintings of shop fronts. These

include *The Butcher's Shop* and several versions of *The Laundry Shop* (Plate 60). It was in this latter work that the painter moved to closer proximity with his subject matter. Whistler, reacting to the ensemble, would on such occasions tend to adopt a more distant viewpoint. In the two versions of *The Laundry Shop* and in their related drawings, his pupil gave greater prominence to the figure standing in the doorway. The gradual evolution of the stages in the composition is taken as evidence of the growing domination of Degas. Sickert later declared that what impressed him about Degas was the painter's ability to create a picture by conscious stages to a foreseen end. The tendency to work in series was to become a consistent feature of Sickert's practice.

One of his recreations in 1885 was to go to Pinder's Circus which was playing a summer season at Dieppe. One of its stars, Leah Pinder, an *equestrienne*, was portrayed delighting the crowd. Although Degas may well have guided its selection, the containment of the action in the middle distance and the light sketchy handling of *The Circus* (Plate 61) is Whistlerian. The same is true of *Le Quatorze Juillet* (Plate 62) in which the details of the crowd – a perambulator, a balloon-seller, a dog, a group of soldiers and a woman with an umbrella – are picked out with deft touches upon a panel primed in grey. All of Whistler's followers were infected by a 'grey panel craze' around 1885 and only in the tentative *Figures on a Lawn, Poston* (Plate 63) did Sickert approach the full-blooded *plein air* of Lavery's *Grey Summer's Day, Grez*.

60
Walter Richard Sickert
(1860–1942).

The Laundry Shop, 1885. Oil on canvas, 38.7 × 27.7 cm. (15¼ × 9¾ in.) Leeds Art Galleries. Whilst he consorted with Blanche and Degas at Dieppe in 1885, Sickert remained a pupil of Whistler. During the decade Whistler painted many small panels of shop fronts. These were inspired by a renewed admiration for Vermeer, a photograph of whose *Little Street in Delft* used to hang in Whistler's studio.

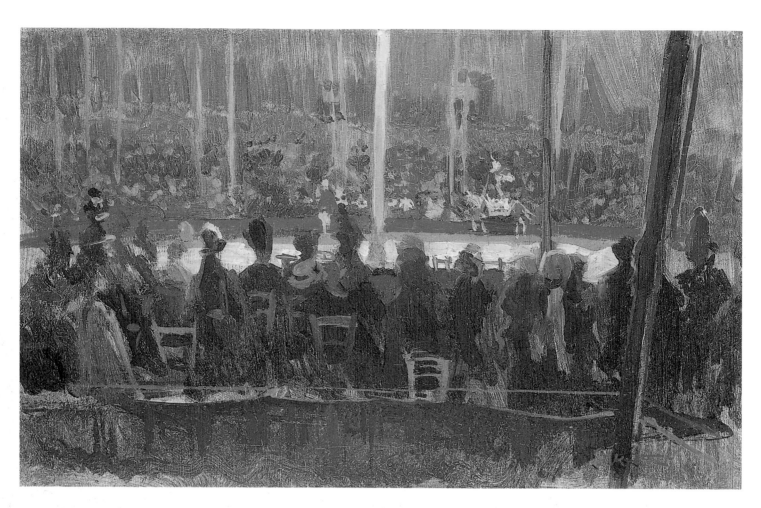

61
Walter Richard Sickert
(1860–1942).

The Circus, 1885. Oil on panel, 21 × 35 cm.
(8¼ × 13¾ in.) Private collection. For all its
seeming casualness, *The Circus* is one of Sickert's
most complete early compositions. Having pulled
back to the periphery of the crowd he endeavours
to show the event in its entirety, whilst retaining
the viewer's concentration on the central
performer.

62
Walter Richard Sickert
(1860–1942).

Le Quatorze Juillet, 1885. Oil on panel,
22 × 35 cm. (8⅝ × 13¾ in.) Private collection.
Public occasions, fêtes and festivals, attracted
Sickert, Lavery, Kennedy, and other British
Impressionist painters. Each of these artists
became proficient at observing figures in motion,
forming and re-forming groups. These studies,
often reminiscent of the boulevard scenes of
Monet and Renoir, stressed the abstractness and
autographic qualities of the statement.

63
Walter Richard Sickert
(1860–1942).

Figures on a Lawn, Poston, 1886. Oil on panel,
28 × 40 cm. (11 × 15¾ in.) Private collection. The
deft handling and use of thin paint which
characterized Sickert's early work could be seen as
remnants of the influence of Whistler. Yet
throughout the 1880s Sickert struggled to develop
a bolder style which was more responsive to
variations of local colour. This fluidity was not
fully achieved until the mid-1890s, but it was
hinted at in *Figures on a Lawn, Poston*.

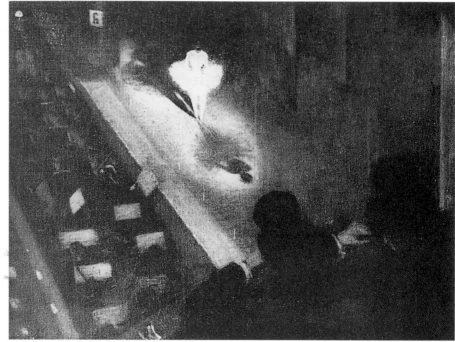

64
Walter Richard Sickert
(1860–1942).

(Left) *Collin's Music Hall, Islington Green*,
c. 1887–8. Destroyed. A number of Sickert's
early theatre pictures have not survived. Formats
altered, but the central focus was firmly upon the
pool of light in which the performer moved.

65
Philip Wilson Steer
(1860–1942).

Signorina Zozo in 'Dresdina', c. 1887–89.
Unlocated. Steer's new theatre interiors differ
from Sickert's in their much more daring
compositions. In its choice of a high vantage
point the work appears to have more in common
with the early orchestra sketches of Sargent than
with that of either Sickert or Degas.

Light sketchiness separates these paintings from the more regular handling in the preparatory studies of the majority of New English Art Club painters. Sickert's capacity for experimentation fed upon the enthusiasm of the exciting company he was keeping, and when he returned to London it was to give glowing accounts of the 'ballet girls' of an artist referred to by Mortimer Menpes as 'Digars'. Despite the fact that Sickert acquired Degas' *Green Dancer*, there is no obvious evidence of 'low-toned ballet girls' in his work. Sickert was rather more attracted to the *café-concert*, the low-life theatre which was arousing the interest of literati. George Moore saw this subject matter as ' a protest against the villa, the circulating library, the club'.[6] The first of this series of paintings was the *Lion Comique* (Plate 68), exhibited at the Royal Society of British Artists in 1887. Atmosphere is sacrificed to a marquetry of flat shapes which by simple tonal alterations place the spectator out in the darkness of the hall behind the leading violinist. Sickert evidently had observed in Degas' work the degree to which a pool of light emanating from a proscenium could form a back projection for figures more immediately within the spectator's space.

The exhibit chosen for Sickert's debut at the New English Art Club in 1888 was *Gatti's Hungerford Palace of Varieties, Second Turn of Katie Lawrence*. A critical furore greeted the event. For *The Times* the picture was simply a 'rather disagreeable failure', while for *The Magazine of Art* it was 'anything, in fact, but what one would imagine to be an honest and recognizable "impression" of the glare and glitter of the music hall stage.' This large upright painting can best be judged from a similar work, *Collin's Music Hall, Islington Green* (Plate 64), which was exhibited in 1889, and later destroyed.[7] Two smaller paintings of Gatti's Music Hall extend the picture plane and also place the spectator in the centre stalls. Their symmetrical compositions are further emphasized by the placing of Katie Lawrence in one and Queenie Lawrence in the other, to coincide with a vanishing point of the perspective directly above the forward-facing chairman,

Tom Tinsley. Around this central axis are arranged the back views of heads, angled in various directions. Particularly in the case of *Queenie Lawrence on the Stage at Gatti's* (Plate 67), they are smudged into and on top of one another like the transient beings in a long exposure photograph. The presence of these graphic *pentimenti* expresses Sickert's delight, more evident in later works, in constant revision. Here it serves the purpose, whether recognized or not, of underscoring the informality of the 'impression'. In spite of such references to French practice, however, the parallel layers of receding space contrast with the unusual angles and abrupt space-cutting of Degas. Only in his music hall themes developed with *The Old Bedford* and *Vesta Victoria . . .* did Sickert tentatively engage such issues.

The most important of the elusive ballet pictures painted by one of Whistler's followers was Philip Wilson Steer's *Signorina Zozo in 'Dresdina'* (Plate 65), a work planned in the winter of 1886 but not exhibited until 1890.[8] Steer had evidently imbibed, at an early stage, Degas's love of unusual viewpoints; but whereas Degas would have insisted upon a linear and colouristic treatment, Steer's approach

66
Philip Wilson Steer
(1860–1942).

The Bridge, 1887. Oil on canvas, 49 × 60 cm. (19¼ × 23⅝ in.) London, Trustees of the Tate Gallery. Steer's treatment of the meeting of a man and a woman on a bridge cleverly subdues the relationship which may exist between them. It is presented as an enigma much in the same way as Degas does in *Pouting* (Metropolitan Museum of Art, New York). It is impossible to separate the interpretation of their relationship from the evening atmosphere which evelopes them and over which Steer has expended considerable skill.

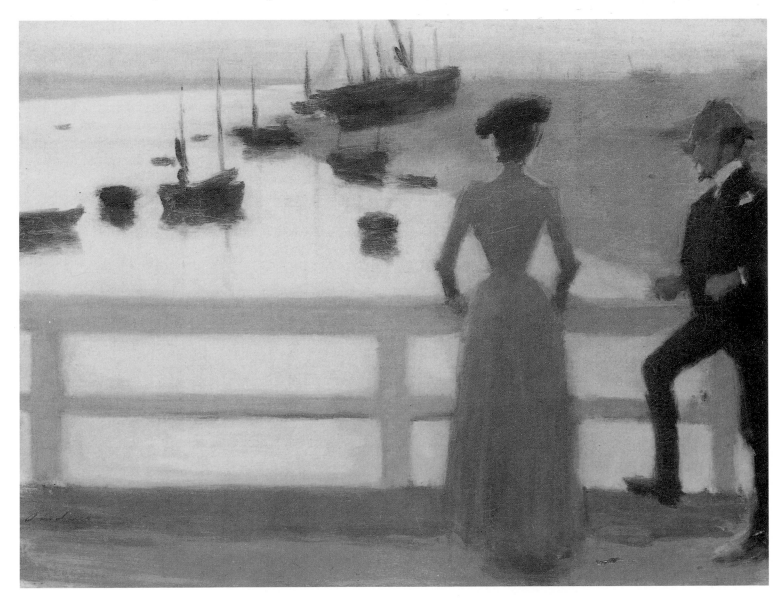

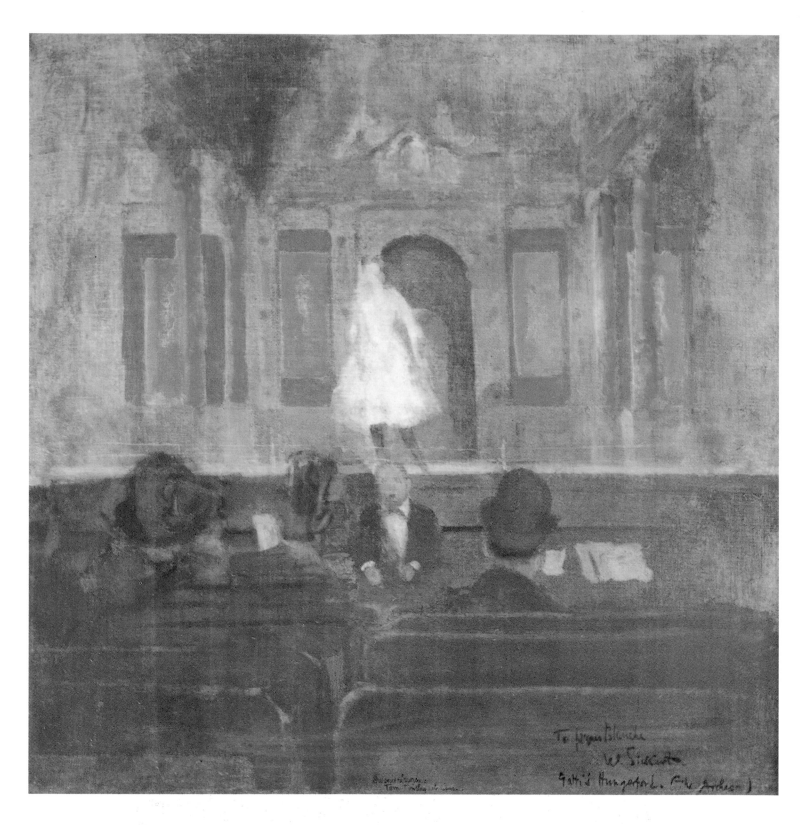

67
Walter Richard Sickert
(1860–1842).

68
Walter Richard Sickert
(1860–1942).

Queenie Lawrence on the Stage at Gatti's, 1880. Oil on canvas, 61 × 61 cm. (24 × 24 in.) Private collection. *Queenie Lawrence on the Stage at Gatti's* splendidly exemplifies the flexible style which Sickert was beginning to develop at the end of the 1880s. The positions of foreground figures have been altered during the process of painting and the remaining paint marks coupled with the lack of definition in the figure of the performer, suggests the animation of the scene.

Lion Comique, 1887. Oil on canvas, 51 × 31 cm. (20 × 12¼ in.) Private collection. It is easy to see the *Lion Comique* as a move away from Whistler towards the style and subject matter of Degas. It is worth remembering, however, that this canvas is of full-length portrait proportions. Sickert shows the whole performer where Degas would daringly cut the figure in order to concentrate upon the musicians.

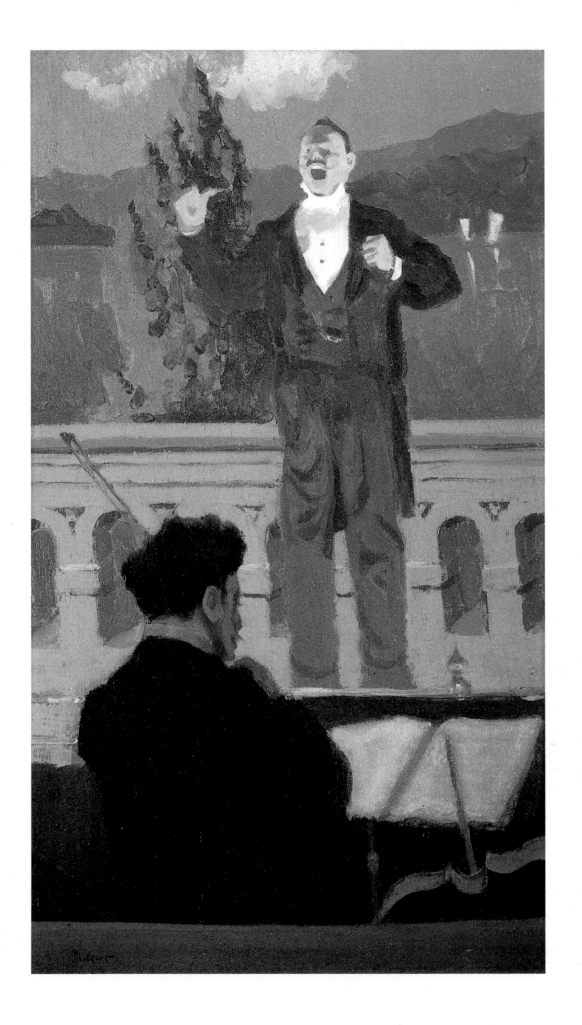

69
Frederick Brown
(1851–1941).

When the Setting Sun is Low, 1888. Unlocated.
Works like *The Bridge* (Plate 66) and *A Summer's
Evening* (Plate 78) exemplify the shared interest in
crepuscular effects which was common to many
of the British Impressionists. Brown's frieze-like
composition owes much to Stott of Oldham and
the more poetic strand of rustic naturalism.

appears to have been very much in the direction of tonal atmospherics. These
inclinations are explicitly declared in *The Bridge* (Plate 66), a canvas depicting a
man in a deerstalker trying to engage the attention of a young woman. In keeping
with bourgeois naturalism, the relationship between those represented is
inferred rather than made explicit. Steer's footbridge is a trysting place providing
a good view of the estuary at low tide. The picture appears to have been painted
on a single occasion – as Whistler would say, 'in one wet'. There is therefore
nothing disjointed in the extraordinary evocation of mood. At this time
crepuscular light and an almost tangible ether were essayed in more direct terms
in Frederick Brown's *When the Setting Sun is Low* (Plate 69). Brown's and Steer's
canvases appeared in the New English and the Grosvenor Gallery respectively in
1888. Any comparison of the two would observe the rather disjointed activity of
Brown's children fishing, but might observe the frieze-like compositions of both
works.

Signorina Zozo . . . and *The Bridge* are only two examples of a fascinating
development which took their author through a gamut of influences from
Whistler and Degas to Monet, Pissarro and Neo-Impressionism. At the outset it
would be wrong to expect these transitions to occur in a neat and logical way,
corresponding to notions of historical sequence within the work of the
Impressionists. Steer's work is not an orderly progression to radicalism. Different
stylistic sources are applied to different subjects and the only consistent factor
seems to be in his profoundly intuitive understanding of the various modes. In
landscapes and coastal scenes, Steer adopted the tactics of Monet and the Neo-
Impressionists, while with interiors and portraits, he returned to the orthodoxy of
Whistler, Degas and Sargent. His allegiance to Monet can only have been
stimulated by the awareness of Sargent's increasing engagement with Impression-
ism. At the first exhibition of the New English Art Club in 1886, Sargent
produced the portrait of *Mrs. Frederick Barnard* and a small unidentified study
which was described by *The Times* as 'Impressionist'.[9] It is possible to accept by
the definitions then in currency that such pictures as *Home Fields* (Plate 70)
would be labelled in this way. Painted at Broadway in the Vale of Evesham
around 1885 and inscribed 'to my friend Bramley', this picture is a souvenir of a
tantalizing but undocumented relationship. Frank Bramley's *Eyes and No Eyes*

and Sargent's *Carnation, Lily, Lily, Rose* (Plate 1) were grouped together by *The Art Journal* in 1887 as examples of the work of the 'dab and spot' school. Of all the Newlyn painters, Bramley accentuated the square-brush method, leaving paint marks of such expressive force that in 1886, when *Domino* was exhibited, one reviewer commented upon the 'intrepid handling' and 'extraordinary force of effect' in which 'no record of impressions could be completer and more convincingly thorough'.[10] Yet for all its conviction, Bramley's work retained the regular handling of the *plein air* painters. Infiltrating the alien world of the Royal Academy, he successively modified his language and purged the dabs and spots.

Sargent, on the other hand, successively 'deranged' his visual language. In sketches leading up to *Carnation, Lily, Lily, Rose* he evolved an unsystematic and pliant use of paint.[11] The picture was begun in August 1885 in the garden of Farnham House, Broadway, which was temporarily leased by two American painter friends, Frank Millet and Edwin Austin Abbey. The area had a reputation as an artists' colony: Edward Stott and Walter Osborne had passed the

70
John Singer Sargent
(1856–1925).

Home Fields, 1885. Oil on canvas, 73 × 96.5 cm. (28¾ × 38 in.) Detroit Institute of Arts. Although *Home Fields* must at some point have been owned by Frank Bramley, Sargent and Bramley's friendship remains impossible to disentangle. The picture is a plein-air sketch painted around 1885 in the fields near Broadway in Worcestershire.

See previous page

71
John Singer Sargent
(1856–1925).

(See page 74) *St. Martin's Summer*, 1888. Oil on canvas, 91.2 × 71 cm. (36 × 28 in.) Private collection, photo courtesy of the Coe Kerr Gallery, New York. The flourish of sunlight on St. Martin's Day (11 November) gave rise to one of Sargent's most important pieces of Impressionism. When he exhibited this together with *A Morning Walk* (Plate 72) at the New English Art Club in 1889, Sargent was thought to have gone 'rather far' in the direction of Monet. Whilst his work appears loosely structured, having been painted *alla prima*, there is immense compositional strength in the dramatic foreshortening of the foreground figures.

72
John Singer Sargent
(1856–1925).

(See page 75) *A Morning Walk*, 1888. Oil on canvas, 60.7 × 50 cm. (26⅜ × 19¾ in.) Private collection, photo courtesy of the Coe Kerr Gallery, New York. From the moment of its exhibition, *A Morning Walk* was habitually compared with Monet's work, particularly his series of girls with parasols (Plate 73). The picture was probably painted during the summer of 1888 at Calcot Mill in Oxfordshire, where the Sargent family assembled for the summer. It depicts Sargent's sister, Violet, later Mrs Ormond, against a background of river bank which really alludes to the dry brush scumbling and 'comma' strokes of Monet.

previous autumn at nearby North Littleton. Carrying the recollection of Chinese lanterns slung amongst the trees at Pangbourne, Sargent began to work upon a large canvas which was to take its title from the refrain of a popular song. Returning to it the following autumn, he settled upon Dorothy and Polly, the Barnard daughters, as his models. Edmund Gosse presents a vivid account of the artist limbering up with a game of lawn tennis before taking his position for a short period in front of the picture each evening as the light was fading. Then came 'wagtail' actions as he ran back and forth to place his 'dabs and spots'. Although it was painted in the open air, the degree of contrivance in *Carnation, Lily, Lily, Rose* places it at a distance from orthodox Impressionism. The practical difficulties which Sargent encountered were, to some extent, similar to those which Monet had experienced in 1865 with his *Déjeuner sur l'Herbe*. Sargent's idea also involved the aestheticism of lanterns and flowers and this also places it at a tangent to the mainstream, like Monet's *Japonnerie*, 1876. At the same time, the Chinese lanterns, carnations and lilies help to qualify the pictures as a piece of Salon Impressionism which in its handling and effects carries the preoccupations publicly associated with the new sensibility. Roger Fry's recollection of the work is accurate in this respect, though it is inevitably tinted by hindsight. Considering the painting after Sargent's death, he declared that it

> . . . seemed a new revelation of what colour could be and what painting might attempt, and how it could be at once decorative and realistic . . . what thrilled us all then was the fact that this picture was the first feeble echo which came across the channel of what Manet and his friends had been doing with a far different intensity for ten years or more. This new colour was only a vulgarization of the new harmonies of the Impressionists; this new twilight effect only an emasculated version of their acceptance of hitherto rejected aspects of nature.[12]

Such an educated view was not possible in 1887 when Sargent was travelling to and fro between London and Paris and spending time with Monet at Giverny. It was probably in this year that *Claude Monet Painting at the Edge of a Wood* (Plate 3) was produced. One of Monet's British visitors a few years later described the master's routine of sallying forth each day followed by a daughter 'trundling a barrow bearing six canvases, three for grey and three for sunny effects, and on these he worked according to weather, for about twenty minutes'. It was one of these sessions which Sargent recorded. Monet later told the dealer, René Gimpel, 'I gave him my colours and he wanted black, and I told him, "but I haven't any," "then I can't paint," he cried, "how do you do it?" '[13] This conversation is more significant in the context of Sargent's observation of Monet at work. Since his student years in the mid-1870s, under Carolus Duran, Sargent had always accepted the need to 'block in' the entire canvas in the *manière noire* of the Spanish Caravaggesque masters, filtered through the second-generation realists. Now, under Monet, it was necessary to look less for shape and more for colour: to see that surfaces under bright sunlight or strong shadow had their own distinct hues as well as tonal relationships. Monet's method, which was being developed, was to blend the dominant colours throughout the picture surface. The palpitating effects of figures under sunlight became the object of Sargent's attention during the next two summers. In a series of river scenes painted at Calcot and Fladbury, he evolved his own correlative of the sparkle of Monet's

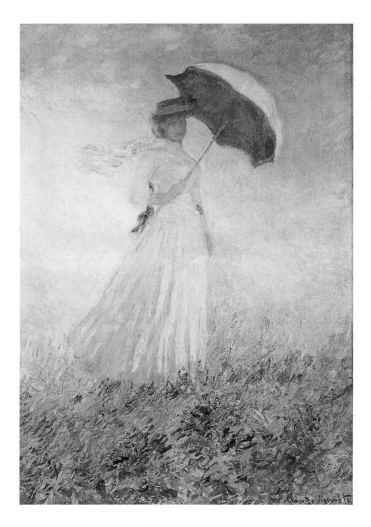

73
Claude Monet
(1840–1926).

Essai de Figure en plein-air (vers la droite), 1886.
Oil on canvas, 102.7 × 93 cm. (40½ × 36⅝ in.)
Paris, Musée d'Orsay.

atmospherics. Eventually such effects began to be integrated with his deeper instincts for the visual drama of shape in works like *St. Martin's Summer* (Plate 71). In this painting, he appears to have been working particularly close to his friend Alfred Parsons, who also exhibited a more conventional work under this title. Sargent's canvas, however, shows his female companions enjoying a siesta upon an abnormally sunny November day. Highlights and shadows are given tonal as well as colouristic value in creating the effects of dappled sunlight.

The clearest example of kinship between Monet and Sargent is provided in *A Morning Walk* (Plate 72), painted in the summer of 1888, and echoing a sequence of *plein air* essays of two years earlier. Where Monet projected his figures against the sky, Sargent engineered a more naturalistic encounter in which there was less obvious seduction of shape. *A Gust of Wind* (Plate 74), one of the most vivid of these earlier pictures, adopts a similar viewpoint to Monet's celebrated *Essai de Figure en plein air (vers la droite)* (Plate 73). The figures, in white dresses, are placed in front of a brilliant blue backdrop. Sargent's version of 1886 is nevertheless treated in sweeping strokes which accentuate the silhouette. By contrast, in *A Morning Walk* Mrs Ormond is surrounded by the blues, greens and yellows of a verdant river bank. *A Morning Walk* and *St. Martin's Summer* were exhibited at the New English Art Club in April 1889, coincidentally with a collection of twenty 'Impressions by Claude Monet' at the Goupil Gallery. *The*

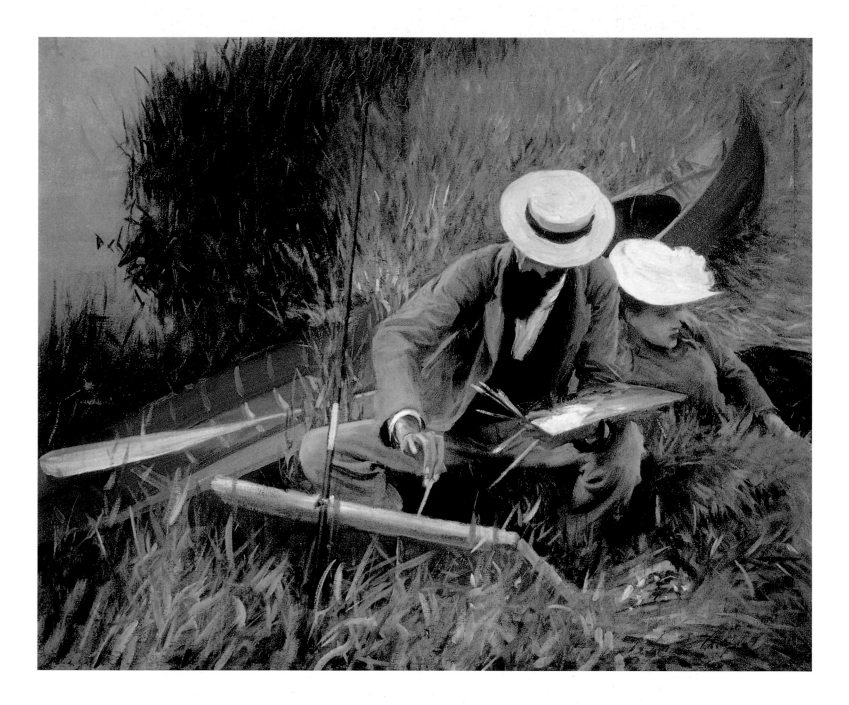

74
John Singer Sargent
(1856–1925).

A Gust of Wind, 1887. Oil on canvas, 61 × 38 cm. (24 × 15 in.)
Private collection, photo courtesy of Coe Kerr Gallery, New York.
Painted a year earlier than *A Morning Walk* (Plate 72), *A Gust of Wind*
demonstrates Sargent's *alla prima* technique prior to his adoption of
the surface characteristics of Impressionism. Here, as in his later
portraits, the emphasis is clearly upon dramatic abstract shapes rather
than texture.

75
John Singer Sargent
(1856–1925).

Paul Helleu Sketching with his Wife Alice, 1889. Oil on canvas,
66.2 × 81.4 cm. (26 × 32 in.) New York, the Brooklyn Museum. Not
all the summer of 1889 was spent in boating parties. Helleu spent
some of the time painting and, like Denis Bunker and Claude Monet,
became the subject of an animated study by Sargent.

Magazine of Art grudgingly noted that Sargent's pictures had been painted 'under the direct inspiration of Claude Monet, but they are none the worse for that . . .'

Sargent's implacable allegiance to the new way of seeing led him to lease a house at Fladbury, a few miles from Broadway, for the summer of 1889. Having produced many smaller informal sketches, he was anxious to reconcile opposing methods. *Lady Fishing, Mrs Ormond* attempts a *plein air* full-length portrait, whilst the more finished *The Boating Party* (Plate 76) shows the same model with two new arrivals at Fladbury, Paul Helleu and his wife Alice. Again Sargent evokes the relaxed ambiance of late summer, carefully premeditated in its asymmetry. Other criteria were now asserting themselves. The French painter and his nineteen-year-old wife posed for one of Sargent's most forceful re-creations of *plein air* practice in *Paul Helleu Sketching* (Plate 75). This moves further away from Monet's atmospherics towards the comment upon human relationships sometimes found in the work of Manet and Degas. Sargent was captivated by Helleu's floating fingers, his deft handling of the brush which was particularly suited to what Edmond de Goncourt was to describe as 'snapshots of female charm'. Monet at the edge of the wood was much less animated and was totally devoid of delicate dash. By 1892, when he finally exhibited *Paul Helleu Sketching*, Sargent had moved back into Helleu's world of society portraiture.

Nevertheless, during this crucial period there could be no mistaking Sargent's pre-eminence. Frederick Wedmore later recalled that *Carnation, Lily, Lily, Rose*

76
John Singer Sargent
(1856–1925).

The Boating Party, 1889. Oil on canvas, 87.7 × 92.2 cm. (34¹/₂ × 36 in.) Providence, Rhode Island School of Design. With *The Boating Party* Sargent moved back into the social milieu. The characteristic poses of his protagonists, Paul and Alice Helleu and Violet Sargent, were his principal concern and his view of their activities was to be like a snapshot. Thus madame Helleu gingerly picks her way across the punts while her husband sprawls indolently in the bow of a canoe in the foreground.

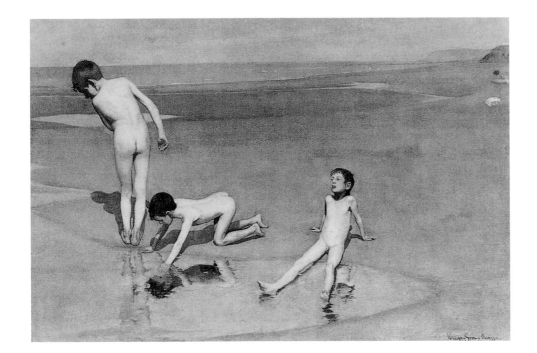

77
William Stott of Oldham
(1857–1900).

A Summer's Day, 1886. Oil on canvas,
132.9 × 189.3 cm. (52½ × 74⅝ in.) Manchester
City Art Galleries. To their contemporaries in
Paris in the early 1880s, it often seemed as if Stott
and Harrison were in competition, In 1885
Harrison sent *Bordes der Mer*, a picture of five
boys bathing, to the Salon. In the following year
Stott's *A Summer's Day* was shown at the winter
exhibition of the Society of British Artists.
Although it was undoubtedly modified to suit the
Society's Whistlerian clientele, its salon scale and
subject matter suggest that competition was still
alive between the two artists.

was the one picture in the Royal Academy of 1887 to provide solace for Philip Wilson Steer. 'The only thing that one can care about is Sargent's picture,' he told him. A sympathetic reaction to Sargent was one of the first steps in Steer's understanding of Monet and the more radical French Impressionists. His commitment to re-enacting the recent battles of his mentor established Steer's painting as 'a sort of standard round which the stiffest fighting took place'.[14] His important contribution to the evolution of an Impressionist sensibility also lies in this dialogue with the accepted systems by which he secured his right to the attention of critics and clients. Throughout the late nineteenth century, the annual Salon received important work. The painter was obliged to compete in this arena by producing large exhibition pieces which, even if they remained unsold, would provide a form of advertisement. Whistler's novel treatment of the Suffolk Street Galleries of the Royal Society of British Artists suggested an alternative. In a sense it was an alternative already active in dealers' shops and in the more selective annual exhibitions. Yet for all this, the exhibition picture remained significant. The Impressionists had been amongst the first to rethink the Salon system and to acknowledge the fact that the preponderance of art activity was conducted on a smaller scale for humbler bourgeois tastes. George Moore recognized the importance of 'art for the villa' and questioned the need of painters to struggle over large self-consciously conceived subjects. Up to the Great War, many painters who counted themselves progressive were equivocal on this issue. Back in the 1880s for instance, Georges Seurat hoped to combine all of the most novel ideas about perception in grand exhibition pieces. This seems to have been Steer's idea in *A Summer's Evening* (Plate 78), his contribution to the New English Art Club in 1888.[15]

Steer's subject matter, three nude bathers, was not in itself controversial, since

78
Philip Wilson Steer
(1860–1942).

A Summer's Evening, 1888. Oil on canvas, 146 × 228.6 cm.
(57¾ × 90½ in.) Private collection. In 1888 Steer surpassed his
British Impressionist colleagues with *A Summer's Evening*. In its
treatment of the nude it obviously relied heavily upon the precedents
set by Harrison (Plate 52) and Stott of Oldham (Plate 77). However, in
his picture Steer forsook naturalism in a desire to achieve the shrill
colour associated with Salon-scale Neo-Impressionism.

79
Philip Wilson Steer
(1860–1942).

Knucklebones, 1888–9. Oil on canvas, 61 × 76.2 cm. (24 × 30 in.)
Ipswich Museums and Art Galleries. After he painted *A Summer's
Evening* (Plate 78) Steer moved on to *Knucklebones*, a less premeditated
work, but one where his stylistic preoccupations are more clearly laid
bare. The different treatments given to figures, shingle, and sea could
each be related to different mentors whom Steer did not feel
compelled to reconcile. As one of the most important London
Impressionist exhibits, the picture set a kind of standard for all the
various beach scenes by Steer and others produced in the 1890s.

Tuke, Roussel and Harrison had already tackled the theme. Perhaps the closest parallel was provided by William Stott of Oldham's large canvas *A Summer's Day* (Plate 77), exhibited at the Society of British Artists in 1886. It is easy to appreciate why Whistler would have admitted such a work to the Society over which he presided. Its grand simplicity in the placing of figures upon a vast unmodulated stretch of sandy beach alluded to the kind of abstract values which Whistler had always advocated. But even the authoritative gestures of Stott, echoed elsewhere in Steer's work, did not prepare spectators for the extraordinary *A Summer's Evening*. The uncomplicated illumination of Stott's daytime had assumed a richly problematic Impressionist patina in Steer's evening. It is almost as if Steer adopts a variety of radical approaches to different areas of the canvas, as the *plein air* naturalists had done. This is certainly the case with *Knucklebones* (Plate 79) the following year where there is modified divisionism for the shingle, Monet's 'comma' brushstrokes for the sea and a Degas-esque grouping of figures. But with the simple placing of the nudes in *A Summer's Evening*, Steer like Seurat was attempting a manifesto which would prove Impressionism capable of engaging the idealist concepts of Puvis de Chavannes. Steer is unlikely to have seen Seurat's *Les Poseuses*, though his and Seurat's canvases hung together at the *Less XX* exhibition in Brussels in 1889.

At the time of its first showing, *A Summer's Evening* achieved the desired result. The hot, humid vibrancy of the colours assaulted all of the critics. *The Times* rhetorically asked 'whether one ever saw the colours of nature with Mr. Steer's eyes . . .', while *The Magazine of Art* found that

> The effect is in some respects painful, Mr. Steer's endeavours to do justice to sunlight having missed the mark, while the vivid reds and yellows against the deep blue positively hurt one's eyes.[16]

During the following year, Steer produced a number of smaller works which explored different aspects of Impressionism. Amongst these, *Summer at Cowes* (Plate 80) is so close to its sources in Monet and Sisley, as almost to be considered a pastiche. Elsewhere, in sketches on panel, a greater variety of techniques are attempted, and these informed *Knucklebones*, a picture the complex derivation of which can best be appreciated in diagrammatic form in Sickert's illustration for *The Whirlwind*. Although a variety of influences were at play, there is nonetheless a greater sense of overall pictorial unity in *Knucklebones*.

This painting was one of eight which Steer showed at an exhibition advertised in *The Times* on 2 December 1889 as 'A collection of 70 Paintings in oil by a group of London Impressionists'. Steer's works were regarded as 'perhaps the best in the show' and 'frankly inspired by Monet'. The moving force behind this one and only showing of the 'Impressionist nucleus' was undoubtedly Walter Sickert, and he contributed the introduction to the catalogue of the exhibition. Firstly Sickert attacked William Morris and those painters who practised a utilitarian form of decorative painting. In the preceding year, the Arts and Crafts Exhibition Society had been formed and some New English associates had been wooed. Sickert goes on to assert that one should not look at a painting to glean new facts about its subject as critics were apt to do in a post-Ruskinian era. One should rather look for that 'subtle attribute which painters call "quality" the appreciation of which is a matter, not only of temperament, but of education and experience'. This throws the appreciation of painting into the realm of

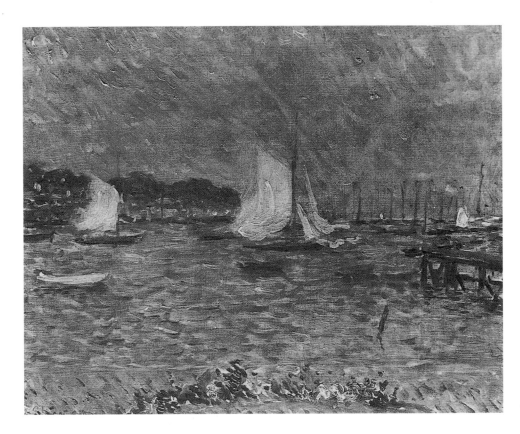

80
Philip Wilson Steer
(1860–1942).

Summer at Cowes, 1887. Oil on canvas,
50.9 × 61.2 cm. (20 × 24 in.) Manchester City
Art Galleries. Almost without realizing it, in his
headlong thrust towards the Neo-Impressionism
of *A Summer's Evening* (Plate 78) Steer created in
Summer at Cowes a work which fully measures up
to the Argenteuil riverscapes of Monet and
Renoir. Here the surface consists of an open
hatchwork of brush marks with little evidence of
a basis in drawing and tone.

connoisseurship – 'real quality, like style in literature, is the result of complete knowledge of the subject treated, and of simplicity and directness in the treatment.' His mentors in this were Whistler and Sir Frederic Leighton. Sickert then proceeded to make the connection with Impressionism. He admitted that the word had an elastic meaning, but at the same time declined to sum up 'the aims of painters so varied in their intentions as the present group'. Nevertheless, Impressionism could be negatively defined.

> Essentially and firstly it is not realism. It has no wish to record anything merely because it exists . . . it accepts, as the aim of the picture, what Edgar Allan Poe asserts to be the sole legitimate province of the poem, beauty. It is . . . strong in the belief that for those who live in the most wonderful city in the world, the most fruitful course of study lies in a persistent effort to render the magic and the poetry which they daily see around them . . .[17]

Beauty, magic, poetry; these are the words which Sickert uses to define his idea of Impressionism. It is a language of mystification, describing a visual language addressed to the *cognoscenti*. There is nothing in Sickert's essay about simultaneous contrasts of colour; nothing about light and atmosphere; nothing about the touch of the brush corresponding to sensations felt in front of nature. There is, however, an insistence upon the urban metropolis as the essential provider of stimulus. These were *London* Impressionists at a time when Paris, in the wake of the Exposition Universelle, was undisputedly *la capitale de l'art*.[18] Yet even this claim was not totally watertight. Aside from Sickert's music hall pictures, Roussel and his pupil, Paul Maitland, exhibited Whistlerian views of Chelsea. Starr and

81
Albert Ludovici jun.
(1852–1932).

A Busy Street, n.d. Oil on panel, 28 × 11.5 cm. (11 × 4½ in.) Richard Green Galleries. During the 1890s Ludovici and Blanche specialized in London street scenes. This tiny panel, possibly painted in the environs of Regent's Park, typifies Ludovici's shorthand.

82
Alexander Jamieson
(1873–1939).

The Construction of South Kensington Museum, n.d. Oil on canvas, 60.7 × 50.6 cm. (24 × 20 in.) David Messum Fine Paintings. Like Ludovici, Jamieson evolved his own shorthand, although in this instance it is used to portray the gaunt silhouette of the South Kensington Museum. This grey mass on a grim day is balanced by the tiny foreground *city atlas*, the passengers of which are fortified by black umbrellas. With this juxtaposition, Jamieson vividly portrays the emergent metropolis of the late Victorian and Edwardian era.

Thomson also showed London scenes, though Brown and Steer presented pictures from Walberswick and Montreuil, while Francis James in his twelve pictures drew subjects from Corsica, Italy and Cornwall. The incongruity of insisting upon the pictorial possibilities of the metropolis and in the same breath appealing to the authority of Sir Frederic Leighton was not lost upon the critic of *The Magazine of Art*. The puerility of Sickert's introduction and its emphasis upon the uniqueness of the group was rejected. In a further extensive criticism, a new periodical, *The Art Review*, preferred 'to shut one's ears to the manifesto with which this group of painters have chosen to burden themselves'. Accepting the experimental nature of the work on display in the main room of the Goupil Gallery, it found 'an unusual sense of the possibilities of the painting, of how the medium may be used to best advantage and what motives are best suited for artistic representation'. In this, the critic rejected the English preoccupation with High Art based on literary narrative.

> The legitimate artist does not aim at illusion making, nor has he anything in common with the photographer: his productions are, more often, the result of almost momentary impulse; they can have little topographical interest, since it is a phase of nature, and not a place that he attempts to portray. Even a very successful artist of this kind must meet with many failures, for the success of his endeavours depends more on the receptive capability at the time of production than on his adherence to recognized rules of picture-making.[19]

Here was the beginning of an understanding of the mutability of nature and the individual's receptive powers. There was at least an acceptance of the unusual and the unfinished. In order to gain fresh perception, it was necessary to suspend one's notions about what was exhibitable. These were the challenges of an exhibition of this kind. Sidney Starr, 'a too transitory meteor', showing *A City Atlas* (Plate 83), presented the back view of a young woman on the upper deck of an omnibus in St. John's Wood, taking in the kind of view which Degas greatly preferred.[20] It almost seems as though Starr was taking literally the advice of Edmond Duranty in *La Nouvelle Peinture*, when he declared that a back view, accurately perceived, should be as revealing of age and social status as a portrait. *The Art Review* approved of this as 'an example of a painter's independence of matters outside expression . . .' The texture of the woman's dress in *A City Atlas* is given in fanning strokes which imitate pastel, one of Starr's favourite media. Like many of the New English and Whistler followers, he contributed to the pastel exhibitions at the Grosvenor Gallery which had started in 1888. The medium links his 'London Impressionists' exhibit even closer to Degas. At that stage, it was seen as an instant way to obtain the surface vibration of colour associated with Impressionism.

Of the other exhibitors, Theodore Roussel and his pupil, Paul Maitland, were complimented for 'graceful handling'.[21] Eyes attuned to the frieze of Battersea warehouses in Whistler's nocturnes could only approve the greater legibility of the work of such painters. However, in his own terms, Roussel produced supremely meditative works which turned away from popular taste. The calm accumulation of marks and meditations characterized the work of the young Maitland, who was even more retiring than his teacher (Plate 56). In the end, Sickert came to the conviction that 'in the silent dialectic of the brush',

83
Sidney Starr
(1857–1925).

A City Atlas, 1889. Oil on canvas, 61 × 50.8 cm. (24 × 20 in.) Ottawa, National Gallery of Canada, Gift of Massey Foundation. A number of British artists, notably Clausen and Frederick Brown, tried to portray London life as if they were witnessing its bustle at pavement level. The upper deck of a city atlas, or horse-drawn omnibus, provided the unusual viewpoint for one of Starr's contributions to the London Impressionists' exhibition. In his handling and conception there are remarkable echoes of Monet and Degas.

Maitland was 'the more distinguished of the two'. His scenes in Kensington Gardens with their tall trees and frail distant figures provide the basis of a vision of the capital which slowly emerged in the twenty years after the London Impressionists' exhibition and gave belated approval to Sickert's speculations in the catalogue introduction (Plate 86). Jacques-Emile Blanche and Albert Ludovici (Plate 81) were to paint the parks and busy streets of the metropolis, while in one spectacular image, reminiscent of the grim Boston and New York cityscapes of Childe Hassam and John Sloan, Alexander Jamieson painted *The Construction of the South Kensington Museum* (Plate 82). Aerial views like this had their precedent not only in Monet's classic Impressionist canvases, but also in the Glasgow scenes of Nairn, Pringle and Lavery. This Baudelairean vision of a swarming city was fully realized, albeit in altered syntax, in Camden Town painting. The true *correspondance* of this vision was in the Arcadia of *A Summer's Evening*, the alternative world of Baudelaire's 'luxe, calme, et volupté'.

Back in 1889, there was some confidence in the view that the London

84
Philip Wilson Steer
(1860–1942).

On the Shore, 1890–94. Oil on panel, 21 × 27 cm. (8¼ × 10⅝ in.)
London, The Fine Art Society. The varied technique of *Knucklebones*
(Plate 79) was adopted for many smaller beach scenes painted by Steer
up to 1894. Although they were intended to be no more than swift
sketches, they reveal an extraordinary confidence and lucidity.

85
Lucien Pissarro
(1863–1944).

Jeanne, 1889. Oil on canvas, 73 × 59 cm. (28¾ × 23¼ in.) Richard
Green Galleries. Because of his proximity to the sources of Neo-
Impressionism, Lucien Pissarro had an undoubted advantage over his
English contemporaries. This did not stop him from admiring the
work of Steer and Sickert. Because it can be securely dated to 1889,
Jeanne provides the opportunity of comparison between advanced
styles in France and England. No English painter, including Steer,
achieved its density of surface.

**86
Paul Maitland**
(1869–1909).

Kensington Gardens, Afternoon Haze, n.d. Oil on canvas, 63.5 × 76 cm. (25 × 30 in.) Fine Art Society. Having begun his career by representing Battersea Reach and the streets of Chelsea in a Whistlerian manner, Maitland spent the rest of his life perfecting his observations. His delicate distant figures and tall trees recall the work of the *petits-maîtres* of the *école de St. Cloud*.

Impressionists were far from unique and that their exhibition did not sum up all of the Impressionist tendencies which had already emerged. Although it was accepted 'if only by way of indicating the tendencies of modern art', the exhibition was seen by *The Times* as little more than a collection of the work of followers of Degas, Monet and Whistler. Impressionism continued to be bound up vaguely with these three personalities and it was difficult to obtain any definition which did justice to all. Even Steer, in his work and in his recorded utterances, presents a bewildering set of variations. He too was obsessed by an idea of poetry. When called upon to address the Art Workers' Guild in 1891, he declared that,

> Impressionism has always existed from the time when Phidias sculptured the Parthenon frieze . . . Impressionism is of no country and of no period, it has been from the beginning; it bears the same relation to painting that poetry does to journalism. Two men paint the same model; one creates a poem, the other is satisfied with recording facts . . .[22]

What can be made of this absurdity? Jacques-Emile Blanche acutely observed that Steer had the air of being upset if he had to give an opinion. One can certainly imagine him feeling uncomfortable in having to explain Impressionism to what might have been a group of followers of Morris, but perhaps the unintended strategy worked and he was able to leave the stage secure in the knowledge that if his audience did not already have an understanding of Impressionism, they would be none the wiser. The only element of his oration which might have awakened dissenting voices was his heavy reliance upon Whistler's 'Ten O'Clock' lecture. This concluded with a memorable allusion to

the 'marbles of the Parthenon' and 'the fan of Hokusai'. Such elevated poetic thoughts of Whistler's were possibly better than any Steer could hope to commit to paper – but not to canvas.

During the years between the London Impressionists' exhibition and his own solo exhibition at the Goupil Gallery in 1894, Steer's work almost defies cataloguing. It appears that the painter worked in a number of different styles simultaneously. Steer's many small beach scenes, painted between 1888 and 1894, make the viewer even more acutely aware of a painter who, unlike Seurat and the Neo-Impressionists, studied appearances until he could conceive of an appropriate method to represent them. Figures are blobbed in, the sea is smeared in creamy horizontal strokes and the sand or stones are stippled in works such as *On the Shore* (Plate 84), *Boats on Southwold Beach* and *Sur la Plage, Boulogne*. Some of the most appealing Impressionist works – the tiny panels of Boudin, for instance – revealed the new phenomena of tourism and sea-bathing on the Normandy coast. Paintings by Blanche, Ludovici, Roussel and others provide equivalents to these works. One of Sickert's first oil paintings was a scene of this kind, studied through binoculars from his hotel window at St. Ives. But it was in Steer's small oil panels that the possibility of a new relationship between sensation and expression emerged.

This was independently corroborated by Lucien Pissarro. By 1890, Camille Pissarro's son already had an avant-garde reputation. In the previous year, he had exhibited the portrait of his younger sister, *Jeanne* (Plate 85), at the Salon des Indépendants. Although it was badly hung and did not live up to his father's counsel of perfection, this picture revealed a formidable grasp of the new technique. Red/green contrasts predominate and colours are intensified at contours. Having attained such an understanding, Lucien, who moved to London in 1890, reported his impatience with the English Impressionists. He recorded his views of the Art Workers' Guild meeting in May 1891 in a letter to his father:

> . . . at the club the speakers were young men from the New English Art Club. In other words English Impressionists. They spoke as if they did not know the first thing about Impressionism, they are artists who paint flat and have black on the palette . . .[23]

Lucien apparently weighed in to explain some of the scientific principles of Impressionism. Afterwards the young Pissarro met Steer and Sickert, 'a young man who knows Degas'. Of the two it was Steer who merited longer consideration – 'he separates the tones as we do and is very intelligent: here is at last an artist. Only he has doubts because the others make fun of him . . .' Steer, perhaps diplomatically, told Lucien that he preferred Pissarro's work to that of Monet. Seen in the context of the debate about the nature of Impressionism, Steer's doubts and hesitations can be condoned. The issues were not resolved around 1890 and to some extent they would never be.

CHAPTER FIVE

'Seeds from a ruined garden'

In 1890 the Glasgow School emerged before a London audience at the last exhibition of the Grosvenor Gallery. The painters who comprised this group had been exhibiting together at the Glasgow Art Club and the Glasgow Institute of Fine Arts since the mid-1880s. The emphasis upon this city of 'cotton mills, shipbuilding yards and philanthropic efforts' may at first seem equivalent to Sickert's insistence upon London as the essential stimulus to Impressionism in England.[1] It takes on a different connotation when, in the eyes of the world, Edinburgh was seen to monopolize 'literature, music and the arts of design' in Scotland. Having been trained in Paris, the members of the Glasgow School had more in common initially with the Newlyn painters than the London Impressionists, though unlike their contemporaries south of the border, they did not devote themselves to representing the life of a particular community. Only Lavery, acting as 'artist in residence' to the Glasgow International Exhibition, had produced images which arguably reinforced the distinctive claim of Scotland's second capital. Glasgow, in the comfortable saloon of its Art Club, provided the meeting place, and from here the ascendency of the Royal Scottish Academy in Edinburgh was challenged. The West of Scotland painters had common cause with their contemporaries in the New English Art Club. Lavery, Walton, J. E. Christie and Alexander Mann had been admitted to the ranks of the New English when the membership was extended in 1887, but aside from isolated pictures in mixed exhibitions, there was no concentrated showing outside Scotland before the one at the Grosvenor Gallery. For this special occasion, important early paintings by members of the group were drawn together and these included Guthrie's *Pastoral*, Lavery's *Dawn after the Battle of Langside*, and the product of George Henry's and Edward Atkinson Hornel's recent collaboration, *The Druids* (Plate 88). Although surrounded by a miscellany of over three hundred works, the pictures were sufficiently distinctive to command the attention of two German artists who were in London, talent-scouting for the forthcoming Munich Glaspalast Exhibition. So it was that the Grosvenor pictures, augmented by others, were given a room to themselves in Munich. Richard Muther, in his *History of Modern Painting*, vividly recalled the 'powerful effect' of the 'Scotch Gallery' at the exhibition.[2] The display appealed to the German audience for its romance, its 'sonorous fantasies of colour', 'its poetic dreams of a wild world of legend', contrasting sharply with a milieu then 'under the spell of Manet', recognizing the highest aim of art as 'objective reproduction of an impression of nature'.

The Glasgow School was thus set up in opposition to Impressionism as something which had developed to engage the deeper truths of the mystical and the decorative. A different kind of language had evolved in Scotland from the *premier coup* painting of the Atelier Julian. George Henry's *Spring* (Plate 89), one of a sequence of *The Seasons*, took some of the implications of Sargent's *Carnation, Lily, Lily, Rose* and tried to make them more explicit in decorative and aesthetic terms. The youthful female embodiment of Spring in this rendition is a modern dryad, smothered with blossom. This vague symbolism became almost a commonplace in Scottish painting of the 1890s in the work of Park, Gauld and Yule. The most obvious exponent of this type of painting was Edward Atkinson Hornel. In 1891, his *The Dance of Spring* and *Midsummer* (Plate 90) accentuated a mosaic of decorative dabs of colour which has more in common with Nabi and Neo-Impressionist painting than with Manet or Monet. Its true synthesis was achieved in 1894 when Henry and Hornel visited Japan.[3] The resulting pictures

87
Edward Atkinson Hornel
(1864–1933).

Japanese Dancing Girls, c. 1894. Oil on canvas, 71 × 91.2 cm. (28 × 36 in.) Glasgow, Ewan Mundy Fine Art. Both Henry and Hornel found confirmation of their tendencies towards a primitive exoticism in the Orient. Their Japan was not one of serene nocturnes of Mount Fuji, so much as a world of clashing colours and rhythms seen particularly in paintings like *Japanese Dancing Girls*.

have none of the tentative quality of Whistler; they are robust and self-confident in handling and strongly coloured. The surface design of lanterns, costumes, fans and parasols in *Kite-Flying* and *Japanese Dancing Girls* (Plate 87) reached such a complexity that Western conventions of light and shade were rendered redundant, in striking contrast to the earlier efforts of Menpes.

It would be wrong, however, to accept Muther's analysis totally. Although the newer Glasgow painters arrived quickly at a rich decorative manner, the founder members of the School, like Lavery, Guthrie, Walton and Roche, continued to rely upon direct visual stimulus. Guthrie, provoked perhaps by the substantial incursion of the French Society of Pastellists into the Grosvenor Gallery's first pastel exhibition in October 1888, experimented with the medium. At Helensburgh, he produced a series of drawings of dark, firelit rooms, which contrast with sunny exteriors such as *Tennis* and *The Morning Walk* (Plate 91). The speedy response to fleeting circumstances demanded by this new medium led Guthrie to the height of his Impressionism in *Midsummer* (Plate 92).[4] Though in later years, swamped by society portraits, he considered this an uncharacteristic work, there can be little doubt that his aberration of 1892 produced one of the most confident pieces of British Impressionism. *Midsummer* has little in common with Hornel's picture of the previous year. It shows Maggie Hamilton, Hannah

88
George Henry
(1859–1943)
and Edward Atkinson Hornel
(1864–1933).

The Druids: Bringing in the Mistletoe, 1890. Oil on canvas, 152.4 × 152.4 cm. (60⅛ × 60⅛ in.) Glasgow Art Gallery and Museum. Around 1890 there was a clear possibility that radical painting in Scotland would bypass Impressionism in the search for decorative effects and mystical subject matter. In works like *The Druids*, rich colour coupled with surface embellishments were intended to give the work an iconic quality which was closer in purpose to Symbolist painting.

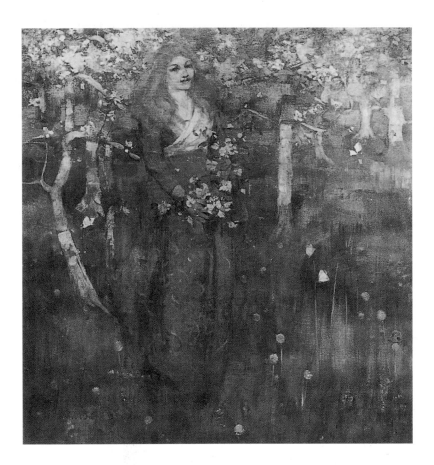

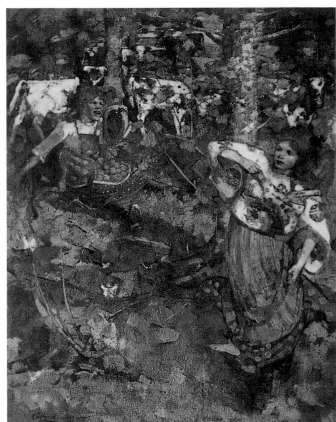

Walton and a companion taking tea in the garden of Thorton Lodge, Helensburgh. The resulting image drew rapturous enthusiasm from George Moore who saw it as

> . . . Summer's very moment of complete efflorescence; a bower of limpid green, here and there interwoven with red flowers. And three ladies are there with their tiny Japanese tea-table. One dress – that on the left – is white, like a lily, drenched with green shadows; the dress on the right is purple, beautiful as the depth of foxglove bells. A delicate and yet full sensation of the beauty of modern life, from which all grossness has been omitted . . .[5]

Reacting to the subtle yet no less spontaneous response to local colour in Guthrie's ensemble, James L. Caw later observed that 'the devils of crude green and positive purple which possessed much modern painting at that time were here . . . transformed into ministering angels of beauty.'[6] Regrets were expressed that Guthrie did not exploit more fully the Impressionism of *Midsummer*, but in a sense its uniqueness was part of its strength. Like *Carnation, Lily, Lily, Rose* and Steer's *A Summer's Evening*, it brought the intimate engagement in studies and sketches up to the level of public performance.

From 1889, Lavery was involved in comparable investigations, although perhaps his most closely parallel work, *A Garden in France* (Plate 95), was not painted until 1897. Though he effectively submerged his figures in foliage, Lavery did not move towards decorative abstraction, so much as study the irregular fall of

89
George Henry
(1859–1943)

(Left) *Spring*, c. 1888. Oil on canvas, 115 × 107.3 cm. (45¼ × 42¼ in.) Paisley, Renfrew District Museums and Art Galleries. In 1888 Henry painted a sequence of pictures on the four seasons. These were his first works to combine Impressionist effects with a decorative purpose. They therefore reveal the connection, readily made by some British artists, between Impressionism and a range of diverse surface characteristics.

90
Edward Atkinson Hornel
(1864–1933).

The Dance of Spring and Midsummer, 1891. Oil on canvas, 127 × 101.5 cm. (50⅛ × 40 in.) Liverpool, National Museums and Galleries on Merseyside. Hornel's colourful decorative style reserved detail for focal points of human interest in pictures like *Midsummer*. As in *The Druids* (Plate 88), he constantly made use of heraldic devices which, coupled with peasant costume, was intended to establish a primitive context for his work.

91
James Guthrie
(1859–1930).

The Morning Walk, c. 1890. Pastel on paper, 49.4 × 24 cm. (19½ × 9½ in.). David Messum Fine Paintings. Affected by the revival of interest in pastel, James Guthrie produced a series of works in this medium around 1890. These range from firelight interiors to pictures such as *The Morning Walk*. In these he, like Lavery before him, became a recorder of middle class life. The stylistic freedom of his pastels led Guthrie to a more colourful Impressionism than he had yet produced.

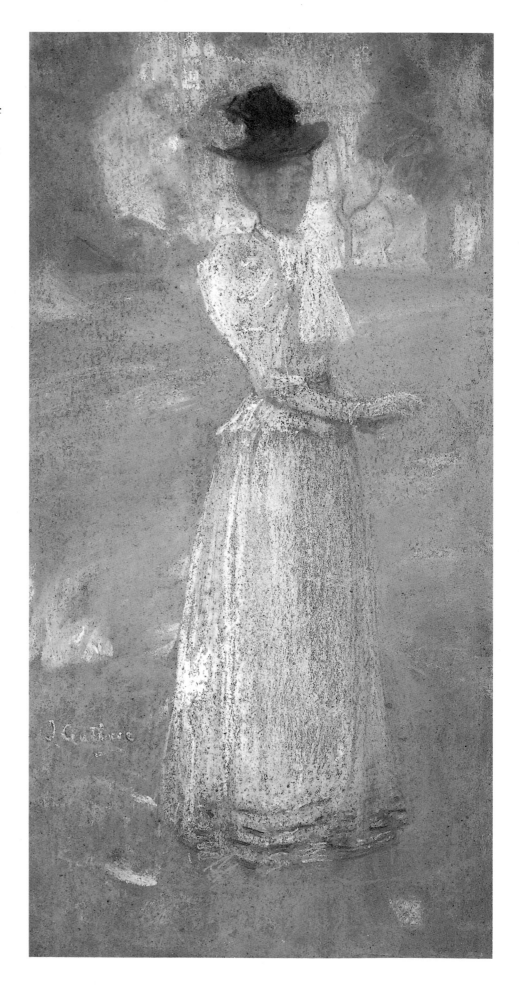

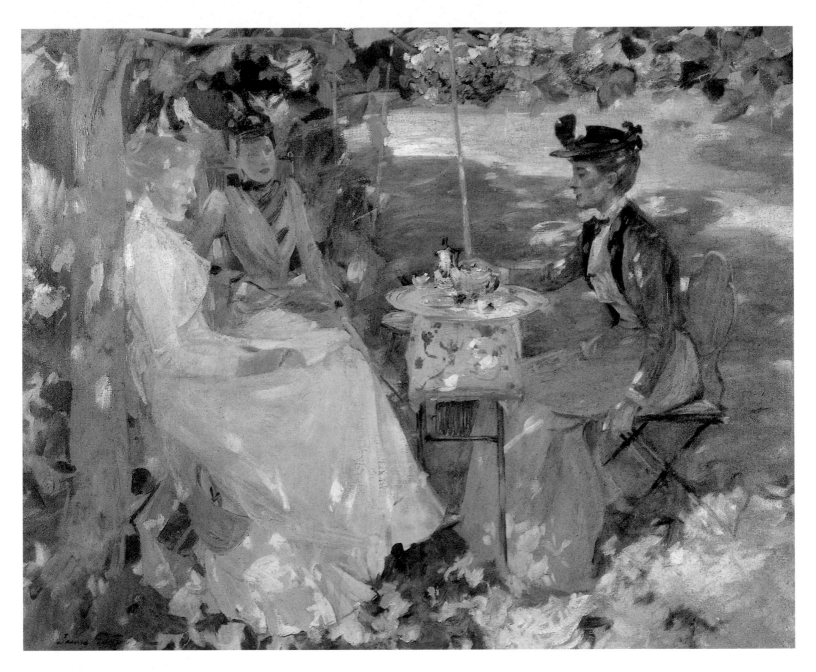

92
James Guthrie
(1859–1930).

Midsummer, 1892. Oil on canvas, 99 × 124.5 cm. (39 × 49 in.)
Edinburgh, Royal Scottish Academy. Experiments in pastel led directly
to *Midsummer*, an extraordinary work in James Guthrie's *oeuvre*. In
later years, and by comparison to his portraits of Edinburgh society, the
clashing greens and mauves of *Midsummer* seem superficial. Although
Guthrie failed to develop the strident Impressionism of 1892, it
nevertheless marks an important waystage in the development of
modern painting in Scotland.

light. In the sketch for *A Garden in France*, foreground plants have been swept away to reveal the trio of figures. Greater tension is evoked in the final version by almost obscuring the mother and child with flowering bushes, while, in a stroke of brilliance, a woman has been removed from the bench on the left. Background greens and browns are broadly brushed to provide the base for delicate tints of flowers and reflections. The return to Grez in 1897 and again in 1900 provided the opportunity for a more concentrated assimilation of Impressionism. The most important product of these visits was a final version of *The Bridge at Grez* (Plate 94), an Impressionist variant of a *plein air* composition which had been painted in 1883. It contains the same idyllic qualities as Sargent's boating parties. Yet as a familiar subject, being seen with fresh eyes, it assumed an authority beyond the narrow discussion of a technical mode of painting. The innate luxury and tranquillity of the broad slow-running stream transposed Impressionism into the archetypal imagery of the late Victorian summer.

The Impressionist exercises of Lavery, Guthrie, Walton and Roche must have seemed the more exceptional because they came from the hands of those who were primarily known as portraitists. All of the major figures of the Glasgow School produced stylish full-length portraits and saw themselves as followers of Whistler. In 1892, the ageing American expatriate had staged a solo exhibition in London at the Goupil Gallery. His reputation in the 1890s rested upon 'chevalet pieces' rather than nocturnes, and for these the principal inspiration was Velazquez. George Moore contended that Whistler's flowing and limpid execution 'was the result of the study of Velazquez'.[7] Around the Spanish master a mythology had grown. Jacques-Emile Blanche must have told his English associates of Manet's constant search for the mid-tone, the 'silvery mud' of Velazquez, Chardin and Corot. From this a powerful thesis on Impressionism in the 1890s was derived. The basic lesson to be learned from the Spanish court painter was the truth of the ensemble. This essential unity was seen as the basis of Impressionism. The belief that parts could be separately completed and combined was argued down. R.A.M. Stevenson declared that

> Those who have not been taught from the beginning in an impression-istic school must remember difficulties which beset them when they are working from nature . . . how often it seemed to them impossible to finish a picture. The more closely they applied themselves to study and complete a part, the more it seemed to change to their eyes, and to invalidate previous observations.[8]

To avoid remaining forever 'in the ante-room of preliminary changes' the painter must observe every part of a picture 'in subservience to the impression of the whole'. These views, taken from Stevenson's *Velasquez*, published in 1895, challenged British art educational principles. The Velazquez of the 1890s was the 'great Spanish impressionist'. He should be the starting point for all who wished to pick their way amongst the painters of 'instantaneous photographs, ugly subjects, rough unmodelled surfaces, blotches and blurs . . .'

Such a guide had not been available two years earlier when Sir George Reid, President of the Royal Scottish Academy, delivered a broadside on Impressionism in *The Westminster Gazette*. Although Muther was anxious to separate the Glasgow Boys from the orthodoxy of Manet, they were sufficiently close to be attacked as Impressionists. As well as gaining renown at major exhibitions

abroad, the group was exerting a stronger presence in Edinburgh. In 1889, for instance, Walton and Guthrie had been elected Associates of the Royal Scottish Academy, and Lavery was to follow in 1893. In attacking them, Sir George wished to see proper respect for the traditional disciplines of the painter's craft against which were now arrayed the 'empty superfluities' of the Impressionists. Realizing that there was good copy in this dispute, the editor of *The Art Journal* invited members of the Glasgow School to respond, but they, possibly because they had a vested interest in ultimate acceptance by the Academy, all declined.[9] Brown, Stott, Sickert and Clausen were among the respondents. For the most part, it was recognized that this dispute was as Brown described it 'the outcome of local party politics'. The debate about the new manner was not advanced, except in that several painters expressed the conviction that in painting impressions from nature, they were not producing impressions of other people's work. Francis Bate reiterated that 'English impressionism is not an imitation of anything French', it was 'no mushroom growth' but was traceable to the very roots of British painting. Here, as in Hercules Brabazon Brabazon's reply, was reference to early nineteenth-century precedents, rather than simple pastiches of Manet, Monet and Pissarro.

The appropriation of Brabazon by the New English Art Club in 1891 may be read as an effort to vindicate present tendencies by emphasizing venerable precedents. Brabazon, who had been painting watercolours, suddenly found himself the object of attention, hailed by MacColl as the successor to Turner, or 'raised from the dead' as 'our modern Lazarus' by George Moore. Brabazon's watercolours, shown at the Goupil Gallery in 1892, brought back a formidable English tradition in their blotchy masses.[10] The paint marks of his limpid *The Pink Palace* (Plate 93) almost detach themselves from the architecture they describe, in the same way as Sickert's nervous notation of the interior of St. Mark's in 1896 is an accumulation of dabs and spots. Brabazon had painted all of the picturesque sights: he had stood in Durham where Girtin stood, in Venice where Turner

94
John Lavery
(1856–1941).

The Bridge at Grez, 1900. Oil on canvas, 89.1 × 148.3 cm.
(35¼ × 58½ in.) Belfast, Ulster Museum. Lavery regarded the time he
spent at Grez in 1884 as the happiest in his life. When he returned to
the village around the turn of the century he was in part motivated by
the desire to recapture something of his youthful experience. Whilst
the early autumn idyll presented in *The Bridge at Grez* expresses this, it
also epitomizes in a single image, our shared conception of the *belle
époque*.

95
John Lavery
(1856–1941).

A Garden in France, 1897. Oil on canvas, 101 × 127 cm.
(39¾ × 50 in.) Private collection. Lavery, unlike Guthrie, did
successfully incorporate aspects of Impressionist handling into his style,
as is evident from a sequence of works painted during summers spent in
France at the end of the 1890s. Of these *A Garden in France* is the most
fully worked, in that it combines the hothouse atmosphere of lush
vegetation with the mood of relaxation and shared confidences passed
between his female subjects.

stood. These obvious echoes greatly appealed to critics who were taking Sickert's manifesto and making from it a strictly national form of Impressionism. Sickert's painting in the 1890s achieved ultimate lucidity upon such widely applauded locations as in *Nocturne: The Dogana and Santa Maria della Salute* (Plate 97). Images like this came forward to confirm Harry Quilter's reasons for self-congratulation. In 1892, when reprinting an essay on French art of nine years earlier, he declared in a footnote, 'impressionism is dead amongst the French (advanced) School, and has naturally found its home in England: like last year's Paris bonnets.' Quilter was evidently not prepared to hail the new phenomenon. George Moore in a florid flight of fancy, on the contrary, signified approval. 'Art', he claimed, 'has fallen in France, and the New English seems to me like a seed blown overseas from a ruined garden. It has caught English root, and already English colour and fragrance are in the flower.'[11]

English fragrance was located in those masters whom Brabazon evoked. 'The ruined garden' was not the rich floral pathway at Giverny, but the verdant alfresco chamber of Watteau. At the beginning of 1893, in exemplification of these beliefs, Steer painted *A Classic Landscape* (Plate 98), a view of Richmond Bridge. This picture bends Monet's texture to a crystalline Claudian atmosphere. The richly impasted foliage of works like Monet's *Effet d'Automne, Argenteuil* is linked by an eighteenth-century bridge and relegated to the middle distance by gaunt silhouettes of Whistler's Thames barges. It is not suprising that the painter of such a picture should refer to Reynolds' *Discourses* in the discussion of Impressionism. Steer believed that art was generally 'progressive' and had little to do with the endless repetition of formulae which meant commercial viability.[12] He did not, however, attempt to account publicly for the vagaries of his own practice. What must have been the conclusions drawn from a solo exhibition in 1894 which included the early Whistlerian *Lady in Grey*, the conventional *Sion House* and the dynamic Post-Impressionist *Girls Running, Walberswick Pier*? Steer seemed to map the borders of contemporary painting, to lay out the full range of possibilities without opting for any in particular. Indeed, the more *retardataire* his subject matter became, the more vociferously he was applauded. There can be little doubt that in *Girls Running, Walberswick Pier* (Plate 10), he achieved one of the most arresting British Impressionist images. This extraordinary composition with its gliding female figures has no comparison in contemporary painting. Its format loosely follows Alfred Hartley's *A Frolic* from the second New English exhibition, but here the village school girls, in hob-nail boots, have none of the weightless, butterfly presence of Steer's creations. For all its Post-Impressionist stipple, the picture, as Rothenstein indicated, aspires to visionary intensity.

The growing coherence in Steer's work after 1894, predicted in *A Classic Landscape*, replicates the consolidation of the New English Art Club. It seems obvious, but the exclusion of the Glasgow School in 1892 had made the Club appear more homogenous and conspicuously English. To one reviewer in *The Art Journal* it was apparent that in its tenth exhibition in 1893, the Club had matured and had become 'consistent in both beliefs and practices, and conscious not only of a mission, but of a policy as well'.[13] It was to be admitted that this also went hand in glove with increased conservatism. The periodical chose for its illustration what must have been the safest example, Charles Wellington Furse's *The Master of the Hounds*, a work which, with a little more finish, might easily slot into an Academy show. Bate, Steer and Sickert were all exhibiting portraits,

96
Charles Conder
(1868–1909).

The Moulin Rouge, 1890. Oil on panel,
25.6 × 34.1 cm. (10 × 13½ in.) Manchester City
Art Gallery. When he arrived in Paris in the
summer of 1890, Conder submerged himself in
the life of the city. The *Moulin Rouge*
commemorates 'a pleasant evening' spent in the
company of Charles Rothenstein. The picture
was, therefore, painted from memory, and its
rather stiff handling of figures recalls the
techniques of Australian plein-air painting with
which Conder originated.

whilst Monet exhibited three works along with 'admirable expressions' and 'well-selected "bits"' of landscape by the British contingent. The critical language was one of absorption. Even Monet at this stage was unlikely to raise eyebrows.

There were, however, changes around and about the Club which were to have a significant effect. Following Brabazon, a succession of new artists were introduced. These included older artists such as C. E. Holloway and William Lionel Wyllie who painted scenes of the river Thames. The addition of Charles Conder to the ranks was a more important event. Conder had spent his formative years in Australia, abandoning a career as a surveyor to join Tom Roberts's artists' camp at Eaglemont in 1887.[14] Roberts, in the early 1880s, had imbibed the lessons of *plein air* painting as a student in London. But the vivid on-the-spot sketches of Roberts must have seemed tame by comparison to the dynamic and colourful evocations of the Moulin Rouge by Toulouse Lautrec, whom Conder met shortly after his arrival in Paris in August 1890. On 30 October that year, he spent the evening at the Moulin Rouge with Charles, the elder brother of William Rothenstein (Plate 96). Conder was attracted to the reckless abandon of the dancers 'in their foamy lace, black stockings and flaming skirts', and commemorated the evening with a small oil sketch. While it contains some of

97
Walter Richard Sickert
(1860–1942).

Nocturne: the Dogana and Santa Maria della Salute, 1895. Oil on
canvas, 49.4 × 65.8 cm. (19½ × 25⅞ in.) Glasgow, Ewan Mundy Fine
Art. Sickert visited Venice in the summer of 1895 where he produced
a number of extraordinarily lucid canvases. The light atmosphere and
limpid reflections of the city impressed him, and he found – working
upon well-tested motifs – the ability to reconcile tendencies derived
from both Monet and Whistler.

98
Philip Wilson Steer
(1860–1942).

A Classic Landscape, Richmond, 1893. Oil on canvas, 60.8 × 76 cm.
(24 × 30 in.) London, Chris Beetles Ltd. *A Classic Landscape,*
Richmond is one of the most important canvases painted by Philip
Wilson Steer in the early 1890s. Not only does it indicate his
exploration of turn-of-the-nineteenth-century traditions, it presages a
growing desire to revive those same traditions. Whilst he was not alone
in this, as with Impressionism, his understanding betrayed a prodigious
visual intuition, rather than a theoretical or cultural understanding.

99
Henri de Toulouse-Lautrec
(1864–1901).

Charles Conder, 1893. Oil on canvas,
48.5 × 37.3 cm. (19 × 14¾ in.) Aberdeen Art
Gallery.

100
Charles Conder
(1868–1909).

La Plage, c. 1900. Oil on canvas, 34 × 49.5 cm.
(13⅜ × 19½ in.) Unlocated. By the turn of the
century, after he had made many designs for fans,
and painted decorations for Siegfried Bing's
Maison de l'Art Nouveau, Conder's beach scenes
became more like eighteenth-century *fêtes
champêtres*.

the verve of Lautrec's definitive descriptions of such scenes, the picture, in spite of Conder's legendary Baudelairean debauchery, seems exceptional. The painter found his *métier* more in landscape and coastal scenes in the environs of Dieppe or on the Seine near Giverny. Although Lautrec painted his portrait (Plate 99) and included him in the background of *Two Waltzers at the Moulin Rouge*, to Conder it was the dreamy sunlit beach at Yport, the strand at Dieppe, the flowering orchard at Vetheuil or the struggles of the lone fisherman on the banks of the Epte (Plate 105) which really fired his imagination. Conder was arguably more impressed by his meeting with D. S. MacColl in 1892 than by his contact with the 'dwarf of Velazquez' – as Lautrec was described by William Rothenstein. MacColl may well have aroused Conder's interest in the art of the *fête galante*. As they emerged in the early years of the century, Conder's busy beach scenes, painted at Newquay (Plate 100), assumed a luxury and sensuous langour which was to be a vindication of the emergent view of Impressionism as well as an expression of the 'hot-house atmosphere of the decadence'.[15]

Conder's closest companion in these years was William Rothenstein, a young painter who had studied at the Slade under Legros before setting off for Paris.[16] Little survives of Rothenstein's early pastels, though right at the end of his Paris sojourn, after staging a small exhibition on the Boulevard Malesherbes in April 1892, important contacts were made. Lucien Pissarro, for instance, introduced Rothenstein to his father, Camille, and Rothenstein also received an invitation to Degas' studio. In Paris, he did not escape the orbit of Whistler, and it may be that Degas and Whistler between them dissuaded Rothenstein from returning to Giverny to paint landscapes. Certainly after he was reinstalled in London, Rothenstein produced an image in *The Coster Girls* (Plate 101) which relied heavily upon the examples of Degas and Whistler. These somewhat Hogarthian types were drawn with the confident naturalism of Degas in a Thames-side ambiance, reliant upon Whistler.

Other new arrivals at the New English Art Club confirmed the pre-eminence of Degas in the representation of city life. In 1892, Alphonse Legros had retired after sixteen years service as Professor of Fine Art at the Slade School. He was replaced by Fred Brown, who immediately installed Steer and Henry Tonks as his assistants. Tonks had already been a pupil of Brown's at the Westminster School of Art, but he had the added authority of being Demonstrator in Anatomy at London Hospital Medical School.[17] He joined the New English in 1891 and it was clear from his earliest works that Tonks' belief in the efficacy of drawing was heavily influenced by what he had learnt about Degas. It is impossible to imagine that works like *The Hat Shop* (Plate 103) were not inspired by Degas' images of *modistes*. This being the case, it is possible to see just how close the paintings of Rothenstein and Tonks were to courting controversy, simply by association. In London, in 1892 and 1893, Degas was a byword for 'vulgar, boozy, sottish, loathsome, revolting, ugly, besotted, degraded, repulsive . . .' subject matter.

In February 1892 Captain Hill's pictures were consigned to Christie's, and amongst the lots was Degas' *L'Absinthe*.[18] It was purchased by the Glasgow dealer Alexander Reid, as the rest of the occupants of the saleroom hissed. Reid passed it on quickly to the collector Arthur Kay. Kay, in turn, was then invited to lend the painting to an exhibition at the Grafton Galleries in March the following year, where 'by error or by devilment' its original title was altered to the more explicit one by which it is now popularly known. It was taken as an offence to

101
William Rothenstein
(1872–1945).

The Coster Girls, 1894. Oil on canvas, 100.6 × 75.8 cm.
(39½ × 30 in.) Sheffield City Art Galleries. Like Sickert, Rothenstein
was struggling to reconcile the conflicting claims of Degas and Whistler
in the 1890s. His academic background demanded that he achieve a
sophisticated naturalism, even in early experimental works such as
The Coster Girls.

102
Walter Richard Sickert
(1860–1942).

L'Hôtel Royal, Dieppe, 1894. Oil on canvas, 50 × 61 cm.
(19¾ × 24 in.) Private collection. Sickert painted the old Hotel Royal
at Dieppe on several occasions during the 1890s. In the first version
(Plate 104) the foreground is punctuated by figures dressed in
crinolines, possibly in recollection of Canaletto, Longhi or the French
rococo lifestyle which currently fascinated his pupil Aubrey Beardsley.
The present canvas, closely related to this composition, was probably
painted on 14 July 1894, when Jacque-Emile Blanche recalled the
British painter working in to the evening in a 'violet mist'.

103
Henry Tonks
(1862–1937).

The Hat Shop, c. 1895. Oil on canvas, 67.7 × 92.7 cm. (26⅔ × 36½ in.) Birmingham City Museum and Art Gallery. Tonks' *The Hat Shop* immediately calls to mind Degas' studies of *modistes* of the early 1880s. Where these were often executed in pastel and were thus vividly coloured, Tonks' picture is more of a tone study. The general manipulation of space, however, as well as figure-to-field relationships, equally refers to Degas' paintings of ballet rehearsals, with which the painter would have been familiar.

public morals in its portrayal of 'two rather sodden people drinking in a cafe'. MacColl protested the aesthetic beauty of the subject, while George Moore was riled by the pronouncements of Walter Crane and William Blake Richmond that human degradation was portrayed without even the attributes of craftsmanship. 'No doubt impressionism is an expression in painting of the deplorable side of modern art,' Richmond pompously concluded. The hapless painter was then treated to Moore's correction that Degas was not, of course, an Impressionist, though he might have 'once or twice exhibited with Monet and his followers'. He was emphatically the descendant of Ingres, convinced of the probity of draughtsmanship, a student of the human figure and not landscape. In spite of minor inaccuracies, the criticism does give evidence of the awareness of different goals amongst the Impressionist group. Moore constantly emphasized the conflicts of personality amongst those who frequented the Café de la Rochefoucauld and the Nouvelle Athènes. Yet the full message of *L'Absinthe*, its tense organization, its *ennui*, did open the door to a number of serious British interpretations of the potential drama of human relationships. Rothenstein's *The*

Doll's House and his brother, Albert Rutherston's *Confessions of Claude*, both have obvious literary sources, while the early interiors of Orpen and McEvoy revive particular theatrical effects. Yet only Sickert took in the full significance of *L'Absinthe*, and then only around 1910 when Camden Town public houses provided the setting for low-life dramas.

At that time, Sickert's attention was momentarily turned to the exterior of the Hôtel Royal at Dieppe. He was absorbed by the idea of ladies in crinolines, parading in front of its long, featureless facade, in an evocation of the Second Empire or the ancien régime (Plate104). As with many of Sickert's early works, the resulting image is known only from a poor reproduction, but this is enough to emphasize its singularity, as a bizarre anticipation of the 1930s, when he turned to old engravings for visual stimulus. Its archaisms were, however, highly significant as an expression of the stylistic preferences which were emerging in 1893, the year in which it was shown at the New English Art Club. Ostensibly, the version of *L'Hôtel Royal* shown the following year is more orthodox (Plate 102).[19] It is recognizable from Jacques-Emile Blanche's recollections, as the product of sketches made on the day of the national fête, 14 July. He remembered that he had driven off 'the rag-tag and bob-tail who were making fun of his painting'. The experience was the more vivid because as Sickert worked, the moon rose in a violet mist. Those moments of changing light at nightfall bewitched Sickert, as they had done Monet and Sargent. These were the effects to which he was drawn on his visit to Venice in 1895. En route, he could well have had the opportunity to study the record of fugitive light effects at an exhibition of Monet's pictures of Rouen cathedral at Durand-Ruel's gallery in Paris in May 1895. It is certainly the case that after his arrival in Venice, Sickert wished more than ever before to work in series. Four versions of the *Facade of St.*

104
Walter Richard Sickert
(1860–1942).

L'Hôtel Royal, Dieppe, 1893. Destroyed.

105
Charles Conder
(1868–1909).

Scene on the Epte, c. 1894. Oil on canvas, 45.5 × 53.2 cm.
(18 × 21 in.) Unlocated. Conder quickly absorbed the lessons of
French Impressionism in pictures of blossoming orchards at Vetheuil
and on the Epte. Whilst the effects upon which he concentrated are
often reminiscent of those of Monet and Van Gogh, he did
occasionally produce works which are dramatically vivid such as *Scene
on the Epte*.

106
Philip Wilson Steer
(1860–1942).

The Embarkment, 1900. Oil on canvas, 55.8 × 69 cm. (22 × 27¼ in.)
Manchester City Art Galleries. The heavy brushwork of Steer's *The
Embarkment* reveals a further period of stylistic experimentation around
1900. Having collected three works by Adolphe Monticelli, he was
fascinated by the reworking of eighteenth-century themes in
Monticelli's rich decorative impasto. There is however a light airiness
about *The Embarkment* which pays due regard to Monticelli's
inspiration in the work of Watteau and Fragonard.

Mark's were produced *in situ* and another four were painted after his return to London. At the same time, three versions of *The Dogana and Santa Maria Della Salute* were painted, two of which were nocturnes. It is important to stress, however, the difference of purpose between Monet's use of dry crumbly pigment to record the directions and strengths of moving sunlight upon the ornate cathedral front and Sickert's free-running and speedy execution. He was, as he wrote to Steer, trying 'to see the thing all at once. To work open and loose, freely, with a full brush and full colour. And to understand that when, with that full colour, the drawing has been got, the picture is done.' This goal – to arrive at drawing – can be perfectly understood in *The Interior of St. Mark's* (Plate 107), where the dark cavernous vaults are hollowed out with hatching brushstrokes in a swift reaction to architectural space.

Sickert's temporary excursion into artifice in 1893 was paralleled in Steer's *A Classic Landscape*. The logical extension of the implications of this had a more profound effect upon Steer. Nude studies in the manner of Boucher and Fragonard coexist with densely impasted *sous bois* picnics and boating parties. *The Embarkment* (Plate 106) is a typical example of this genre, taken to reveal the passing influence of Monticelli in its heavy pigment. But there is at least a suggestion in Steer's distant figures embarking in punts on the river at Knaresborough, that they are bound for the ideal world of Cythera. This eclogue is complemented by imposing views of Richmond, Chepstow and Ludlow castles, calling to mind the high poetry of the romantic movement. The marvellous lucidity which Impressionism had set free, is applied to familiar, almost predictable vistas, with remarkable results. It is as if, having been given the subject matter, Steer could now be directly expressive. His inconsistent sweeps and splodges of paint proposed a direct relationship between perception, feeling and the act of realization. In this, he became, by one set of definitions, more truly Impressionist than he had been when painting the sand spits of Walberswick.

107
Walter Richard Sickert
(1860–1942).

The Interior of St Mark's, 1895. Oil on canvas, 69.9 × 49.2 cm. (27½ × 19⅜ in.) London, Trustees of the Tate Gallery. Having rehearsed the eighteenth-century civilities of Venetian painting in the first version of *L'Hôtel Royal, Dieppe*, Sickert's Venetian summer of 1895 led him to less premeditated responses to the environment. *The Interior of St Mark's* was swiftly noted in a fluent sketch which was to be the basis of numerous later pictures in Venice, Dieppe and Camden Town.

Exhibition-piece Impressionism

The evidence of this period provides a view much in keeping with Frank Rutter's recollections. Although the younger generation had learned to distinguish between Monet's 'luminism' and the breadth of vision required by Velazquez, these approaches existed coincidentally. 'In England, at all events,' Rutter concluded, 'impressionism meant Whistler.'[1] This is not as limited as it sounds. The literature of art during the period, especially in new cosmopolitan periodicals like *The Studio*, addressed wider issues. In Paris the Rosicrucian Salons, Symbolism, the Nabis and the development of *art nouveau* – courtesy of the entrepreneurial activities of Siegfried Bing – caught up painters such as Conder and Brangwyn. Extending beyond the modernist map to the salons of the Champ de Mars and the Champs-Elysées an even more bewildering array of approaches was visible. In the latter, the conservative Société des Artistes Français, there was a heavy reliance upon big naturalistic genre pieces, while at the breakaway Société Nationale des Beaux Arts amongst the reverent followers of Puvis de Chavannes, Cazin, Aman-Jean and Carrière, there continued to be some debate about 'the Ideal' and 'the Beautiful'.

The awareness in *The Studio* that there were things to talk about other than Impressionism had the result of encouraging its consolidation in Britain. Nevertheless, the temptation remained to label everything new as 'Impressionist', even if it did not neatly fit into either of Rutter's categories. The powerful central force of consensus was provided by the successful establishment in London of such leading members of the Glasgow School as Lavery and Walton. These painters were already international names. From 1896 onwards they worked towards the foundation of an exhibiting society with a larger brief than the New English and they called upon Whistler, now resident in Paris, to act as their president. Whistler took this as proof of his acceptance by the younger generation. His biographers record that he once said, 'the New English Art Club was "only a raft", while the International was to be a "battleship" of which he could take command.'[2] In 1898 the first exhibition of what became known as the International Society of Sculptors, Painters and Gravers was staged. Although artists like Klinger, Zorn, Thaulow, Besnard, Aman-Jean, Thoma and Segantini were represented, the core of the exhibition was provided by the Glasgow School. Much discussion was devoted to the Degas, the Monet and the two early works by Manet which were included. Since the Manets and one or two of the Whistlers dated from the 1860s, these canvases looked increasingly Old Masterish and they confirmed the commonly held belief in Velazquez as the mentor of the modern movement. Manet's paintings made everything else, in MacColl's eyes, seen 'thin, flat, uncertain and void of substance'.[3]

Such an emphasis upon the 1860s, when something had been 'lost', smoothed out the diversity of contemporary painting and diluted the effect of the more extreme styles. The dominance of Velazquez-inspired portraiture explains the reaction of Bonnard and Vuillard when they visited the second International Exhibition. 'Why do all these people want to paint Old Masters?' they asked.[4] The vivacity of British landscapists was not enough to correct the general impression. At the same time, it is difficult to know why painters at the International, such as Walton, Priestman, Hornel and Paterson, would not have been acceptable in the Royal Academy, apart from the fact that they, in each case, continued to be outsiders. Indeed the rules of the International demanded

108
Walter Osborne
(1859–1903).

The Birthday Party, 1900. Oil on canvas, 61.5 × 76 cm. (24¼ × 30 in.) Private collection. In its extravagant use of paper lanterns Osborne's *The Birthday Party* obviously echoes Sargent's *Carnation, Lily, Lily, Rose* (Plate 1). But there the comparison ends. Osborne's children are seated around a table taking part in what might be a birthday tea. The swiftly brushed mauves and cerises create an almost synthetic effect which was subdued in works like Llewellyn's *A Winter Night* (Plate 47) and the pastels of Guthrie.

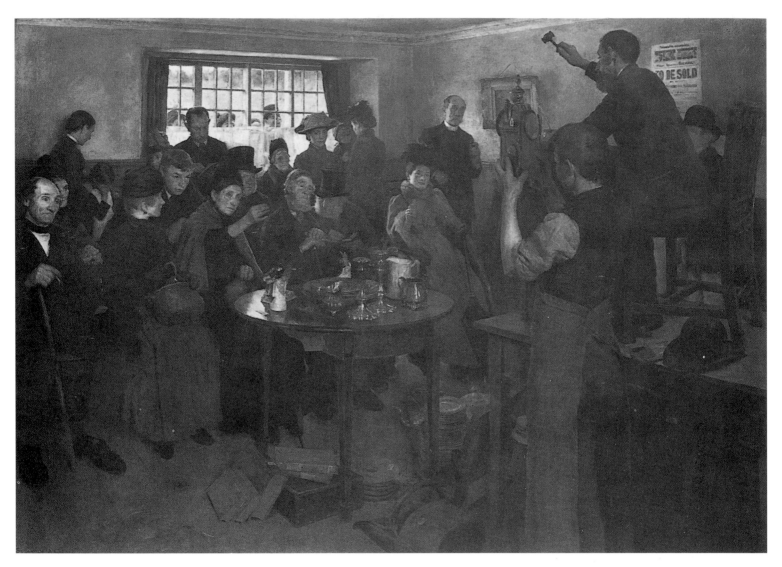

109
Stanhope Alexander Forbes
(1857–1947)

By Order of the Court, 1890. Oil on canvas,
60 × 80.5 cm. (23²⁄₃ × 31²⁄₃ in.) Liverpool,
National Museums and Galleries on Merseyside.
An auction sale provides the occasion for one of
Stanhope Forbes' most accomplished exercises in
modern naturalism. The picture was, he later
recalled, to some extant autobiographical since in
the early years of his marriage he frequently
attended such events. The real drama on these
occasions was in the audience, the character,
gesture and disjointed action of which Forbes set
about observing accurately.

that they be so. Materially their painting was, however, not greatly different from
that of landscapists who had already been subsumed.

By the end of the 1890s, there was as much Impressionism in the International
Society and the Royal Academy as there was in the New English Art Club.
Sickert's efforts to excise the conservative naturalist painters led to the Club
losing its impact. Only the Slade generation of John, Orpen and McEvoy would
bring it back into prominence, though these painters, in company with Steer,
Tonks and Rothenstein, proposed what was in effect an alternative academicism.
Seeing clearly the nature of the dispute between modern life and landscape
Impressionism, there were claims and counter-claims to be weighed in the
balance. Stanhope Forbes, whose monumental interiors were shown at the Royal
Academy from 1888 onwards, articulated his own view of modern life. He
claimed 'simplicity and directness' in setting out what he saw. Responding to the
criticism that such pictures as *The Health of the Bride* and *By Order of the Court*
(Plate 109) were 'laboured' and contained characters who were 'mostly ugly',
Forbes asserted that everything had its own beauty. One could not be dismissive.
His modern life was not that of the urban metropolis viewed through

Baudelairean spectacles. He would have read Sickert's declaration that London Impressionism was specifically not the 'struggle to make intensely real and solid the sordid and superficial details' of the scene as a thinly veiled attack. For his part, he would have scorned Sickert's appeal to 'magic' and 'poetry'. Forbes had gained enough 'exact science' to be able to paint what in nature was evanescent. Degas had reached such heights, and Degas – the readers of *The Magazine of Art* were told – was 'one of the painters whose work Mr. Forbes sees to be good'.[5] In view of Sickert's and Moore's appropriation of Degas, this seems extraordinary. Forbes' pictures aimed at naturalistic truth. They were democratic in contemporary critical terms, not solely for their representation of a particular social class, but for their neutral acceptance of the scene, in order to achieve universal legibility. Why then was there such a gulf between Forbes and Sickert and Moore?

In 1892 Sickert delivered his most cogent broadside directed at the followers of Bastien-Lepage in an essay entitled *Modern Realism in Painting*. 'Hourly *tête-à-tête* with nature', Sickert wrote, only produced 'a handful of tiresome little facts.' It was important to consider the character of the reportage. Sickert's poetry could only be defined against this prose. What was required was 'not a catalogue of facts, but the result of the observation of these facts on an individual temperament'.[6] This was the difference between the 'modern photo-realist' and the Impressionist. In a more pointed way, Gabriel Mourey attacked this 'reproduction of commonplace material life', validated by 'the mob' with exclamations of 'how true . . . how real!' 'The public,' he emphasized, 'have killed the artist and his art by vulgarizing and democratizing them.'[7] These words were applied to the Paris Salons, but they had an equal relevance in the context of the Royal Academy in the mid-1890s. There were nevertheless notable exceptions to this general view.

Alas that very year, 1892, Stanhope Forbes was elected Associate of the Royal Academy, and George Moore was obliged to examine his principal exhibit, *Forging the Anchor* (Plate 110), in order to drive home the distinction between the Impressionist and the photo-realist. Forbes had copied the trousers of his blacksmith 'seam by seam, patch by patch'. Moore would not have been surprised if Forbes had built a forge in his studio 'and had copied it all as it stood'. He must have known that the painter had done precisely this. And what did this effort add up to? 'A handful of dry facts instead of a passionate impression of life in its envelope of mystery and suggestion.'[8] Any proposal from the painter that he had gone to such lengths in order to convey the truth of the impression would be brushed aside. It was almost as if in grappling with an important subject, Forbes was condemned to pedestrian technique. In later years he did however move closer to Impressionism in a splendid series of outdoor fishing scenes which became exhibition pieces. *The Seine Boat* (Plate 111), shown at the Royal Academy in 1904, reworks the bleak greys of *Off to the Fishing Ground*, 1886, in a much brighter palette. The grey sea has become a luminous cobalt pond, sunlight reddens the faces of the fishermen and the shadows are tinged wth blue. Yet for all its public Impressionism Forbes remained fundamentally a naturalist who was only interested in effects and where they might appropriately be deployed. In other words, swift brushwork might give the effect of firelight on faces or, as here, calm registration aspires to a robust monumentality which would have been inconceivable to Sickert.

The processes of assimilation of technical innovation were swifter in other

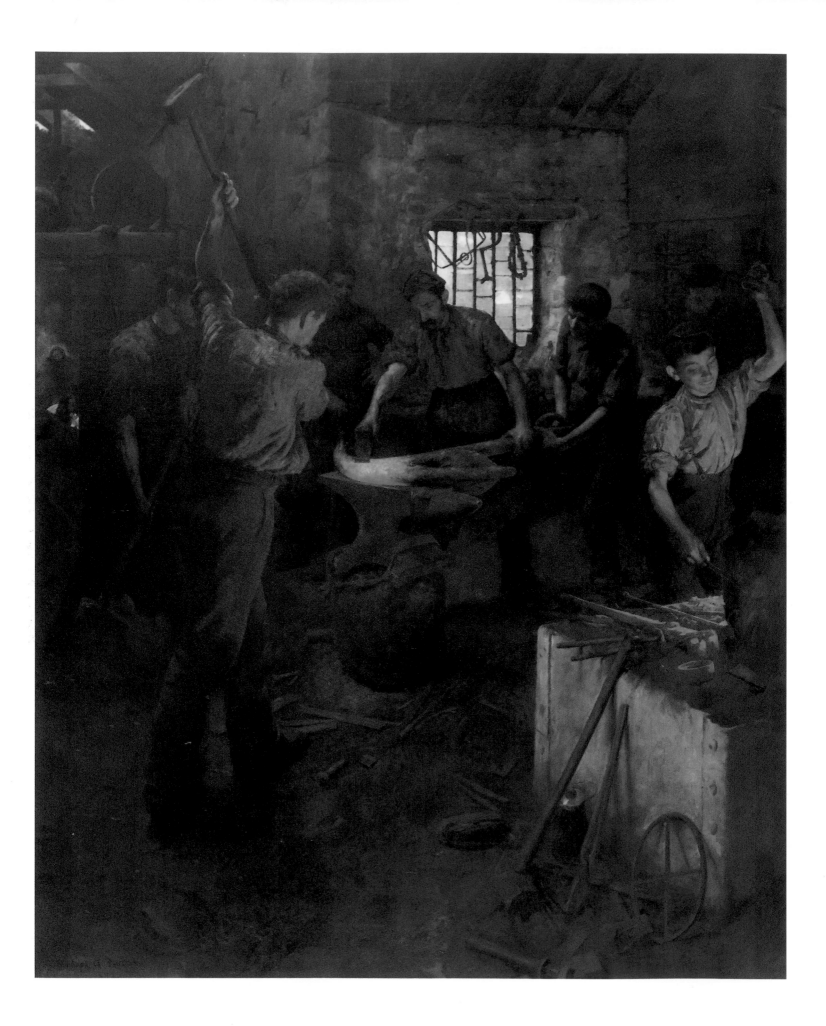

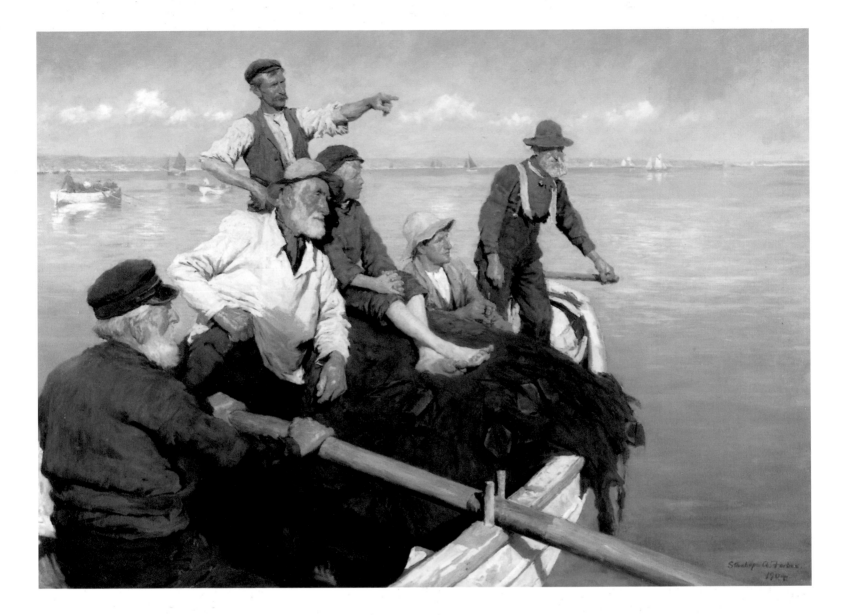

110
Stanhope Alexander Forbes
(1857–1947)

Forging the Anchor, 1892. Oil on canvas, 214.5 × 172.5 cm.
(84¾ × 68 in.) Ipswich Museums and Art Galleries. Forbes was
criticized for aiming at popular success with *Forging the Anchor*. It
embodied the robustness of Britain's maritime strength, conveyed
through detailed rendering of the facts of appearance in what seemed
to be an actual forge. George Moore greatly objected to its prosaic
detail and found that it lacked the truth of genuine experience. By the
time the picture was executed, Forbes had moved to a large
conventional studio where it was possible to build room sets in order
to ensure the accuracy of his work.

111
Stanhope Alexander Forbes
(1857–1947)

The Seine Boat, 1904. Oil on canvas, 114 × 157.5 cm. (45 × 62 in.)
The Marchman Collection. Forbes escaped from prosaic naturalism
in *The Seine Boat*. Although it restates the theme of *Off to the Fishing
Ground* (Plate 41), its freshness and vitality are an indication of the
confidence Forbes had achieved. The title refers to a particular type of
fishing net.

cases. George Clausen, for whom a visit to the Exposition Universelle in Paris in 1889 had been a revelation, began to revise his opinions. Having participated in the current interest in pastel, he began to reassess the technical basis of his painting. The watershed was *The Girl at the Gate* (Plate 112), purchased from the Grosvenor Gallery exhibition of 1890 for the Chantrey Bequest. Rather than stick to a successful formula, Clausen was already moving away from the square brush manner and he re-entered the Royal Academy exhibitions in 1891 with radical intentions. In these terms, *The Mowers* (Plate 113), 1892, was hailed as a new departure. The comparison with *Forging the Anchor*, Moore found illuminating. Clausen had shaken himself free from his early education and his canvas exhaled 'a deep sensation of life'. Thereafter in works like *The Little Flowers of the Field*, Clausen continued to expand upon his knowledge of Monet's practice,

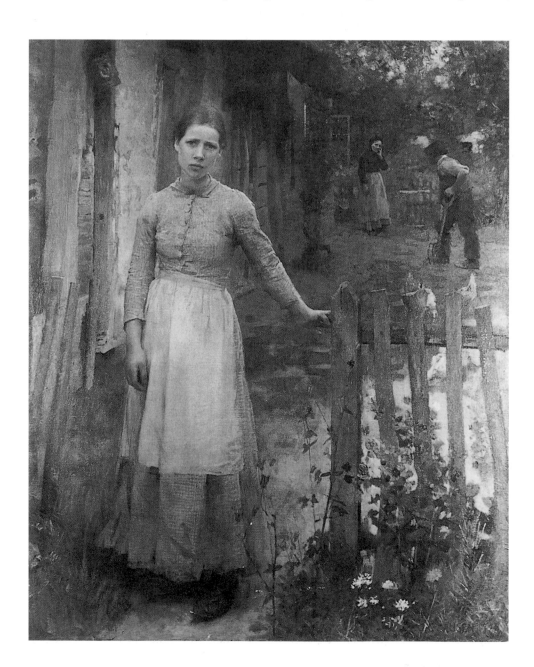

112
George Clausen
(1852–1944).

The Girl at the Gate, 1889. Oil on canvas, 171.5 × 138.5 cm. (67½ × 54½ in.) London, Trustees of the Tate Gallery. Clausen's monumental *The Girl at the Gate* marks a watershed. After its completion he was able to visit the Exposition Universal in Paris where he studied Bastien-Lepage's *Joan of Arc* in the context of other recent French painting. He began, as a result of the experience, to revise his opinions. He had initially intended to call this picture *Marguerite*, but in the end opted for *The Girl at the Gate*, a title perhaps derived from a popular story by Wilkie Collins.

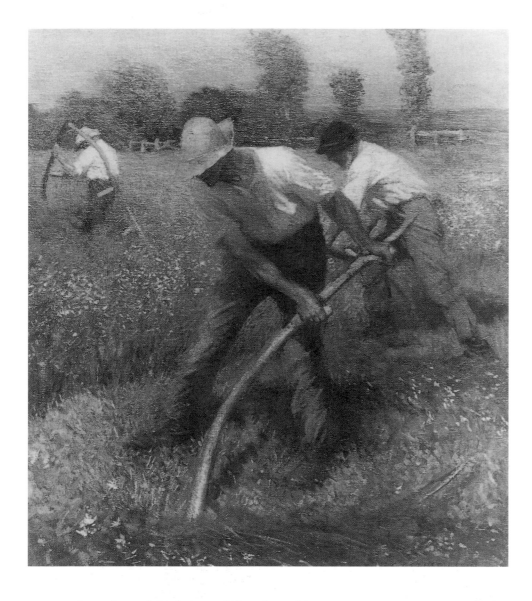

113
George Clausen
(1852–1944).

The Mowers, 1892. Oil on canvas,
97.2 × 76.2 cm. (40 × 34 in.) Lincoln, Usher
Gallery. The indian red flesh tones of Clausen's
Mowers complement the bright sunny landscape
in which his figures are situated. Close
observation gives the impression of dynamic
figure movement rather than simple snapshot
realism. Clausen first essayed this theme in a
watercolour version of 1885, but in this the
figures are more static than those of 1892.

noting the colour of shadows and the glow of flowering grasses in strong sunlight. If such pictures maintained a vague symbolism, Clausen moved even closer to Monet in his pastel haystack studies which began around 1889.[9] At the turn of the century, he produced a range of pictures in which strong silhouettes of hayricks dominate the composition. Whilst the relationship with Monet seems obvious at first, it should be recalled that Clausen was familiar with the most important source for Monet's imagery in Millet's late work, *Autumn, the Haystacks*. In any case, he had his own working experience which to some extent concurred with Monet's. In an interview he stated that,

> the more a man studies Nature out of doors, the more he sees how evanescent is the play of light. At the same time he becomes more critical of his work.[10]

The painter then pointed to a pile of unfinished canvases which had been abandoned because of changing light conditions. The accumulation of this kind of experience led to the well-felt evening light of *Dusk* (Plate 114) in which the

114
George Clausen
(1852–1944).

Dusk, 1903. Oil on canvas,
56 × 68.5 cm. (22 × 27 in.)
Newcastle upon Tyne, Tyne and
Wear Museums. It may well seem as
though canvases like *Dusk* were
inspired by the work of Monet (Plate
118), but given the constant
reference to humanity in Clausen's
haystack pictures at the turn of the
century, it is likely that he was more
conversant with the Realist paintings
of Millet and Breton. In the case of
Dusk he was clearly fascinated by
what one critic referred to as 'the
crepuscular light that lingers on the
haystack'.

115
Alfred Munnings
(1878–1959).

Cutting Reeds, n.d. Oil on canvas,
48 × 58.3 cm. (18⅞ × 21¼ in.) In
the possession of Frost and Reed Ltd.
Munnings was a painter of East
Anglia, as La Thangue had been.
Early in his career he treated themes
made familiar by the photographs of
Emerson (Plate 39). Learning much
from painters like Clausen and La
Thangue he swiftly evolved his own
characteristic shorthand for rendering
effects which were complex in nature.

116
Alfred East
(1844–1913).

(Top opposite) *September Landscape*,
n.d. Oil on canvas, 175 × 215.5 cm.
(69 × 85¼ in.) Private collection. By
the turn of the century East's
landscapes were a regular feature of
Royal Academy exhibitions.
Although he often showed Midlands
and Cornish scenes, East had a
particular liking for the valley of the
Seine. Here the topography and tall
trees often make direct comparison
with the work of the Impressionists.
However in terms of scale and the
rather subdued handling of his work,
East was more concerned with the
traditional values of the exhibiting-
piece.

117
Edward Stott
(1859–1918).

(Below) *The Team*, 1903. Oil on canvas, 40.5 × 61 cm. (16 × 24 in.) London, Pyms Gallery. Stott's team of horses plodding homeward in the dusk might seem to be a recapitulation of themes derived from Clausen and La Thangue, but his scumbled surfaces are more reminiscent of the work of Le Sidanier than either of these contemporaries. By 1903, when *The Team* was first exhibited, Stott had developed his own Impressionistic style, noted for its tone, its exclusion of the inessential and in the words of one commentator, 'its vision, temperament and emotion'.

118
Claude Monet
(1840–1926).

Haystacks, Snow Effect, 1891. Oil on canvas,
65 × 92 cm. (25½ × 36¼ in.) Edinburgh,
National Gallery of Scotland.

119
Henry Herbert La Thangue
(1859–1929).

Cutting Bracken, 1899. Oil on canvas,
119 × 100 cm. (47 × 39½ in.) Newcastle upon
Tyne, Tyne and Wear Museums. With *Cutting
Bracken* La Thangue tackled again the rhythmic
character of country labour. His pictures of wood
and bracken cutters tended to take attention
away from the cultivation of produce towards
issues of subsistence and self-sufficiency in the
country community.

aggressive stance of Monet's *Haystacks* (Plate 118) is modified with 'delicate' tree stems, 'dusty' water and an 'idyllic' figure.[11] These important qualifications are more immediately obvious when compared to the work of Alfred Munnings and others for whom the construction of hayricks was a more prosaic affair. Such images demand the recognition of a social and cultural context which was quite distinct from the constraints placed upon French painters. They are the embodiment of current mythologies of rural life in England.[12]

The move away from factual, 'democratic' or social realist essays to more universal themes, is witnessed in the work of Henry La Thangue, in whose *An Autumn Morning* and *Cutting Bracken* (Plate 119), a staccato brushwork, aimed at conveying effects of light, is to be found. A similar terse handling is evident in Munnings's *Cutting Reeds* (Plate 115). Here the imagery of Emerson's photographs is given an expressive immediacy. Such pictorial record of the activities of one of the rural poor strikingly contrasts with all of the rosy rustics who in skullcaps, and corduroy, and spotted handkerchiefs, attend the horse fairs and village fêtes elsewhere in Munnings's art. When he and La Thangue used to meet at the Chelsea Arts Club, they rhapsodized about finding a quiet old-world

120
Wilfred de Glehn
(1870–1951).

Jane Emmet de Glehn by a Stream, Val d'Aosta, 1905. Oil on canvas,
63.4 × 76.2 cm. (25 × 30 in.) London, Richard Green Galleries. As a
friend and companion of John Singer Sargent, de Glehn profited
greatly by their painting excursions together. In essence his picture of
his wife sitting by a stream at the Val d'Aosta was a recapitulation of
Sargent's eighties Impressionism.

121
Wilfred de Glehn
(1870–1951).

Gwendreath Blossom – Jane Sitting in the Shade, n.d. Oil on canvas,
50.6 × 63.4 cm. (20 × 25 in.) David Messum Fine Paintings. At times
de Glehn stepped out beyond his subordination to Monet and Sargent
and his work attained an expressiveness which extends the borders of
Impressionism. The almost hurried notation of *Gwendreath Blossom . . .*
with the dimunitive figure of Jane de Glehn overshadowed by its
presence, achieves such an impatient intensity.

**122
Edward Stott
(1859–1918).**

Noonday, 1895. Oil on canvas, 71.8 × 91.5 cm. (28¼ × 36 in.) Manchester City Art Gallery. In the 1890s Stott treated subjects which involved figures seen out-of-doors in a warm evening light. The richness of his palette on these occasions vied with that of Steer, but where Steer represented middle-class girls at the seaside, Stott was content with the farm children near his home at Amberley.

village where real country models could be found. Alas, both lived to see revolutionary changes take place in British agriculture.

The sense of passing time and seasons' change was even more important to the work of Edward Stott who maintained his contacts with the New English Art Club into the 1890s. All of Stott's work after he settled at Amberley on the Sussex Downs in 1889 projects the image of an English Arcadia in which Impressionism is deployed in order to reinforce myth. The lads who divest themselves by the pond in *Noonday* (Plate 122) are those who return with *The Team* (Plate 117) on a summer evening. Elsewhere, Monet's example was used in the work of Fred Hall, Bertram Priestman, Arthur Douglas Peppercorn, Mark Senior and many others to support the rustic idyll. In each case, there were different degrees of commitment. *Cornricks*, exhibited in 1898 by A. D. Peppercorn, adopts a format and contains tonal contrasts more reminiscent of a

Barbizon painting than the work of Monet or Clausen. The heat haze in Fred Hall's *Sultry Summer's Day, Edam*, 1899, is communicated by an orderly system of brush marks adapted from Neo-Impressionism.

Impressionist techniques were employed in a wide variety of circumstances and at different stages of individual development. Sargent, who devoted the years up to 1907 to portraiture, made a habit of producing dynamic holiday sketches. Throughout the 1890s, his Broadway Impressionism was not forgotten. Frank Bramley, when he left Newlyn, returned to the inspiration of *Carnation, Lily, Lily, Rose* in floral garden studies such as *Sleep*, shown at the Royal Academy in 1895. The flickering light of Chinese lanterns illuminated Walter Osborne's *The Birthday Party* (Plate 108), 1900, and led to startling contrasts of complementary colour which surpass Guthrie's and Llewellyn's earlier firelight interiors. Sargent's ability to revert to a modified Impressionism on his trips abroad, had a more direct effect upon his companions such as Wilfrid de Glehn.[13] Having studied at the Government Art Training School and at the Ecole des Beaux Arts, de Glehn worked as an assistant to Edwin Austin Abbey and Sargent on the murals for Boston Public Library. At the same time, he energetically pursued a reputation as a portraitist. However, the works with which he gained acceptance amongst the ranks of the New English Art Club were richly coloured Impressionist scenes, similar to those painted in company with Sargent at the Val d'Aosta in 1905 (Plate 120). At times the sheer dynamism of handling in paintings like *Gwendreath Blossom – Jane Sitting in the Shade* (Plate 121) transcends all possible precedents and rivals the expressive urgency of the early Fauve painters. The essential contrast in de Glehn's work was similar to that in Steer's. At one level he produced canvases which aimed at a decorative, eighteenth-century synthesis of nudes and formal gardens, while at another level, he responded to 'women in fairy-white dresses' entering 'into the life of a summer's day'. These seemingly contradictory worlds coexisted in de Glehn's imagination and to some extent they fed upon one another as they did with Renoir.

In describing de Glehn's work, T. Martin Wood was acutely aware of the significance of the idylls which were being created. The ambiance which the Impressionists had introduced was one of summer days, and elegant women. Even Newlyn, in the early years of the century, had lost its grim cement skies. In the hands of Harold and Laura Knight it had become a holiday resort.[14] When they arrived in 1907, the Knights did not continue the sombre realism which they had practised at Staithes. Forbes's new strength in Impressionist effects led them to the invention of an Arcadia of children's play and summer afternoon swimming parties. Far from the hard-bitten world of 'old salts', they found that Newlyn had become 'a riot of brilliant sunshine, of opulent colour and of sensuous gaiety'. Initially, Laura Knight's *The Beach* (Plate 123) produced an academic form of Impressionism, adopting obligatory blue shadows, while her husband's *In the Spring* (Plate 2) could be an equally academicized version of Guthrie's *Midsummer*. By 1912 Laura Knight was less detained by the need for painterly flourish. She adjusted her viewpoints to set her single figures against the immensity of sky or sea. *Wind and Sun* (Plate 124) expresses something of these symbolic relationships. Like Lavery in *A Garden in France*, Knight uses an empty chair to dramatic effect. The beach towel slung over the chair sways imperceptibly in the breeze, momentarily drawing the spectator's attention away from the two young women – the indolent audience of nature.

123
Laura Knight
(1877–1970).

The Beach, 1908. Oil on canvas, 127.5 × 153 cm. (50¼ × 60¼ in.)
Newcastle upon Tyne, Tyne and Wear Museums. After their arrival at
Newlyn, Laura and Harold Knight set about dispelling its sober image
of hopeless dawns. Already this process had begun in works like *The
Seine Boat* (Plate 111), but increasingly they saw the area around
Penzance and Land's End as a holiday resort. A more appropriate
comparison therefore with *The Beach* might be Steer's *A Summer's
Evening*, but although she imported some of the characteristics of
Impressionism, Laura Knight did not fully accept its premises.

124
Laura Knight
(1877–1970).

Wind and Sun, c. 1913. Oil on canvas, 96.5 × 112 cm. (38 × 44 in.)
London, Pyms Gallery. As she continued at Lamorna Cove, Laura
Knight's bright Impressionism concerned itself with the accurate
recording of local colour rather than the scientific analysis of the
mechanism of seeing. In this instance two young women are placed
upon the edge of an immensity of sea and sky, their position
emphasized by the isolated empty deckchair.

125
Arnesby Brown
(1866–1955).

Silver Morning, 1910. Oil on canvas,
160 × 183.5 cm. (63 × 72½ in). London,
Trustees of the Tate Gallery. Brown's landscape
settings for his paintings of cattle, going to and
coming from pasture, often involved a variety of
techniques derived in part from Constable and
Turner, in part from the Impressionists.
Expresssive brushwork and powerful effects were
deployed in grand public exhibition-pieces such
as *Silver Morning*.

Bright afternoon sunshine, the silver morning, spring blossom and golden
autumn became the familiar moods of the Edwardian rural Arcadia. England in
the grand landscapes of Alfred East (Plate 116), Arnesby Brown (Plate 125) and
numerous others, was a 'haunt of ancient peace', a place of pilgrimage and escape
from the savage world of industry and trade. The majestic trees are unruffled and
the cattle solemnly process in a countryside which contains unmistakable
references to that of Constable. Echoes of old England were supported if not
demanded from a literary culture which had spawned Richard Jefferies, Thomas
Hardy, Alfred Austin and Edward Thomas.[15] The all-embracing significance of
the images of East and Brown emerged from a shared youthful experience of

136

naturalism and filtered Impressionism. Arnesby Brown was typical in this respect. After his training under Herkomer, he had to struggle to make his 'impression' 'pictorially effective', by ridding himself of all hesitation 'about the way in which the record of his observations should be managed'. Here was the restatement of Francis Bate's belief in the veracity of the initial impression. However, beyond A. L. Baldry's description of Brown's creative processes lay the fact that it had taken the painter until the turn of the century to have impressions which were of universal value.[16]

Impressionism was thus rendered down to a few popular clichés and tricks of technique used to support the grander vision. The return to the studio from the open air was via the path of academicism. Since they owed their success to the Royal Academy, East and Brown continued to believe in the exhibition-piece as the summation of visual research. Clausen observed the tendency in his contemporaries to paint 'up to exhibition pitch', to extend the register and exaggerate the harmonies in order to create sensational effects by which to attract attention.[17] The showy rhetoric of 'grand manner' Edwardian landscape was intended to appeal to popular taste and to find its way to public art galleries, as the trophy of enlightened municipal patronage. In the absence of Sickert and the submersion of Steer in a romantic reverie of the eighteenth century, it was easy for such painters to be seen as the central consensus on Impressionist practice. They occupied the Academy, and their circle extended to all the other major exhibitions, including the International Society and the New English Art Club. Into this, the gamut of Monet, Renoir and Pissarro was dissolved.

Impressionism: French or British?

In 1889, in an article in *The Universal Review*, the prophetic 'philistine' Harry Quilter stated his conviction that 'some *via media* will perhaps, as the years go on, be found between the old academic painting, the "plein air" school, and the impressionists properly so called.'[1] Such an accommodation was inevitable by the turn of the century, and in examining the academies and secessions throughout western Europe, a consensus emerges. Its nature varies from place to place, but the same representative names, those found in the catalogues of the International Society, keep recurring. Monet, Pissarro and Sisley had become common currency within a league table of familiar names chosen to represent national schools or particular tendencies. Great exhibitions proliferated in these years, culminating in the Paris International in 1900, at which French Impressionism was at last wholeheartedly approved. The overall effect of these exhibitions was to blur the fact that painters within the modernist caucus often represented quite distinctive and opposing factions. Catholicity was the aim, and the only exclusions were placed upon outmoded academicians. The modern movement was not located in Impressionism any more than it was specifically symbolist or *plein airiste*. It was enough to be somewhere within the general ambiance.

British painters, if not the British public, had reconciled themselves to Impressionism. In 1902 *The Magazine of Art* recapped on the debate in two dialogues, one 'pro' and the other 'con'.[2] The principal layman's objection to Impressionism, one which might follow from Francis Bate's explanations of 1886, was that Impressionism was necessarily subjective and because of this, it effectively disarmed criticism. In making the case in favour of the movement, T. B. Kennington did not specifically tackle this point; he rather concentrated upon the prejudices concerning 'finish'. General truth was preferred to elaboration of detail and Velazquez, Titian, Hals and Rembrandt were enlisted in support. At the same time, it was admitted that criticism had not been discriminating enough and Kennington got himself into difficulties by claiming that a picture 'must not only be true, but it must be *done beautifully*'. The ghost of 'quality', raised by Sickert, remained unlaid. It was a notoriously troublesome expression even for Kennington's fictitious 'pictor'. 'Experience teaches us,' he declared, 'that without these "spots", "streaks" and other methods of looseness and freshness, paint refuses to yield either beautiful colour or luminosity.' Predictably, by the end of the conversation the sceptic was converted by the painter and vowed to go to the National Gallery to begin with Velazquez, 'the so-called impressionist'. From there no doubt, the education would proceed to the late eighteenth-century British portraitists and the early nineteenth-century British landscapists, where it was commonly believed the real beginnings of the sensibility were to be found.

As the first histories of Impressionism appeared in the early years of the century, these beliefs were given increasing authority. D. S. MacColl in a celebration of the Glasgow International Exhibition of 1901, entitled *Nineteenth Century Art*, went some way to providing a general history. In the actual exhibition, Barbizon School landscapes far outweighed those of the Impressionists – Corot was represented with twenty-one works, while Monet, Manet and Pissarro had two each. MacColl, however, took the excuse to form his views on the development of modern painting. While he repeats Monet's reliance on Turner and even restates the rumour that Degas' racecourse pictures were inspired

126
Philip Wilson Steer
(1860–1942).

Boats at Anchor, 1913. Oil on canvas, 50.5 × 65.7 cm. (20 × 26 in.) London, Pyms Gallery. *Boats at Anchor* was painted at Harwich in 1913 as one of ten studies of the harbour and its shipping. In these simple and lucid canvases the earlier influence of Monet, Whistler and Turner are successfully fused. These were the mentors of British Impressionism so far as Steer was concerned, and no original style could be forged without reference to them.

139

127
Wynford Dewhurst
(1864–c. 1941).

The Picnic, 1908. Oil on canvas, 82 × 100.7 cm.
(32¼ × 39¾ in.) Manchester City Art Gallery.
For Wynford Dewhurst, Monet was the pre-
eminent Impressionist. In his volume on the
genesis and development of Impressionism and in
his work as a painter, Monet takes pride of place.
His working procedures and the surface texture of
his finished canvases closely imitate Monet,
though he lacked Monet's ability to achieve
compositional strength.

by Frith's *Derby Day*, he does arrive at an acceptable structure for understand-
ing the immediate past. Degas and Manet were grouped with Courbet under
'Realism', while 'the lead in "impressionism" proper seems to belong to
Monet'.[3]

The British origins of French Impressionism returned with renewed emphasis
in Wynford Dewhurst's *Impressionist Painting, Its Genesis and Development*,
published in 1904. Dewhurst was a painter from Manchester who, though he had
trained under Gérome at the Ecole des Beaux Arts, was heavily influenced by
Monet. In works like *The Picnic* (Plate 127) and *Château d'Arques, Dieppe* (Plate
130), he reveals a sympathetic understanding of French Impressionism, building
his surfaces more methodically than Steer or Sargent had done, but remaining
doggedly close to the surface texture of Monet's river landscapes of the 1890s
(Plate 128). Dewhurst was anxious therefore to justify the position of all those
who, like himself, had taken up the Impressionist manner. 'Those Englishmen',
he stated, 'who are taunted with following the methods of the French
Impressionists, sneered at for imitating a foreign style, are in reality but practising
their own, for the French artists simply developed a style which was British in its
conception.'[4] The writer deliberately set great store by Monet's and Pissarro's
escape to London during the Franco-Prussian War. At that point, they began to
understand light through the eyes of Constable and Turner. Pissarro objected to
this preposterous claim. 'Mr. Dewhurst has his nerve,' he wrote. Nevertheless,
the view was generally accepted in England. Lecturing to the Royal Academy
students in 1904, Clausen stated that Turner, who had 'left no successor in
England', lay fallow until 'some years after his death', when Monet and some
other French artists 'endeavoured to develop his principles'.[5] This comforting
theory remained vaguely absurd to the initiated of an earlier generation. On the

128
Claude Monet
(1840–1926).

Poplars on the Epte, c. 1892–4. Oil on canvas, 86.9 × 81.3 cm. (34¼ × 32 in.) Edinburgh, National Gallery of Scotland.

question of who painted the first Impressionist picture, George Moore was obliged to point out in 1906:

> It was stated that Monet had been to England and had been influenced by Turner. The impressionists admired Turner, of course, platonically as they admired the old masters, Salvator Rosa and Hobbema, but any more personal admiration were impossible . . . It may be doubted if it will ever be possible to discover who painted the first impressionist picture or what suggested the abandonment of chiaroscuro. It certainly was not Constable or Turner.[6]

Yet for all the attempts to assimilate the work of the Impressionists, the British collector remained, for the most part, xenophobic. Durand-Ruel's splendid display of Impressionist masterpieces at the Grafton Gallery, London, in 1905, provoked little warmth. Rutter recalled the intending purchaser of a Monet being 'severely cautioned' by an aged academician. He later learned that she had purchased a David Murray instead.[7] Murray, of course, was a respectable landscapist whose *In the Country of Constable* had been purchased by the Chantrey Bequest in 1903, a majestic, brightly coloured Suffolk scene, which, alongside the works of East and Arnesby Brown, rehabilitated the native tradition. Murray's picture is one of the vast array of landscapes painted in the early years of the century which locate themselves in the various phases of Constable's career, but which fail to move significantly from it. Steer's landscapes in these years contained similar ingredients, but where Murray was composing a careful pastiche, Steer was concerned with metamorphosis. Given the precedents of Turner and Constable, how should the painter react to the majestic Richmond and Chepstow castles? Steer's unsystematic sweeps, splodges and scratchings in

129
Philip Wilson Steer
(1860–1942).

Chepstow Castle, 1905. Oil on canvas,
76.5 × 91.8 cm. (30⅛ × 36 in.) London, Trustees
of the Tate Gallery. The majestic sweep of the
River Wye at Chepstow Castle provided the
stimulus for canvases by Steer which vary in scale
and in degrees of finish. Although he visited the
site, the painter relied heavily upon one of
Turner's mezzotints from *Liber Studiorum* for the
basic format of his picture. *Chepstow Castle*
therefore shows a meeting of notions of the
picturesque with Steer's increasingly archaic style.

these works, rise to crystalline freshness in the harbour scenes painted at Harwich in 1913 (Plate 126). He, more than his contemporaries, understood the need for a tradition which placed distance between what was perceived and what was produced.

Because this tradition was irredeemably English however, it retarded the acceptance of the French Impressionists by all but a few. After a gargantuan effort, Rutter succeeded in purchasing a Boudin for the National Gallery in 1906. His first inclination, to buy Monet's *Vetheuil: Sunshine and Snow* from Durand-Ruel, had to be rejected, since its author was a living artist. Instead, this picture went to Hugh Lane, a recent proselyte to the Impressionist cause. Boudin's *The Entrance to Trouville Harbour* was the compromise suggested for the National Gallery.[8] Lane had only begun to acquire his extraordinary collection of

130
Wynford Dewhurst
(1864–c. 1941).

(See page 143) *Château d'Arques, Dieppe*, 1908. Oil on canvas, 91 × 73.5 cm. (36 × 29 in.) Richard Green Galleries. By 1908, when he painted *Château d'Arques, Dieppe*, Dewhurst was known as an exhibitor of scenes of the Seine Valley and the area around Dieppe. This made his connections with Impressionism even more obvious to those who viewed his work. Despite such echoes, there is a subtlety of surface in *Château d'Arques, Dieppe* which betrays his authority and lifts him beyond the ranks of imitator.

131
William Orpen
(1878–1931).

Homage to Manet, 1906–9. Oil on canvas, 163 × 130 cm. (64¼ × 51¼ in.) Manchester City Art Gallery. Orpen's *Homage to Manet* succinctly generalizes the debate about Impressionism in England. It shows George Moore reading his reminiscences of the Impressionists to Steer, Sickert, MacColl, Tonks and Hugh Lane. Four years prior to its completion in 1909, Lane had emerged as a leading collector of modern French painting, and the soirée depicted by Orpen is a fictitious celebration of his acquisition of Manet's portrait of *Eva Gonzales*.

Impressionist pictures in the summer of 1905. He visited Paris in company with William Orpen, also an admirer of Impressionism, but not an emulator. An important early purchase was Manet's *Portrait of Eva Gonzales* which gave particular pleasure to the painter. Around the canvas, Orpen grouped the clique of Impressionist supporters – Sickert, Steer, Tonks, MacColl, Moore, and Lane himself – in what was to become the *Homage to Manet* (Plate 131), shown in 1909 at the New English Art Club. It supplied belated recognition to a powerful union of personalities which had projected its own view of French Impressionism in England. Orpen's picture once again reasserted the centrality of the Spanish painting tradition embodied in Manet. His *Portrait of Eva Gonzales* was, in George Moore's opinion, 'an article of faith . . . whosoever paints like that confesses himself unashamed; he who admires that picture is already half free – the shackles are broken and will fall presently.' Yet by the time that it was painted, Orpen's *Homage . . .* was more an historical document than a manifesto. Though all of its protagonists, with the possible exception of Moore, had moved on in their thinking, they remained *alumni* of a distinguished school.[9]

By 1909, they had all been overtaken. Frank Rutter, undaunted by his efforts to secure recognition for the Impressionists, set up a London version of the 'no-jury' Salon des Indépendants in July 1908. Known as the Allied Artists' Association, this exhibition attracted over three thousand works which were hung on temporary screens in the Albert Hall.[10] Rutter made strenuous attempts to incorporate all of the major strands of advanced painting – including the work of Gauguin, Van Gogh and Matisse in the first show and Kandinsky in the second. Although such controversial pictures may have been swamped, the exhibition did admit other expatriate British painters who were not aligned. These principally included Roderic O'Conor and John Duncan Fergusson, who even in the 1890s had evolved a radicalism unusual in Britain. O'Conor's landscape, *Field of Corn, Pont Aven*, 1892 (Plate 132), begins from the premises of Gauguin and Van Gogh, rather than from Degas or Monet. Fergusson's *On the Loing*, 1898 (Plate 134) translates a conventional peasant subject into an embryonic *cloissoniste* language. These painters and their 'outsider' contemporaries, Paul Henry, W. J. Leech, Forbes-Robertson, Peploe and Cadell, were united in their complete acceptance of the pathways leading out from Impressionism.

Sickert was persuaded to return to London to give guidance through this critical phase. Around 1906, he began to reserve Saturday afternoons for open-house gatherings at his studio at 8 Fitzroy Street. On these occasions he advocated a tradition of Impressionist practice which gave pride of place to the work of Lucien Pissarro. Although the young Pissarro had painted intermittently during the 1890s, his pictures of his father's garden at Eragny revealed a formalism which was less obviously concerned with Impressionist atmospherics (Plate 133). In Sickert's opinion, he offered an 'authoritative repository of a mass of inherited knowledge and experience' derived from his father Camille; he was 'a guide . . . a dictionary of theory and practice on the road we have elected to travel'.[11] This was the attraction of someone who, under his father's tutelage, had explored the entire range of Impressionist painting. Camille Pissarro had, in George Moore's opinion, 'always followed in somebody's footsteps:

He was a sort of will-o'-the-wisp of painting, and his course was zig-zag. But though his wanderings were many and sudden, he never quite lost his

132
Roderic O'Conor
(1860–1940).

Field of Corn, Pont Aven, 1892. Oil on canvas, 38 × 38 cm.
(15 × 15 in.) Belfast, Ulster Museum. While painters of Orpen's
generation were quite positive that the debate about modern painting
could be settled in the reconciliation of Degas, Monet, and Whistler
with Constable and Turner, isolated figures like O'Conor worked in a
more radical Post-Impressionist manner.

133
Lucien Pissarro
(1863–1944).

Effet de Neige, Eragny, c. 1892. Oil on canvas, 55.7 × 45.7 cm.
(22¾ × 18 in.) Unlocated. Sickert later confessed that one of his
principal influences came from the work of Lucien Pissarro. Through
Pissarro he made contact with Camille Pissarro and the original
Impressionists. It is easy to accept this being the case when considering
works like the Eragny snowscapes of the early 1890s.

individuality, not even when he painted yachts after the manner of Signac, in dots.[12]

The young painters of Sickert's group were thus admitted to a wide range of options. At the same time, they knew where they stood in relation to the prevailing modes of Edwardian painting. They would certainly have walked out of the International Society in 1899 with Bonnard and Vuillard. They felt themselves increasingly alienated in the New English Art Club, to such an extent that while *Homage to Manet* was being fêted, Spencer Gore had to admit that his, Lucien Pissarro's, Harold Gilman's, Robert Bevan's and Henry Lamb's work had been 'gently pushed' into one of the inner rooms of the exhibition. 'They dislike our kind of painting,' he concluded.[13] They did exhibit, however, in their studio at Fitzroy Street, at the Allied Artists' Association, and eventually as the Camden Town Group at the Carfax Gallery.

Roger Fry, who had received his first painting lessons from Francis Bate and had exhibited at the New English from 1894, had also formed serious misgivings about its future and had resigned in 1908. By that stage, Fry had begun to campaign on behalf of modern French painting. His admiration for Cézanne originated in 1906 when he saw two works at the International Society. Two further examples appeared in 1908, accompanied by the works of Monet, Matisse and Gauguin. This provoked an anonymous review in *The Burlington Magazine* entitled 'The Last Phase of Impressionism' attacking Cézanne and Gauguin for the decline of the movement and dismissing Matisse as 'infantile'. Fry was stimulated to reply on behalf of these descendants of the Impressionist sensibility, particularly Cézanne, who, in his estimation, left 'far less to the casual dictation of natural appearance'. The conversion of Fry aroused Sickert's scepticism and was conducted with Moore's disapproval. If he is in fact reading his reminiscences to the elite in Orpen's *Homage . . .* as is supposed, Moore is somewhat confusedly declaring Cézanne's work as 'art in delirium'.[14]

In his 'Essay on Aesthetics' the following year, Fry amplified his ideas, attacking the hedonistic delight in appearances which characterized Impressionism. By extending his argument to the more structured approaches of the Post-Impressionists, he gave the sense of something beyond MacColl's and Moore's advocacy of Manet and Degas and Dewhurst's promotion of Monet. The point was only effectively made in 1910 when this entire development in modern French painting was extricated from the diffuse exhibitions of the International Society and the Allied Artists' Association, and re-presented in concentrated form in Fry's exhibition at the Grafton Galleries, entitled *Manet and the Post-Impressionists*.

Throughout this period, when more extrme standpoints were being adopted, Sickert continued to insist upon the 'broad church'. In his review of the misty Ligurian landscapes of La Thangue, with which this study began, Sickert referred to the general ambiance in which the painter was located. 'The language of paint,' he confidently stated, 'is kneaded and shaped by *all* the competent workmen labouring at a given moment.' This 'language' was described as 'an opaque mosaic for recording objective sensations about visible nature . . . in a personal manner.'[15] Such a definition had eluded him when he penned the 'Introduction' to the London Impressionists' catalogue. La Thangue's particular variant was the product of long gestation. In works like *A Ligurian Valley*

134
John Duncan Fergusson
(1874–1961).

On the Loing, 1898. Oil on canvas, 76.2 × 63.4 cm. (30 × 25 in.) Glasgow Art Gallery and Museuem. *On the Loing* provides valuable evidence of the enduring popularity of the village of Grez. Fergusson may well have wished to catch something of the elegiac tonalism of painters of Lavery's generation, which was currently being revised by his compatriot, David Gauld. For him, however, Grez was a temporary resting place before the call of Paris, and the development of his own Fauvist style.

135
Henry Herbert La Thangue
(1859–1929).

A Ligurian Valley, c. 1910. Oil on canvas, 68.4 × 77.8 cm.
(27 × 30¾ in.) Kingston upon Hull, Ferens Art Gallery. Sickert was
impressed by the originality of La Thangue's landscapes around 1910.
They permitted the articulation of the consensus upon Impressionist
practice. They were concerned with space and atmosphere, conveyed
through a mosaic of tiny touches of colour. La Thangue, of course, did
not especially seek out Sickert's approval. His work was the product of
a lifetime's development and change which freed him from the
dependency still evident in younger painters like Dewhurst.

(Plate 135) and *The First of Spring*, it was skilfully conceived. It was '. . . what he, and not someone else, has to say . . .'

Sickert's typical 'on its own terms' painter's pleading sets out to disestablish the critical hierarchy which was already proving Monet's worth by reference to the 'horde of followers' who appropriated his handling and colour range 'with their eyes shut'. Because La Thangue was beyond the acceptable forms of unoriginality, he was also beyond the critical tyros of the modern movement. His contemporaries in the Royal Academy, the International Society, the New English Art Club and elsewhere, constituted the band of 'competent workmen'. The factions embodied in particular societies are less important than establishing and describing common attitudes and practices.

Sickert's tendency to be ahistorical, understandable as it may be, masks the shifting nature of the consensus, its social and cultural constraints, and its relationship to the development of understanding of French Impressionism in Britain. In essence, this means that the account of the privileged position which he and Steer occupied around 1890, and the critical support which they enjoyed, must be extended forwards and backwards in time. It must take in the extremes of partisanship. It must engage with the teeming details and be able to withdraw to a point where new values and priorities assert themselves. In this sense, the full understanding of British art in the period when it responded to Impressionism, amongst other manifold influences, has barely begun.

Notes

Chapter 1

1. A more detailed discussion of Sargent's impressionist painting is contained in Stanley Olson, Warren Adelson and Richard Ormond, *Sargent at Broadway, The Impressionist Years*, London and New York, 1986; William H. Gerdts, 'The Arch-Apostle of the Dab-and-Spot School: John Singer Sargent as an Impressionist' in Whitney Museum of American Art, *John Singer Sargent*, catalogue edited by Patricia Hills, 1987.

2. 'The conventional viewpoint' emphasizing Sickert and Steer is best expressed in Douglas Cooper's seminal 'Introduction' to the *Catalogue of the Courtauld Collection, 1954*. Other general accounts stressing their centrality are principally Dennis Farr's *English Art 1870–1940*, Oxford, 1978, and Charles Harrison's *English Art and Modernism, 1900–1939*, 1981.

3. *Nocturne in Blue and Green: Chelsea* was exhibited in 1871 at the Dudley Gallery Winter Exhibition. Whilst the date of Monet's departure from London in that year is not known, the possibility of contact with Whistler is alluded to in Wildenstein (New York) and Philadelphia Museum of Art, *Whistler and his World, from Realism to Symbolism*, 1971, p.106, and Arts Council, *The Impressionists in London*, catalogue introduction by Alan Bowness, 1973, p.13.

4. For a discussion of Whistler's first solo exhibition see Robin Spencer, 'Whistler's First One-Man Exhibition Reconstructed', in G. P. Weisberg and L. S. Dixon ed., *The Documented Image, Visions in Art History*, Syracuse, 1987, pp.27–49.

5. Sickert's letter to Alfred Pollard is quoted from Wendy Baron, *Sickert*, Oxford, 1973, p.7.

6. See Wynford Dewhurst, *Impressionist Painting, Its Genesis and Development*, 1904.

7. Sir John Rothenstein, *Modern English Painters, Sickert to Smith*, 1952, p.64.

8. Scottish painting, more specifically that of the Glasgow School, has its own extensive literature dating back to James L. Caw, *Scottish Painting, Past and Present*, 1908, but more recently Scottish Arts Council, *The Glasgow Boys*, catalogue of an exhibition, 1968, and R. Billcliffe, *The Glasgow Boys*, 1985. The principal Irish painters of the period are surveyed in A. Crookshank and The Knight of Glin, *The Painters of Ireland, 1660–c.1920*, 1978; see also National Gallery of Ireland, *The Irish Impressionists*, exhibition catalogue by Julian Campbell, 1984. For the Newlyn School see Barbican Art Gallery, *Painting in Newlyn 1880–1930*, catalogue of an exhibition by Caroline Fox and Francis Greenacre, 1985.

9. Osbert Sitwell ed., *A Free House! Being the Writings of Walter Richard Sickert*, 1947, pp. 270–3; quoted in Oldham Art Gallery, *A Painter's Harvest, H. H. La Thangue 1859–1929*, 1978, p.13.

Chapter 2

1. For a discussion of peasant imagery in British art in the 1880s see Kenneth McConkey, 'Rustic Naturalism in Britain', in G. P. Weisberg ed., *The European Realist Tradition*, Indiana, 1983, pp.215–28.

2. A. Sensier, *Jean-François Millet, Peasant and Painter*, 1881, p.XI.

3. The exhibition of Bastien-Lepage's *Les Foins* in London has been variously considered. See Kenneth McConkey, 'The Bouguereau of the Naturalists: Bastien-Lepage and British Art', *Art History*, Vol. I, no. 3, 1978, pp.371–82.

4. *The Spectator*, 12 June 1880, p.751.

5. André Theuriet, *Jules Bastein-Lepage and his Art*, 1892, p.45.

6. Emile Zola, *Le Bon Combat, de Courbet aux Impressionistes*, Paris, 1975, pp.206–7.

7. Criticism of the Royal Academy Schools is contained in *The Magazine of Art*, 1885, p.346.

8. Reference to painting methods in the work of La Thangue and his circle is contained in Morley Roberts 'A Colony of Artists', *Scottish Art Review*, Vol. 2, 1889, p.73.

9. A. S. Hartrick, *A Painter's Pilgrimage Through Fifty Years*, Cambridge, 1939, p.28.

10. This group of works by Clausen is considered in Kenneth McConkey 'Figures in a Field – *Winter Work* by Sir George Clausen R. A.', *Art at Auction, 1982–3*, 1983, pp.72–7.

11. For a discussion of the Grez community see Kenneth McConkey, 'From Grez to Glasgow, French Naturalist Influence in Scottish Painting', *The Scottish Art Review*, Vol. XV, no. 4, pp. 16–34; National Gallery of Ireland, *The Irish Impressionists*, catalogue of an exhibition by Julian Campbell, 1984; Michael Jacobs, *The Good and Simple Life*, 1985, pp.30–40.

12. For a fuller discussion of Lavery's work at Grez see Ulster Museum and Fine Art Society, *Sir John Lavery, R. A. 1856–1941*, catalogue of an exhibition by Kenneth McConkey, 1984.

13. The fullest account of the formation of the Glasgow School is contained in Roger Billcliffe, *The Glasgow Boys*, 1985.

14. George Moore, 'The Salon of 1888', *The Hawk*, 8 May 1888, p.259.

15. Reference to La Thangue, Clausen and P. H. Emerson is contained in Neil McWilliam and Veronica Sekules ed., *Life and Landscape: P. H. Emerson, Art and Photography in East Anglia 1885–1900*, catalogue of an exhibition at the Sainsbury Centre, University of East Anglia, 1986.

16. For reference to Walter Osborne's Walberswick period see National Gallery of Ireland, *Walter Osborne*, catalogue of an exhibition by Jeanne Sheehy, 1984.

17. The formation of the Newlyn School is considered in Barbican Art Gallery, *Painting in Newlyn, 1880–1930*, catalogue of an exhibition by Caroline Fox and Francis Greenacre, 1985.

18. Stanhope Forbes is quoted from Mrs Lionel Birch, *Stanhope A. Forbes, A. R. A. and Elizabeth Stanhope Forbes, A. R. W.*, 1906, pp.25–9.

19. Francis Bate, *The Naturalistic School of Painting*, 1887, p.21.

Chapter 3

1. For further reference to the formation of the New English Art Club see W. J. Laidlay, *The Origin and First Two Years of The New English Art Club*, 1907; Alfred Thornton, *Fifty Years of The New English Art Club*, 1935; Christie's, *The New English Art Club Centenary Exhibition*, catalogue by Anna Robins, 1986.

2. Reviews of the first exhibition are quoted from *The Times*, 12 April 1886; *The Pall Mall Gazette 'Extra'*, 1886, p. 72; *The Art Journal*, 1886, p.252.

3. The relationship between Brown's picture and Degas' *L' Absinthe* has most recently been proposed in Julian Treuherz, *Hard Times, Social Realism in Victorian Art*, Manchester, 1987, p.114.

4. Brown's background is described in D. S. MacColl, 'Professor Fred Brown, Teacher and Painter', *The Magazine of Art*, 1894, p.407; Professor Fred Brown, 'Recollections', *Artwork*, Vol. V, Autumn 1930.

5. Steer's *Andante* is considered in Bruce Laughton, *Philip Wilson Steer*, Oxford, 1971, p.40.

6. La Thangue's *In the Dauphiné* is reviewed in *The Magazine of Art*, 1886, Art Notes, p.XXX.

7. *The Times*, 7 August 1886, p.6

8. H. H. La Thangue, 'A National Art Exhibition', *The Magazine of Art*, 1887, pp.30–32.

9. For a fuller account of these debates see Tyne & Wear and Bradford Museums, *Sir George Clausen R. A., 1852–1944*, catalogue of an exhibition by Kenneth McConkey, 1980, pp.31–3.

10. William Powell Frith, 'Crazes in Art: Pre-Raphaelitism and Impressionism', *The Magazine of Art*, 1888, p.190.

11. Whistler's period as President of the Royal Society of British Artists has an extensive literature. The principal account is contained in E. R. & J. Pennell, *The Life of James McNeill Whistler*, 1908, Vol. 2, pp.47–74. Supplementary reference is made here to Albert Ludovici jun., *An Artist's Life in London and Paris 1870–1925*, 1926, pp.72–3.

12. Francis Bate, *The Naturalistic School of Painting*, 1887, p.19.

13. Sickert's undated letter is quoted from Jacques-Emile Blanche, *Portraits of a Lifetime*, 1939, p.300.

14. George Moore's view of Whistler is quoted from *Confessions of a Young Man*, 1888 (1961 edn.) , pp.114 & 117.

Chapter 4

1. Early reactions to the work of the Impressionists are contained in Kate Flint ed., *Impressionists in England, The Critical Reception*, 1984; the review quoted here is from *The Times*, 25 April 1876, p.5.

2. This important description of Manet's studio is not cited by Flint or in the Manet literature. It is contained in *The Architect*, 1 December 1877, p.298.

3. Frederick Wedmore, 'The Impressionists', *Fortnightly Review*, Vol. XXXIII, 1883, pp.75–82 (Flint, pp.46–55).

4. Alice Meynell, 'Pictures from the Hill Collection', *The Magazine of Art*, Vol. 4, 1881, p.80.

5. For further reference to Sickert's early years see Wendy Baron, *Sickert*, Oxford, 1973; Anna Robins, 'Degas and Sickert: Notes on their Friendship', *The Burlington Magazine*, Vol. CXXX, March 1988, pp.225–9.

6. George Moore, 'Art for the Villa', *The Magazine of Art*, Vol. 12, 1889, pp.296–300.

7. Reviews of Sickert's debut at the New English Art Club are quoted from *The Times*, 4 April 1888; *The Magazine of Art*, Vol. 11, 1888, Art Notes, p.XXIX. *Collins' Music Hall, Islington Green* (Baron, 1973, catalogue no. 50) is illustrated in Frederick Wedmore, *Some of the Moderns*, 1909, following p.50 as *Sam Collins*.

8. This work is discussed in Bruce Laughton, *Philip Wilson Steer*, Oxford 1971, pp.32–3.

9. Sargent's engagement with Impressionism is considered in Stanley Olson, Warren Adelson and Richard Ormond, *Sargent at Broadway, The Impressionist Years*, London and New York, 1986; William H. Gerdts, 'The Arch-Apostle of the Dab-and-Spot School: John Singer Sargent as an Impressionist' in Whitney Museum of American Art, *John Singer Sargent*, catalogue edited by Patricia Hills, 1987.

10. The criticism of Bramley's *Domino* is contained in *The Magazine of Art*, Vol. 9, 1886, pp.443–44.

11. The evolution of Sargent's composition is considered in Richard Ormond, '*Carnation, Lily, Lily, Rose*' in Olson, Adelson and Ormond, 1986.

12. Roger Fry, 'J. S. Sargent as Seen at the Royal Academy Exhibition of his Works, 1926, and in the National Gallery', *Transformations: Critical and Speculative Essays on Art*, 1926, quoted from W. H. Gerdts, *op. cit.*, p.137.

13. René Gimpel, *Diary of an Art Dealer*, New York 1966, p.75, quoted in W. H Gerdts, 1987, p.120.

14. Professor Fred Brown, 'Recollections', *Artwork*, Vol. V, Autumn 1930, p.270.

15. *A Summer's Evening* by Philip Wilson Steer is considered in Laughton, 1971, pp.14–15 and in Royal Academy of Arts, *Post-Impressionism*, 1979, catalogue entry by Anna Gruetzner.

16. *The Magazine of Art*, 1888, 'Art Notes', p.xxx.

17. Sickert's introduction to the catalogue of the 'London Impressionists' exhibition is reprinted in D. S. MacColl, *Life, Work and Setting of Philip Wilson Steer*, 1945, pp.175–6. *The Times* reviewed the exhibition on 5 December 1889.

18. The phrase *'la capitale de l'art'* is taken from the title of Albert Wolff's study of modern painting (Paris, 1886).

19. Reviews of the exhibition quoted are contained in *The Magazine of Art*, Vol. 13, 1890, Art Notes, p.XV; *The Art Review*, Vol. 1, no. 1, 1890, pp.18–19.

20. Brief references to Sidney Starr are contained in D. S. MacColl, 'Steer', *Artwork*, spring 1929, p.8 and D. S. MacColl, 1945, p.33; *A City Atlas* is considered in Royal Academy of Arts, 1979 (A. Gruetzner), p.345.

21. For reference to Roussel and Maitland see Frederick Wedmore, *Some of the Moderns*, 1909, pp.13–21; Frank Rutter, *Theodore Roussel*, 1926; Osbert Sitwell ed., *A Free House! . . . Being the Writings of Walter Richard Sickert*, 1947, pp.273–4.

22. Steer's address to the Art Workers' Guild is reprinted in D. S. MacColl, 1945, pp.177–8.

23. References to the correspondence between Camille and Lucien Pissarro are contained in Camille Pissarro, *Letters to Lucien*, 1944 (John Rewald ed.).

Chapter 5

1. References to the state of contemporary art in Glasgow and Edinburgh are drawn from anon., 'Art in the West of Scotland', *Scottish Art Review*, Vol. 1, 1888, p.146.

2. For Richard Muther's assessment of the Scottish painters' 'new idealism of colour', see *The History of Modern Painting*, Vol. 3, 1896, pp.645–99.

3. The most complete consideration of Henry's and Hornel's *Japonisme* is given in Scottish Arts Council, *Mr. Henry and Mr. Hornel Visit Japan*, catalogue of an exhibition by William Buchanan, 1978.

4. Guthrie's pastels and *Midsummer* are discussed in Roger Billcliffe, *The Glasgow Boys*, 1985, pp.276–83.

5. George Moore's criticism of *Midsummer* is contained in *Modern Painting*, 1893, p.206.

6. Further references to this picture are made in James L. Caw, *Sir James Guthrie, P.R.S.A., LL.D., A Biography*, 1932, no. 58.

7. Comparison of Whistler and Velazquez is contained in Moore, 1893, p.15.

8. R. A. M. Stevenson, *Velasquez*, 1895 (1900 edn.), pp.121–2.

9. The responses to Sir George Reid are printed in *The Art Journal*, 1893, pp.103–4.

10. References to Brabazon are contained in Moore, 1893, p.208; *The Spectator*, 10 December 1892, p.851.

11. Quilter's and Moore's views are quoted from Harry Quilter, *References in Art and Literature*, 1892, p.287 and Moore, 1893, p.211.

12. *A Classic Landscape* is Laughton 1971, catalogue no. 130. Reference is made to Steer's address to the Art Workers' Guild quoted in D. S. MacColl, *Life, Work and Setting of Philip Wilson Steer*, 1945, p.178.

13. The review of the tenth New English Art Club exhibition is contained in *The Art Journal*, 1893, p.158.

14. Conder's early career in Australia is surveyed in National Gallery of Victoria, *Golden Summers, Heidelberg and Beyond*, catalogue of an exhibition by Jane Clark and Bridget Whitelaw, 1985. The basic account of his life is Sir John Rothenstein, *The Life and Death of Conder*, 1938. Other important references are contained in Sir William Rothenstein, *Men and Memories*, Vol 1, 1931. The most recent monograph exhibition of his work was held at Graves Art Gallery, Sheffield, *Charles Conder 1868–1909*, catalogue by David Rodgers, 1967.

15. This phrase is quoted from Holbrook Jackson, *The Eighteen Nineties*, 1913 (Pelican ed., 1939), p.245.

16. For Rothenstein's early career see Sir Willam Rothenstein, 1931; Robert Speaight, *William Rothenstein, Portrait of an Artist in his Time*, 1962; Bradford City Art Galleries, *Sir William Rothenstein 1872–1945, A Centenary Exhibition*, catalogue by John Thompson, 1972.

17. The early career of Henry Tonks is recalled in 'Notes from Wander Years', *Artwork*, Vol. 5, no. 19, winter 1929: See also Joseph Hone, *The Life of Henry Tonks*, 1939; Norwich School of Art Gallery, *Henry Tonks and the Art of Pure Drawing* catalogue of an exhibition edited by Linda Morris, 1985.

18. The account of the sale and re-sale of *l'Absinthe* is contained in Alfred Thornton, *The Dairy of an Art Student of the Nineties*, 1938, pp.22–35. Important additional references are contained in Moore, 1893, pp.234–6, and D. S. MacColl, 'The Standard of the Philistine', *The Spectator*, 18 March 1893, pp.357–8. Many other references are quoted in Kate Flint ed., *The Impressionists in England, The Critical Reception*, 1984.

19. For a discussion of these works see Royal Academy of Arts, *Post-Impressionism*, catalogue of an exhibition, 1979, pp.336–7 (entry by Anna Gruetzner).

Chapter 6

1. Frank Rutter's recollections are quoted from *Art In My Time*, 1933, pp.57–8.

2. Quoted from E. R. & J. Pennell, *The Life of James McNeill Whistler*, 1908, Vol. 11, p.366.

3. *The Saturday Review*, 21 May 1898, p.681.

4. A. Ludovici jun., *An Artist's Life in London and Paris, 1870–1925*, 1926, p.135.

5. *The Athenaeum*, 8 June 1889; Forbes's response was given as a talk entitled 'The Treatment of Modern Life in Art' at the Birmingham Art Congress, 1890; see *Transactions for the National Association for the Advancement of Art*, 1891, p.126; see also *The Magazine of Art*, 1892, Vol. XIV, p.181.

6. Sickert's essay is contained in A. Theuriet, *Jules Bastein-Lepage and His Art*, 1892, pp.139–141.

7. Gabriel Mourey, 'Some Reflections on Art at the Champ de Mars,' *The Studio*, Vol. V, 1895, p.87.

8. George Moore, *Modern Painting*, 1893, p.116.

9. For reference to this sequence of works see Tyne & Wear and Bradford Museums, *Sir George Clausen R. A. 1852–1944*, 1980, catalogue of an exhibition by Kenneth McConkey.

10. Quoted from anon., 'Painters of the Light, An Interview with George Clausen, A. R. A.', *Black and White*, 8 July 1905, p.42.

11. The review of *Dusk* from which these adjectives are taken is contained in *Illustrated London News*, 30 May 1903, p.834.

12. See Sir Alfred Munnings, *An Artist's Life*, 1950, pp.97–8.

13. For further reference see T. Martin Wood, 'The Paintings of Wilfrid G. von Glehn', *The Studio*, Vol. LVI, 1912, p.7; see also L. van der Veer, 'Wilfrid Gabriel von Glehn', *The Magazine of Art*, 1903, pp.276–80.

14. Norman Garstin, 'Harold and Laura Knight', *The Studio*, Vol. LVII, 1912, p.195.

15. The most important summary of social change in this period is contained in M. J. Weiner, *English Culture and the Decline of the Industrial Spirit*, Cambridge 1981.

16. A. L. Baldry, 'Our Rising Artists, Arnesby Brown', *The Magazine of Art*, 1902, p.98.

17. G. Clausen, *Royal Academy Lectures on Painting*, 1913, p.233.

Chapter 7

1. Harry Quilter, 'The Salon and the Academy', *The Universal Review*, 1889, p.187. Quilter was to be dubbed 'the philistine' by D. S. MacColl for his attitude to the *l'Absinthe* dispute in 1893.

2. Rev. A. Deane and T. B. Kennington, 'Impressionism: Two Conversations, Con and Pro', *The Magazine of Art*, 1902 pp.35–7, 58–60.

3. D. S. MacColl, *Nineteenth Century Art*, 1902, p.152.

4. Wynford Dewhurst, *Impressionist Painting, Its Genesis and Development*, 1904, pp.4–5; Pissarro is quoted from Camille Pissarro, *Letters to his son, Lucien*, 1944, p.356.

5. George Clausen, *Royal Academy Lectures on Painting*, 1913, p.128.

6. George Moore, *Reminiscences of the Impressionist Painters*, Dublin 1906, p.41.

7. Frank Rutter, *Art in my Time*, 1933, p.106.

8. The attempt to purchase a work by Monet for the National Gallery is recounted in Rutter, 1933, pp.114–7.

9. For a full discussion of this work see Kenneth McConkey, *Edwardian Portraits*, 1987, pp.200–203 and Pyms Gallery, London, *Orpen and the Edwardian Era*, 1987, exhibition catalogue entry by Kenneth McConkey, pp.82–5.

10. For reference to the Allied Artists' Association see Rutter, 1933, pp.134–6.

11. *The New Age*, 29 May 1913, quoted from W. S. Meadmore, *Lucien Pissarro*, 1962, p.134.

12. Moore's opinion on Pissarro is quoted from Moore 1906, p.40.

13. Gore's letter is quoted from the Minories, Colchester, *Spencer Gore*, catalogue of an exhibition by John Woodeson, 1970, n.p.

14. Anon., 'The Last Phase of Impressionism', *The Burlington Magazine*, Vol. XII, 1908, pp.272–7: Fry's 'Essay on Aesthetics', first appeared in the *New Quarterly Review* in 1909 and was republished in *Vision and Design*, 1920 (Pelican ed., 1961), pp.22–39. George Moore's views on Cezanne are quoted from Moore 1906, p.35.

15. Sickert's views on La Thangue are quoted from Osbert Sitwell, ed., *A Free House! Being the Writings of Walter Richard Sickert*, 1947, pp.270–3.

Select Bibliography

It is in the nature of this subject that much information is contained in contemporary sources. Reference must be made to periodicals such as *The Athenaeum, The Art Journal, The Graphic, The Illustrated London News, The Pall Mall Gazette, The Magazine of Art, The Saturday Review, The Speaker, The Spectator, The Studio, The Whirlwind* and *The Yellow Book*. Only general sources are listed here. The principal artist's monographs are given, where appropriate, in the biographical index.

ANTHONY BERTRAM, *A Century of British Painting*, 1951

JOHN ROTHENSTEIN, *Modern English Painters*, 1952 (Vol. 1)

DOUGLAS COOPER, *The Courtauld Collection*, 1954

DENYS SUTTON, *British Art, 1890–1928*, Columbus, Ohio, 1974 (exhibition catalogue)

ANNA GRUETZNER, *Post-Impressionism*, London, Royal Academy of Arts (exhibition catalogue) 1979

SIMON WATNEY, *English Post-Impressionism*, 1980

JACQUES-EMILE BLANCHE, *Portraits of a Lifetime*, 1937

WYNFORD DEWHURST, *Impressionist Painting, its Origin and Development*, 1904

ARCHIBALD STANDISH HARTRICK, *A Painter's Pilgrimage through Fifty Years*, Cambridge 1939

G.P. JACOMB HOOD, *With Brush and Pencil*, 1925

W.J. LAIDLAY, *The Origin and first two years of the New English Art Club*, 1907

JAMES LAVER, *Portraits in Oil and Vinegar*, 1925

D.S. MACCOLL, *Nineteenth Century Art*, Glasgow 1902

GEORGE MOORE, *Modern Painting*, 1893

FRANK RUTTER, *Since I was twenty-five*, 1927

FRANK RUTTER, *Art In My Time*, 1933

O. SITWELL, ed., *A Free House: being the writings of Walter Richard Sickert*, 1947

ALFRED THORNTON, *Diary of an Art Student of the Nineties*, 1938

ALFRED THORNTON, *Fifty years of the New English Art Club, 1886–1935*, 1935

Biographical Index

Jules Bastien-Lepage, 1848–1884, was the most influential French artist in Britain in the 1880s. A pupil of Alexandre Cabanel, he achieved renown with the large rustic naturalist composition, *Les Foins (the Hay Harvest)* in 1878. With further controversial works such as *Jeanne d'Arc ecoutant les Voix* (salon 1880) he increased his hold upon young British painters then in training in Paris. His reputation was further consolidated by regular annual visits to London after 1879.
Andre Theuriet, *Jules Bastien-Lepage and his Art*, 1892
Kenneth McConkey, 'The Bouguereau of the Naturalists: Bastien-Lepage and British Art', *Art History*, Vol. 1, no. 3, 1978, pp. 371–382
Kenneth McConkey, 'Listening to the Voices: . . .', *Arts Magazine*, Jan. 1982, pp. 154–160

Jacques-Emile Blanche, 1861–1942, was born in Paris, studied under Henri Gervex and was a close associate of Manet, Degas and Whistler. From the start of his career he maintained a reputation in London, exhibiting with the New English Art Club from 1887. During the 1890s he became one of the leading portrait painters of the Third Republic, much of his success depending upon the 'English style' of his work. In later years his sitters included Nijinsky, D.H. Lawrence, Jean Cocteau and James Joyce.
Jacques-Emile Blanche, *Portraits of a Lifetime*, 1937
Kenneth McConkey, *Edwardian Portraits*, 1987, pp. 182, 189

Hercules Brabazon Brabazon, 1821–1906, was of independent means, having succeeded by the age of thirty-seven to the family estates in Sussex and Ireland. He practised as a watercolourist from the 1860s but only acquired his reputation in the 1890s when he was taken up by painters and critics of the New English Art Club. Thereafter he had five solo exhibitions of watercolours and pastels at the Goupil Gallery.
The Fine Art Society, London, *Hercules Brabazon Brabazon*, catalogue of an exhibition by Al Weil and Martin Kisch, 1974

Frank Bramley, 1857–1915, studied at Lincoln and Verlat's Academy, Antwerp. He began to exhibit at the Royal Academy in 1884, the year in which he installed himself at Newlyn. His most successful picture was *A Hopeless Dawn* (Tate Gallery) which was purchased by the Chantrey Bequest. This combined Victorian sentiment with a modern naturalist style. In later years, after Bramley had moved to Grasmere, in Westmorland, his style broadened and become more painterly.
Barbican Art Gallery, London, *Painting in Newlyn 1880–1930*, exhibition catalogue by Francis Greenacre and Caroline Fox, 1985, pp. 73–75

Sir John Arnesby Brown, 1866–1955, was a pupil at Nottingham and in Herkomer's Art School at Bushey before establishing himself at the Royal Academy as a landscapist and painter of pastoral scenes. During the Edwardian years he enjoyed enormous prestige, having two pictures purchased by the Chantrey Bequest (1901 and 1910). He continued to be an Academy stalwart until after the Second World War.
The Studio, Vol. XX, 1900 pp. 211–216

Frederick Brown, 1851–1941, studied at the Government Art Training School and at the atelier Julian. He was a founder member of the New English Art Club and supporter of La Thangue's reform movement. Though he began as a rustic naturalist he later gravitated towards Whistler and the circle of Steer and Tonks. Having been an art master since 1877 he continued his career as Professor at the Slade School of Fine Art from 1892.

Professor Fred Brown, 'Recollections', *Artwork*, Vol. V, Autumn 1930

Sir George Clausen, 1852–1944, studied at the Government Art Training School and briefly at the atelier Julian. He was a founder member of the New English Art Club who, after the purchase of his *The Girl at the Gate*, 1889, by the Chantrey Bequest, entered the Royal Academy with reforming zeal. He was the most radical Professor of Painting at the Academy in the early years of the century when he was working in a notably impressionist style. An official War Artist during the Great War he was commissioned for a large mural in the Palace of Westminster in 1927.
Tyne and Wear and Bradford Museums, *Sir George Clausen R.A., 1852–1944*, catalogue of an exhibition by Kenneth McConkey, 1980

Charles Conder, 1868–1909, spent his formative years in New South Wales working with Streeton and Roberts at Eaglemont. In 1890 he returned to Europe and attended the atelier Julian and Cormon's studio where he met Rothenstein and Lautrec. During the nineties he led a bohemian existence producing fan designs and paintings in the currently fashionable eighteenth-century revival style. He designed a room for Siegfried Bing's *maison de l'art nouveau* in 1895. Marriage in 1901 came too late to save him from the effects of debauchery and despite a late flowering in 1906 his last years were marked by inactivity.
Sir John Rothenstein, *The Life and Death of Conder*, 1938
Graves Art Gallery, Sheffield, *Charles Conder 1868–1909*, exhibition catalogue by David Rogers, 1967

Wynford Dewhurst, 1864–c.1941, was born in Manchester. He studied at the Ecole des Beaux Arts under Gérôme. An enthusiastic Francophile he extended his training with attendance at the atelier Julian. Even after his return to England he spent regular periods in France painting scenes in the valley of the Seine in an impressionist manner. A follower of Monet, his *Impressionist Painting; its Genesis and Development* (1904) was the first important study of the French impressionists to be published in English. He continued to exhibit throughout the inter-war period staging an exhibition of pastels at the Fine Art Society in 1926.

Sir Alfred East, 1844–1913, was one of the leading landscape painters of his generation. He studied at Glasgow School of Art and at the Ecole des Beaux Arts, Paris. Initially influenced by the Barbizon painters and Whistler, his first success was obtained in 1887 when *Autumn Afterglow* (Dudley Art Gallery) was shown at the Royal Academy. In addition to regular exhibiting he travelled widely, visiting Japan in 1889, he also lectured and published a number of articles and books on landscape painting.
Alfred East, *Landscape Painting in Oil Colour*, 1906
Kenneth McConkey, 'Haunts of Ancient Peace, the landscapes of Sir Alfred East', in Alfred East Gallery, Kettering, *75th Anniversary Exhibition, 1913–1988*, catalogue of an exhibition, 1988

Stanhope, A. Forbes, 1857–1947, studied at the Royal Academy Schools and the Ecole des Beaux Arts under Bonnat. Deeply influenced by Bastien-Lepage he worked during the summers of the early 1880s at Cancale and Quimperlé with Henry La Thangue. In 1884 he settled at Newlyn and his first important work, *A Fish Sale on a Cornish Beach* (Plymouth Art Gallery) was shown at the Academy in 1885. A founder member of the New English Art Club, he was one of the first of

his generation to gain official acceptance, being elected Associate of the Royal Academy in 1892. In 1899 he and his wife opened a School of Art at Newlyn and while other contemporaries moved on, Forbes remained to see the new generation – including Laura Knight – arrive.
Mrs Lionel Birch, *Stanhope A. Forbes A.R.A. and Elizabeth Stanhope Fobres A.R.W.S.*, 1906
Barbican Art Gallery, *Painting in Newlyn, 1880–1930*, exhibition catalogue by Francis Greenacre and Caroline Fox, 1985, p. 51–59

Wilfrid de Glehn, 1870–1951, studied at the Ecole des Beaux Arts under Delaunay and Moreau. He met Sargent in the early 1890s and was asked to assist on the murals for Boston Public Library. This friendship blossomed in the early years of the century and de Glehn accompanied Sargent on sketching trips abroad. By this stage he had already placed his work successfully with the New English Art Club, the Royal Academy and the Salon and his first solo exhibition was held at the Goupil Gallery in 1908. He continued to exhibit regularly throughout the inter-war period.
T. Martin Wood, 'The Paintings of Wilfrid G. Von Glehn,' *The Studio*, Vol. LV1, 1912, pp. 3–10

Sir James Guthrie, 1859–1930, was born in Greenock in Scotland and was essentially self-taught. His first important work *A Highland Funeral* (Glasgow Art Gallery) was exhibited at the Royal Academy in 1882. A succession of paintings of peasants in the 1880s declared his early allegiance to Bastien-Lepage, and this only modified when he began to work in pastel. By the time he painted *Midsummer* his most impressionist work, he was already well established as a leading portrait painter.
Sir James L. Caw, *Sir James Guthrie, P.R.S.A., H.R.A., R.S.W., LL.D.*, 1932
Roger Billcliffe, *The Glasgow Boys*, 1985

Arthur Hacker, 1958–1919, trained at the Royal Academy Schools and under Leon Bonnat. A student friend of Forbes he was one of the founding members of the New English Art Club. He nevertheless took up Biblical amd mythological painting after the success of *By the Waters of Babylon* (Rochdale Art Gallery) in 1888. A teacher at the Royal Academy Schools in the 1890s he produced portraits and scenes of London life in his later years.
A.L. Baldry, 'The Paintings of Arthur Hacker', *The Studio*, Vol. LV1, 1912, pp. 175–182

Thomas Alexander Harrison, 1853–1930, was born in Philadelphia where he studied at the Pennsylvania Academy before going to Paris to become a pupil of Gérôme. He began to exhibit at the Salon of 1880 and thereafter became a close friend of Bastien-Lepage. At Concarneau the two sketched together. With the exhibition of *En Arcadie* (Salon 1886) he was considered Bastien's heir. However he spent much of the rest of his career painting luminous moonlit seascapes.
Michael Quick, *American Expatriate Painters of the late Nineteenth Century*, catalogue of an exhibition at Dayton Art Institute, Ohio, 1977, p. 103

George Henry, c.1860–1943, was born in Ayrshire and trained at Glasgow School of Art. He achieved acclaim in 1889 with *A Galloway Landscape* (Glasgow Art Gallery and Museum), a work apparently inspired by Gauguin. He began to collaborate with E.A. Hornel on large proto-art nouveau canvasses and in 1893–4 both artists visited Japan. By the turn of the century, however, Henry had turned to portraiture.

Scottish Arts Council, *The Glasgow Boys*, exhibition catalogue by Alistair Auld, Bill Buchanan and Ailsa Tanner.
Roger Billcliffe, *The Glasgow Boys*, 1985

Edward Atkinson Hornel, 1864–1933, studied in Edinburgh and at the Antwerp Academy under Verlat. His early work painted at Kirkcudbright c.1885 reveals a dutiful follower of Bastien-Lepage. However contact with Henry encouraged a more impastose and decorative style, seen in *Midsummer* (Liverpool, Walker Art Gallery). For him the visit to Japan in 1893–4 set the precedent for other expeditions to the Far East and for repetitive colourful friezes of girls in blossoming bowers.
Scottish Art Council, *The Glasgow Boys*, exhibition catalogue by Alistair Auld, Bill Bucanan and Ailsa Tanner
Roger Billcliffe, *The Glasgow Boys*, 1985

Alexander Jamieson, 1873–1937, studied in Glasgow and Paris but took up residence in London after his return from France. Throughout the early years of the century he made regular return visits to Paris and its immediate surroundings, painting at Fontainebleau and Versailles, exhibiting at the Goupil Gallery, the Carfax Gallery and, after 1901, at the International Society of Sculptors, Painters and Gravers. During these years his landscape studies were compared to those of Gaston La Touche for their post-impressionist character.
J.B. Manson, 'The Paintings of Alexander Jamieson', *The Studio*, 1910, pp. 274–282

William Kennedy, 1859–1918, studied at Paisley School of Art before attending the atelier Julian in the early eighties. Like Lavery he was impressed by the work of Bastien-Lepage and he numbered Collin and Courtois amongst his teachers. In 1887 Kennedy and Walton attempted to formalize the Glasgow Boys into a group. During this time he painted many scenes of army life from studies made at Kings Park Camp near his studio in Stirling. During the 1890s he worked increasingly in England and in 1912 as a result of ill health he moved to Tangier.
David Martin, *The Glasgow School of Painting*, 1898, (1976 reprint)
Roger Billcliffe, *The Glasgow Boys*, 1985

Harold Knight, 1874–1961, was born in Nottingham and studied initially at its School of Art, where he met his future wife, Laura Johnson. In 1894 he and Laura went to Paris to study at the atelier Julian and on their return they worked in the north-east fishing village of Staithes, Harold producing sombre scenes of the raw existence of the fisherfolk. Knight's work was transformed in 1907 by the experience of Newlyn with its more equable climate. During the Great War they moved to London, Harold already having become a painter of interiors and portraits. He became an Academician in 1937.
Barbican Art Gallery, *Painting at Newlyn*, 1880–1930, Catalogue of an exhibition by Francis Greenacre and Caroline Fox, 1985, p. 97

Laura Knight, 1877–1972, was born at Long Eaton, Derbyshire and trained at Nottingham School of Art. During the later 1890s she worked at Staithes and after her marriage to Harold Knight in 1903 the couple made their first trip to Holland. Their final Staithes compositions of 1906 were greatly influenced by the Hague School, yet this tonalism was dispelled the following year upon their arrival at Newlyn. There Laura produced remarkable impressionist Academy-pieces such as *The Beach* 1908 and *Flying a Kite* 1910. With her husband she moved to London in 1918 and during the inter-war period found new subject matter with itinerant actors, musicians, and circus folk. She became an Academician in 1936.
Dame Laura Kinght, *Oil Paint and Grease Paint*, 1936
Caroline Fox, *Laura Knight*, 1987

Henry Herbert La Thangue, 1859–1929, was born at Croydon and attended Lambeth School of Art and the Royal Academy Schools before entering the Ecole des Beaux Arts, Paris. A founder member of the New English Art Club, he unsuccessfully promoted a large-style exhibition to rival that of the Academy. Throughout the later eighties he worked in Norfolk and in 1891 moved to Bosham on the south coast where his Chantrey picture, *The Man with the Scythe* was painted. In the early years of the century La Thangue discovered new subject matter in Provence and Liguria and such scenes became dominant motifs in the years up to his death.

Oldham Art Gallery, A *Painters Harvest*, H.H. La Thangue, *1859–1929*, Catalogue of an exhibition by Kenneth McConkey, 1978

Sir John Lavery, 1856–1941, was born in Belfast and studied in Glasgow before gravitating to Paris and the atelier Julian. Like many British artists he was influenced by Bastien-Lepage and worked at Grez-sur-Loing. Upon his return to Glasgow he painted *The Tennis Party*, a work which immediately propelled him to leadership of the nascent Glasgow Boys. It was he who was selected to represent the State Visit of Queen Victoria to the Glasgow International Exhibition in 1888 and this launched him upon a career as a portraitist of the rich and famous. Although he moved to London in 1896, Lavery's reputation was international and his works were acquired for national galleries in Berlin, Rome and Paris.
The Ulster Museum and the Fine Art Society, *Sir John Lavery, R.A.*, *1856–1941*, Catalogue of an exhibition by Kenneth McConkey, 1984

Alphonse Legros, 1847–1911, was born in Dijon, France. He began his career as a second generation realist painter who came to London in the early 1860s in company with Whistler and Fantin-Latour. He became an important mediator between radical French artists such as Manet, Bonvin, Cazin and Lhermitte and the London art audience, helping Durand-Ruel set up his Society of French Artists exhibitions in London (1870–75). In 1876 Legros was appointed Slade Professor of Fine Art at University College, London, and was therefore instrumental in extending the knowledge of French practices to artists like Tuke and Rothenstein.
Alexander Seltzer, *Alphonse Legros and the development of an archaic visual vocabulary . . .*, unpublished Ph.D thesis, New York University at Binghampton, 1980

Albert Ludovici jun., 1852–1932, was born in Prague and studied under his father. The family moved to London in the late 1860s. During the 1870s Ludovici achieved success at the Royal Academy with genre paintings of bourgeois interiors. Always cosmopolitan, he cultivated contacts with French naturalists painters. In the mid-eighties, however, Ludovici joined Whistler's circle exhibiting at the Society of British Artists and later at the International Society under Whistler's presidency.
A. Ludovici jun., *An Artist's Life in London and Paris*, 1926

Leon Augustin Lhermitte, 1844–1925, was born at Mont-St-Père, France, and studied at the Ecole Imperiale du Dessin. He began to exhibit at the Salon in 1864, but his contacts with England did not develop until five years later, when he stayed with Legros in England. He made regular visits throughout the 1870s serving on the jury of the Dudley Gallery 'Black and White' exhibitions. During the decade Lhermitte developed a strongly naturalistic style which was rewarded in 1882 when *Paying the Harvesters* was purchased for the Musée du Luxembourg. By the turn of the century he was working more in pastel, a medium which enabled his belief in drawing to be more obviously evident.
Mary Michele Hamel, *A French Artist: Leon Lhermitte, 1844–1925*, unpublished Ph.D thesis, Washington University, 1974

Dugald Sutherland MacColl, 1859–1948, was born in Glasgow and obtained a Master's degree at University College, London before attending Fred Brown's classes at Westminster School of Art. Although a sensitive watercolourist and exhibitor at the New English Art Club from 1892 MacColl's primary role was that of critic in *The Spectator* from 1890 to 1896, and in *The Saturday Review* from 1898 until 1906. His *Nineteenth Century Art* (1902) provided the first serious appraisal of the French Impressionists to appear in English. He was appointed Keeper of the Tate Gallery in 1906, a post he was obliged to relinquish on health grounds in 1911. He nevertheless continued his writing career and saw his papers republished in anthology in 1931 as *Confessions of a Keeper*. This was followed in 1945 by his biography of Steer.

Paul Fordyce Maitland, 1863–1909, painted throughout his life in Kensington and Chelsea. He began as a student at the Government Art Training School and later was a pupil of Theodore Roussel, moving in the circle of Whistler's followers. These qualifications led to his acceptance at the New English Art Club in 1888 and as a member of the London Impressionists

in 1889. In later years Maitland taught drawing at the Royal College of Art.
Walter Sickert, *A Free House*, 1947, pp. 273–4

George Augustus Moore, 1852–1933, was born in County Mayo and grew up in Ireland on his family's estate. He set off for Paris to become an art student in 1873, and by 1879 had met Manet and the Impressionists at the Cafe of Nouvelle Athènes. After returning to London he took up writing, and his first novel *A Modern Lover*, appeared in 1883. His first volume of reminiscences was published in 1888. In the years which followed he published numerous papers on contemporary art mostly for *The Speaker* and he achieved success as a novelist with the Zola-inspired, *Esther Waters*, 1893.

Frank O'Meara, 1853–1888, was born at Carlow, Ireland. Around 1873 he went to Paris and was one of the first students at the newly established studio of Carolus-Duran. He was therefore a friend of Sargent. He lived at Grez-sur-Loing from 1878 until within a year of his death. There he exerted a forceful influence over other artists like William Stott of Oldham and John Lavery.
National Gallery of Ireland, *The Irish Impressionists*, Catalogue of an exhibition by Julian Campbell, 1984

Walter Osborne, 1859–1903, was born in Dublin, the son of an animal painter. He attended the Royal Hibernian Academy Schools before going to Antwerp to train under Verlat. Osborne returned to England with the rest of the plein-airists and joined the New English Art Club. Although he paid occasional visits to Dublin during these years, Osborne did not permanently return until 1892. In the closing years of the century he became the premier Dublin portraitist, painting in a manner which resumes the stylistics of Whistler and Sargent.
National Gallery of Ireland, *Walter Osborne*, Catalogue of an exhibition by Jeanne Sheehy, 1983

Lucien Pissarro, 1863–1944, was the eldest son of Camille Pissarro and was taught by his father. In 1890 he moved to London where he quickly identified Philip Wilson Steer as the most significant painter working in an impressionist style. Despite the fact that he continued to paint in this manner himself, he was known in England during the 1890s for *cloisonné* illustrations. Sickert brought him back into the centre of aesthetic debate in 1907 when he joined the Fitzroy Street Group. Thereafter he was a founder member of the Camden Town Group by which time his work had already had a profound influence upon younger painters like Spencer Gore.
Camille Pissarro, *Letters to his Son Lucien*, 1943
W.S. Meadmore, *Lucien Pissarro*, 1962

William Rothenstein, 1872–1945, was born in Bradford and trained at the Slade School of Fine Art under Legros. He completed his studentship at the atelier Julian in Paris, where in 1890 he met Charles Conder. In 1894 he became a member of the New English Art Club and moved to London. Because of his connections with French artists, Rothenstein occupied a central position which enabled him to promote the interests of younger Slade painters such as John and Orpen. During his long and distinguished career he was an Official War Artist and Director of the Royal College of Art from 1920–1935. He was knighted in 1931.
William Rothenstein, *Men and Memories*, 3 vol., 1931, 1932, 1938
Bradford Art Gallery, *William Rothenstein*, Catalogue of an exhibition by John Thompson, 1972

Theodore Roussel, 1847–1926, was born at Lorient, France. He seems to have settled in London around 1874. Roussel was self-taught although in the mid-1880s he became an avid follower of Whistler. In Whistler's entourage, with Menpes, he showed at the Society of British Artists in 1887. In that year he also joined the New English Art Club and was to be one of the principal exhibitors at the London Impressionists exhibition. Like his pupil Paul Maitland he spent most of the rest of his career painting and etching in and around Chelsea.
Frank Rutter, *Theodore Roussel*, 1926

John Singer Sargent, 1856–1925, was born in Florence and received his training at the atelier Carolus-Duran in Paris. Early successes at the Salons of 1878 and 1882 indicated a promising career which was arrested in 1884 by the showing of the

controversial portrait of *Mme. Gautreau*. Although Sargent moved to London after this, he retained contacts with France and notably with Monet. It was only with the exhibition of the *Lady Agnew* portrait in 1893 that Sargent was wholeheartedly hailed by critics. From that point until 1906 he continued as the leading Edwardian portraitist. Thereafter he returned to landscape painting and to a large mural project for Boston Public Library which was not finished until 1916. After this he was briefly an Official War Artist. Murals and occasional portraits occupied him in the last years of his life
Richard Ormond, *John Singer Sargent*, Oxford, 1970
Patricia Hills ed., *John Singer Sargent*, Catalogue of an exhibition at the Whitney Museum, New York, 1986

Walter Richard Sickert, 1860–1942, was born in Munich, the son of a painter. His family moved to London in 1868 and after a short spell as an actor, he joined the Slade School of Fine Art. Like Menpes he soon became a studio assistant of Whistler's, with whose introduction, he met Degas and other members of the Impressionist circle. In 1888 he infiltrated the New English Art Club and was the guiding spirit behind the London Impressionists. He painted many music hall scenes, although the years 1898–1905 were spent living abroad, in Dieppe, Venice and Paris. Upon his return to London he was taken up by younger painters and formed the Fitzroy Street Group. During his later years he painted from photographs and Victorian engravings exploring the excitement of found images.
Wendry Baron, *Sickert*, Oxford, 1973
Richard Shone, *Walter Sickert*, Oxford, 1988

Sidney Starr, 1857–1925, was born in Hull and studied at the Slade School of Fine Art under Poynter and Legros. He met Whistler in 1882 and in the following years joined his *entourage*. Having shown his work at the Society of British Artists since the mid-seventies he only became a member when Whistler assumed Presidency in 1886. By 1888 his work was, however, more in rapport with that of Degas, both in the exploration of the pastel medium and in low life subject matter. Alas, in 1892 Starr was obliged to leave for London for New York as a result of a scandal. Little is known of his career thereafter.
Royal Academy of Arts, *Post Impressionism*, Catalogue entries by Anna Gruetzner, 1979, pp. 344–345

Philip Wilson Steer, 1860–1942, was born at Birkenhead and studied at Gloucester School of Art, the Government Art Training School and the atelier Julian before transferring to the Ecole des Beaux Arts. In 1886 he was a founder member of the New English Art Club. For the next eight years, up until his solo exhibition at the Goupil Gallery he experimented with various types of impressionism. He showed at the London Impressionists, and became one of Brown's assistants at the

Slade in 1893. His long teaching career extended until 1930, and by successive degrees his style modified in the direction of romantic arcadianism.
Bruce Laughton, *Philip Wilson Steer*, 1862–1942, Oxford, 1971

Robert Allan Mowbray Stevenson, 1847–1900, was born in Edinburgh and took a degree at Cambridge before going to Paris to become an art student in 1873. The following year he entered the atelier of Carolus-Duran as a fellow student of Sargent and O'Meara. He was also an early visitor to Grez-sur-Loing, a village which was eloquently described by his cousin Robert Louis Stevenson in 1876. By 1885 he had joined the staff of the *Pall Mall Gazette* and he remained its leading art contributor until his death, devoting much space to the New English exhibitions. His most important publication was undoubtedly *Velasquez* (1895) an influential volume, frequently issued as an art school prize.
Denys Sutton, 'R.A.M. Stevenson: Art Critic', in R.A.M. Stevenson, *Velazquez*, 1895, (1962 ed.)

Edward Stott, 1859–1918, was born in Rochdale, was trained at the Manchester Academy of Fine Arts and completed his studies in Paris under Carolus-Duran and Alexandre Cabanel. An early member of the New English Art Club, he abandoned London to live his rural idyll at Amberley in Sussex, where he remained until his death. During the 1890s his painting also began to reflect older ideas – Millet and Fred Walker replaced Bastien-Lepage as his mentors – his peasants took on Biblical personalities although this did not override the consistent study of atmospherics.
The Fine Art Society, *William Stott of Oldham and Edward Stott A.R.A.*, exhibition Catalogue by Peyton Skipwith, 1976

William Stott of Oldham, 1857–1900, trained in Paris under Bonnat and Gérôme and was the most successful British artist of his generation in the eyes of French critics. His reputation rested upon two works painted at Grez-sur-Loing, *The Ferry* and *The Bathers*, with which he won a third class medal at the Salon of 1882. When he returned to England it was to occupy a prominent place amongst Whistler's followers at the Society of British Artists, however, in later years he uneasily combined Alpine scenes with Wagnerian phantasies.
Fine Art Society, *William Stott of Oldham and Edward Stott A.R.A.*, Catalogue of an exhibition by Peyton Skipwith, 1976

Henry Tonks, 1862–1937, was born in Solihull and studied medicine at the Royal Sussex County Hospital. Around 1889 he attended the Westminster School of Art as a pupil of Fred Brown. With Steer, he joined the staff of the Slade after Brown's appointment as Professor. By 1893 he had begun to show at the New English Art Club, and his own work with its insistence upon drawing, had much in common with that of Degas. In later years, however, he cut a reactionary figure,

being adamantly opposed to Fry's modernism.
Joseph Hone, *The life of Henry Tonks*, 1939
Norwich School of Art Gallery, *Henry Tonks and the art of Pure Drawing*, exhibition Catalogue by Lynda Morris, 1985

Henry Scott Tuke, 1858–1929, was born in York, studied at the Slade School of Fine Art and under Jean-Paul Laurens in Paris in 1881. At this time he met Bastien-Lepage and later returned to England as one of his followers. A founder member of the New English Art Club, Tuke obtained early notoriety with scences of nude boys bathing, a sequence which culminated in his second Chantrey picture, *August Blue*, 1894. Thereafter Tuke became a pillar of the Royal Academy. He made an exceptional visit to the West Indies in 1923, but returned to his beloved Falmouth where he died.
M. Tuke Sainsbury, *Henry Scott Tuke – A Memoir*, 1933

Edward Arthur Walton, 1860–1922, was born in Renfrewshire and studied at Glasgow School of Art and Dusseldorf Academy. His early landscapes betray a knowledge of Bastien-Lepage and Barbizon painting, however by the end of the 1880s, in common with other members of the Glasgow School, he had revised his style towards that of Whistler. This qualified him to take a leading role in the formation of the International Society in 1898. Although by that stage he had moved to London, he was called back to Glasgow at the turn of the century to execute a decorative panel for the Corporation's Banqueting Hall.
James L. Caw, *Scottish Painting, Past and Present*, 1908, pp. 370–373
Roger Billcliffe, *The Glasgow Boys*, 1985

James McNeill Whistler, 1834–1903, was born at Lowell, Massachusetts, and from 1855 was a casual pupil at the atelier Gleyre in Paris. During the next five years he associated with second generation realists like Legros, and obtained notoriety when *Symphony in white no. 1, The White Girl* was shown along with Manet's *Déjeuner sur l'herbe* at the Salon des Refusés in 1863. By that point Whistler had already moved to London and it was there in the 1870s that he produced the first of his controversial noctures. It was one of these pictures which sparked off the notorious law suit with Ruskin. During the 1880s he offered tutelage to Sickert and Menpes and spawned a large following which included Roussel, Maitland, Starr, Ludovici and others. In 1892 his retrospective exhibition at the Goupil Gallery brought him the critical favour in London which had long eluded him.
E.R. and J. Pennell, *The Life of James McNeill Whistler*, 2 vol., 1908
A. McLaren Young, M. MacDonald, R. Spencer and H. Miles, *The Paintings of James McNeill Whistler*, 2 vol., London and New Haven, 1980

Index